$27.45

"Zen thinking permeates Western arts: the mid-century pivot to Eastern influence is a truism of previous generations, but curiously absent from contemporary mastications of history. Ellen Pearlman gets it all right: *Nothing and Everything* is the perfectly balanced lesson—art, and change, and friendship."

　　—John Reed, novelist, book editor of *The Brooklyn Rail*

"The avant-garde is not ahead of its time; it is *in* it. Ellen Pearlman's book about the ripple effect Buddhism had in American contemporary art is a time capsule filled with treasures."

　　—Michael Goldberg, director of the D. T. Suzuki Documentary Project

"Ellen Pearlman reveals an amazing truth about the American avant-garde: that much of its freshness comes from ancient Zen philosophy and meditation! Nowhere else is this important story told so clearly."

　　—David Rothenberg, author of *Survival of the Beautiful*
　　　and *Blue Cliff Record: Zen Echoes*

"When D. T. Suzuki began to teach 'Buddhist Philosophy 101' at Columbia University in 1952, his class was like honey to bears among New York artists and poets, who had never met an authentic Zen Buddhist. Unknowingly, Suzuki was an important influence on the development of abstract expressionism and Beat-generation poetry. *Nothing and Everything* tells the story of how the seed of Zen was planted in rich, creative American soil.

　　—Denise Lassaw, daughter of sculptor Ibram Lassaw

"Ellen Pearlman vividly captures the feeling of spontaneity and freedom with which the American avant-garde sought *mu* and experienced suchness."

　　—Laura Hoffmann, *Artforum* magazine

"Like fresh footprints after a newly fallen snow, Zen and Buddhism left mindful and distinct imprints upon the post–World War II avant-garde cultural scene in New York City. *Nothing and Everything* leads the reader through an odyssey of social and cultural upheavals in this post-war time and the artistic responses that burst into creative expression in art, music, dance, literature, and media. Through extensive research and interview, Ellen Pearlman explores the influence of Buddhism upon the creative milieu and how it altered the course of imaginative interpretations in the 'new reality' of mental awakenings. An insightful read and an invitation for continued scholarship where the arts and Buddhist philosophy interweave."

—*Cathy Ziengs*, Buddhist Door International

NOTHING & EVERYTHING

The Influence of Buddhism
on the American Avant-Garde

1942–1962

ELLEN PEARLMAN

EVOLVER
EDITIONS

Berkeley, California

Published by EVOLVER EDITIONS, an imprint of North Atlantic Books
P.O. Box 12327
Berkeley, California 94712

Ibram Lassaw, Pencil on Paper, 1949. Permission to reprint from Denise Lassaw.
Michio Yoishihara, Gutai, 1955. © Naomi Yoshihara. Courtesy of the Ashiya City Museum of Art and History.
John Cage, Freeman Etudes; Copyright © 1981 by Henmar Press, Inc. Used by permission of C. F. Peters Corporation. All Rights Reserved.
Allen Ginsberg circa. 1948. © Allen Ginsberg Estate; reprinted with permission.
Daizo Yamaguma, 1988. © Ellen Pearlman.

Art direction and cover design by michaelrobinsonnyc.com
Book design by Brad Greene
Printed in the United States of America

Nothing and Everything—The Influence of Buddhism on the American Avant-Garde: 1942–1962 is sponsored by the Society for the Study of Native Arts and Sciences, a nonprofit educational corporation whose goals are to develop an educational and cross-cultural perspective linking various scientific, social, and artistic fields; to nurture a holistic view of arts, sciences, humanities, and healing; and to publish and distribute literature on the relationship of mind, body, and nature.

North Atlantic Books' publications are available through most bookstores. For further information, call 800-733-3000 or visit our website at www.northatlanticbooks.com.

Library of Congress Cataloging-in-Publication Data

Pearlman, Ellen, 1952–
 Nothing and everything : the influence of Buddhism on the American avant-garde, 1942–1962 / Ellen Pearlman.
 p. cm.
 Includes bibliographical references and index.
 ISBN 1-58394-363-3 (alk. paper)
 1. Buddhism and the arts—New York (State)—New York. 2. Avant-garde (Aesthetics)—New York (State)—New York—History—20th century. 3. New York (N.Y.)—Intellectual life—20th century. I. Title. II. Title: Influence of Buddhism on the American avant-garde, 1942–1962.
 BQ4570.A72P45 2012
 700'.411—dc23
 2011024383

1 2 3 4 5 6 7 8 9 UNITED 17 16 15 14 13 12
Printed on recycled paper

CONTENTS

INTRODUCTION

Modern art, to me, is nothing more than the expression of the contemporary aims of the age we are living in . . . All cultures have had means and techniques of expressing their immediate aims . . . Today painters don't have to go to subject matter outside of themselves . . . they work from a different source. They work from within. It seems to me the modern artist cannot express this age, the airplane, the atom bomb, the radio in the old forms of the Renaissance or any past culture . . . I paint on the floor. That is not unusual. The Orientals did that.[1]

—JACKSON POLLOCK

Nothing and Everything is about the relationship of Eastern thought, particularly Buddhism, to the arts in post-war New York City. In a relatively brief period of time—from the early 1940s to the early 1960s—a handful of individuals brought about major changes in music, performance, dance, theater, installation, video, mixed media, painting, and sculpture, as the evolution from modernism to postmodernism broke down the idea of art as a practice devoted to a particular medium. The world—or life itself—became a legitimate artist's tool, aligning with Zen Buddhism's emphasis on enlightenment occurring at any moment.

Buddhism originated in India, then migrated to China and Japan. The Japanese form of Buddhism, supplemented by more esoteric Tibetan Buddhism, influenced many in the New York avant-garde during the 1950s. Few artists had the resources or access to journey eastward, and were initially exposed to Buddhism either through the books and classes of Dr. D. T. Suzuki, the famed Japanese scholar

and translator, or through sharing knowledge with one another. Simultaneously, parallel movements were occurring in post-war Japan: the artist groups Gutai, Hi Red Center, Group Ongaku, and others were also dealing with the breaking down of artistic boundaries. Though their philosophical basis started at different ends of the spectrum, within just a few years these groups became aware of each another and even collaborated.

This book begins by examining the life of D. T. Suzuki and explores the content of the groundbreaking classes he taught to the public in the mid-1950s at Columbia University. Chapter 2 shifts to the life of Suzuki's most famous student, the music composer John Cage, and traces how Buddhism helped formulate aspects of his oeuvre. After studying with Suzuki, Cage taught a course in experimental composition at the New School for Social Research. From that class sprouted the art movement Fluxus and the birth of "event scores" and "happenings." Participants from Fluxus and other groups mixed with the artistic ferment occurring at the Judson Church in Washington Square as well as in dance, performance, and theater, and interacted with different Japanese groups.

Around the same time, the New York abstract expressionists founded The Club, which birthed new ideas in painting and sculpture and also held lectures—including a series on Zen. The Japanese artist featured prominently in those lectures was Saburo Hasegawa, the first abstract painter in Japan, who was friends with sculptor Isamu Noguchi and painter Franz Kline. The book concludes by recreating the brief meeting between D. T. Suzuki, beat writer Jack Kerouac, and poets Allen Ginsberg and Peter Orlovsky. It shows how these young men's search for new forms and visions led to a breakthrough in literary style and influenced an entire generation.

Early Origins and Initial Exposure

The influence of Eastern thought on American arts traces to the mid-nineteenth century, when the Boston circle of transcendentalists, most notably Ralph Waldo Emerson, became enamored with Hinduism and Buddhism. As early as the 1830s Emerson equated the East with the notion of the divine, writing about it in the publication *Nature*. In 1844 his magazine *The Dial* published an article on the Lotus Sutra.

Commodore Perry opened up Japan to the world in the early 1850s, and a small number of Americans and Europeans brought Asian art back to their home countries. At that time Buddhism was considered the religion of immigrant Chinese gold rush workers. Ethnic Buddhism officially arrived in California in 1852 with the opening of the Tien Hau Temple. Knowledge of Buddhism continued to spread when Asian teachers were invited to the Chicago World's Fair in 1893, and the World Parliament of Religions Conference convened with many prominent teachers, including Soyen Shaku, the Zen teacher of D. T. Suzuki. In 1898 Japanese workers constructed the Buddhist Church of San Francisco, but their beliefs and viewpoints did not spread past their immigrant circles.

The early twentieth century brought ideas inspired by Japanese and Chinese aesthetics into the realm of photography and painting, notably the dematerialization of the art object. Artists devised new inquiries based on light, reflection, and night after being exposed to Japanese and Chinese painting and ceramics, either in person or through reproductions. At the very end of the nineteenth century, painter Arthur Wesley Dow became friends with Boston Museum of Fine Arts curator Ernest Fenollosa and read his book *Epochs of Chinese and Japanese Art*[2], applying these new sensibilities to his work. A certain kind of mistiness in painting and photography

became popular, as did a new treatment of the horizon line. The painter Georgia O'Keeffe studied at Columbia University under Dow, who taught her the calligraphic brushstroke and how to make work emanate from the center, an element of Asian compositional technique. O'Keeffe also read Fenollosa's book[3] as part of her own study of Asian art and literature.

In the 1920s and 1930s, the Pacific Northwest spawned the Seattle School of painting. It included the artist Mark Tobey, who studied Chinese brush painting and later traveled to both Japan and China, as well as painters Kenneth Callahan and Morris Graves and composer John Cage. All investigated meditation and Zen thought.

World War II and the Interpolation of Cultures

The catastrophic effects of World War II forced thousands of European émigrés—academics, architects, designers, philosophers, scientists, and artists—to evacuate their homelands and settle in America. New York City benefited enormously from this wartime exodus, becoming the art capital of the world. Within a decade the idea and practice of what art was, and what it could be, shifted. Art was not just an object for aesthetic viewing but instead sought to involve the viewer as an active participant. This idea echoed Immanuel Kant's exploration of the nature of perception and Martin Heidegger's phenomenological reduction of the basis of consciousness.

After witnessing the Holocaust's horrors of man's inhumanity to man, European philosophy turned to existentialism to deal with the absurdity of the world. When the atomic bombs detonated, effectively ending the war, the power of the nuclear threat eclipsed anything mankind had previously imagined. There was a certain

cold exhaustion among young poets, writers, and artists, and they looked for another way. Many of them turned toward Eastern religions, especially Zen Buddhism, which was the most written about and the most accessible form of Buddhism at the time.

Buddhism's emphasis on pacifism, nontheism, antimaterialism, and techniques of meditation and contemplation attracted many forward-thinking individuals. The Indo-Tibetan Mahayana and Vajrayana Buddhist schools of thought and practice had texts in English that were available for study, though composed in arcane and obtuse language. The original (Southeast Asian) school of Buddhism, the Theravada, did not exert its influence until later, as there were no significant teachers residing in the United States at that time. Simultaneously, war-torn Japanese youth were turning from Zen Buddhism. A search for new ideas and need for experimentation led some Japanese to study and collaborate with their Western counterparts. The Japanese wanted to be free, modern, and Western; the Westerners wanted to be free, modern, and Zen.

D. T. Suzuki: Philosophical Breakthroughs

D. T. Suzuki's influence was limited mainly to a select group of cognoscenti who attended the open classes on Buddhism he taught at Columbia University from 1952 to 1955. He was not a household name and was neither written about in popular publications nor discussed on topical TV shows. More visible were artists such as Jack Kerouac and Allen Ginsberg, who caught the nation's attention with their unique personalities and provocative literary works (*On the Road, The Dharma Bums, Howl,* and others).

Suzuki's classes attracted many prominent individuals. Daybooks from the very first abstract sculptor in America, Ibram Lassaw, and

class notes from poet Jackson Mac Low reveal for the first time what ideas, concepts, and theories were actually taught in those classes. Arthur Danto, a professor of philosophy and art critic who attended Suzuki's class, believes that "the direction of art history itself changed in . . . a radical way. Whether Dr. Suzuki helped cause this change, or merely contributed to it, it is not something I can say with certainty. But the people who made the changes were themselves Suzuki's students one way or another."[4] Suzuki's teachings seeped into the worlds of music, painting, poetry and literature, performance, dance, and intermedia. Composers John Cage, Morton Feldman, and Earle Brown; poet Jackson Mac Low; painters Philip Guston, Ad Reinhardt, and Sari Dienes; sculptors Isamu Noguchi and Ibram Lassaw; critic Arthur Danto; gallery owner Betty Parsons; and even psychologists Karen Horney and Erich Fromm are a few of the individuals on record who attended the class.

John Cage and a Change in Music

The chapter on John Cage starts with the re-creation of his groundbreaking 1952 piano composition of silence, *4'33"*. The narrative follows his years in California and Europe, as well as his early studies at the Cornish School in Seattle, where he was exposed to Zen thought in Nancy Wilson Ross's lecture "Zen Dada." Cage befriended painters Mark Tobey and Morris Graves, who were interested in Buddhism, and met the dancer and choreographer who became his lifelong collaborator and partner, Merce Cunningham. Cage's move to New York and early experiments in composition are looked at through the lens of his studies with D. T. Suzuki, as are his years of teaching at Black Mountain College in North Carolina. Discussed in detail are the groundbreaking experimental "proto

happenings" he created with the artist Robert Rauschenberg. Cage attended Suzuki's Buddhism classes at Columbia and afterward taught a class on experimental composition at the New School for Social Research that was partially based on his studies with Suzuki. Notebooks from future Fluxus artist George Brecht reveal much about that class. Brecht, Dick Higgins, Allan Kaprow, Jackson Mac Low, Al Hansen, and Japanese composer Toshi Ichiyanagi used Cage's ideas on chance, indeterminacy, and spontaneity to make performances, compositions, and mixed-media scenarios that became Fluxus event scores and happenings. Their fresh approach ricocheted across to Europe and Japan and back to downtown Canal Street and Washington Square. Danto remembers when "overcoming the gap between art and life became a kind of mantra for the avant-garde artists of the early sixties. It was certainly a point of principle with Fluxus artists, so many who came to art through music as conceived of by Cage."[5]

Fluxus, Judson, Happenings: Performance, Dance, Theater, Intermedia

This chapter opens with a re-creation of the very first performance of Fluxus at the 1962 Fluxus festival in Wiesbaden, Germany. This reconstruction is based on an extremely rare video that was in the possession of the Korean video artist Nam June Paik. But Fluxus was not the only important artistic movement that was connected to individuals who had taken Cage's classes. Happenings and performance events at Judson Church in Washington Square had also been influenced by Cage, and by inference to Suzuki's teachings. Simultaneously, some of the avant-garde artists in Japan, like Group Ongaku and Hi Red Center, were producing remarkably similar work. The

origins of Fluxus and its incubation in Europe are shown in this chapter, as is the involvement of Nam June Paik, Ben Patterson, Emmett Williams, Toshi Ichiyanagi, Jackson Mac Low, Dick Higgins, Alison Knowles, George Maciunas, George Brecht, and others. The experiments around Judson Church developed the idea of the dematerialization of the object as art and gave rise to process-oriented creative practices. The Judson Dance Theater sprang from classes taught by Robert Dunn, John Cage's occasional pianist. Dunn, who had read the Abidharma, the text codifying Buddhist psychology, did not lecture the dancers about his studies, but the way he thought about the mind and creativity certainly contributed to breakthroughs in experimental dance and performance.

The Club, Abstract Expressionism, and the Triumvirate

The Club started in 1948 after a group of then-unknown abstract expressionists set up an informal place on Eighth Street where they could discuss important issues of the day. A short overview of the founding of The Club is included as an introduction. Among the myriad topics presented was a series of panels on Zen Buddhism delivered by a prominent abstract painter in Japan, Saburo Hasegawa. Hasegawa was invited to visit the United States by painter Franz Kline and sculptor Isamu Noguchi and gave a lecture at the Museum of Modern Art dressed in a traditional kimono. Kline, Hasegawa, and Noguchi's relationship was complex. Noguchi, a Japanese American, journeyed to Asia to find inspiration for contemporary abstract forms. Hasegawa looked to Noguchi, raised in America, to reveal to him the mysteries of his own traditional Japanese culture. Kline, a New York–based European American

painter, was in contact with both men and promulgated the incredible denial that his bold black-and-white paintings were not influenced by his exposure to Japanese calligraphy and art. Hasegawa and Kline both published works in the Japanese magazine of contemporary calligraphy *Bokujin-Kai* (Human Ink Society) and were well aware of each other's work. The discourse on calligraphy is traditionally tied up with Zen aesthetics.

The abstract expressionist sculptor Ibram Lassaw investigated *tathagata* ("suchness") in art that corresponded to Buddhist views of mental cognition, based on what is called in Sanskrit the five *skandhas*, or "heaps." The question of what "Zen Art" is in light of traditional Zen monastic art practices is explored within the context of traditional Japanese art. The chapter concludes with a look at art movements going on in Japan at the time, including Group Ongaku, Hi Red Center, and the Gutai, which incorporated performance and nontraditional use of materials.

Kerouac: Literature and the Cultural Zeitgeist

The chapter on Jack Kerouac re-creates his 1957 meeting with D. T. Suzuki, which Kerouac's friends Allen Ginsberg and Peter Orlovsky also attended. The visionary experiences of Ginsberg and his relationship to the nineteenth-century poet and artist William Blake is explored in light of the Beat artists' search for a "New Vision." Kerouac's forays in the San Francisco literary world and his friendships with the Buddhist poets Gary Snyder and Philip Whalen are touched upon. Also included in this chapter is a brief section on Geshe Wangyal, the first Tibetan Buddhist lama to settle in the United States, brought over by the Tolstoy Foundation. When the Beat poet Anne Waldman was only seventeen years old, she met

the elderly monk, an encounter highlighted for the first time in this book. Waldman later started the St. Mark's Poetry Project in New York and co-founded the Jack Kerouac School of Disembodied Poetics at Naropa University with Ginsberg.

Kerouac read prodigiously about Buddhism, including *The Life of the Buddha* by Ashvagosa and Dwight Goddard's *A Buddhist Bible*, and he translated French texts about Buddhism. He even wrote a hundred-page book meant to instruct Ginsberg titled *Some of the Dharma*. Kerouac's insights into the nature of reality developed outside an authentic lineage of teachers and approved techniques of meditation practice, a not-uncommon experience in Tibet.

The Avant-Garde and Its Need to Be

The term *avant-garde* is commonly understood to signal a shift in philosophical, verbal, visual, or auditory change in perception arising from a complex set of historical circumstances. The end of feudalism in Europe gave rise to the middle class, or bourgeoisie. Religion's influence waned; worship became individualized; and economic and political systems broke apart from their cultural systems. Art representing religion freed itself from rituals to represent the bourgeoisie and nobility. As the city-state expanded, the division of labor grew specialized. No longer considered mere craftsmen working at a guild, artists became unique. They produced aesthetic objects for collectors, enhancing the rising cult of individualism.

This industry of cultural production reflected a new division between art and life, one that accelerated with the advent of industrialization. In 1917, when the Dada artist Marcel Duchamp took an upside-down urinal and declared it a piece of art, he attacked artists and the egoistic preciousness of individual production. His signature

on the urinal (R. Mutt) was more important than the object itself (a lowly urinal).[6] In a museum the urinal lost its radical power of protest and became the latest demystified representation of the bourgeois world. Art for art's sake fueled a consumer society's constant need for new products. The American critic Harold Rosenberg realized, "The power of defining art is vested in art history, whose physical embodiment is the museum."[7] Art referenced itself within the museum, but artists threw art out of the museum and integrated it back into life. The avant-garde examined the art commodity by encouraging ephemeral experiences that could not be easily replicated. This integration with life was also part of Buddhism's emphasis on the importance of everyday objects and experiences. These ideas, based in Zen and Buddhist philosophy, were also present in Italian futurism and Dada—except that Buddhism de-emphasized the ego of the performer. Zen addressed direct cognition involving the artist, the viewer, and the art experience.

The Fluxus artist Dick Higgins said, "Avant-garde art is thus defined by its relation to the present moment. It gives expression to our present experience of now. The authentic avant-garde does not arise so much out of opposition to previous avant-gardes [the current establishment]. This opposition is more of a side effect that results from the fact that new avant-garde has rediscovered the present moment and given expression to it in a way that naturally differs from previous forms."[8]

What did Buddhism offer to artists? The Zen approach to making art *is* the work of art—that emphasis on being on the spot. Creation includes moments of silence, contemplation, spontaneity, and streams of consciousness. Dematerialization, a reaction against formalism, helped art objects morph from being single physical things to time-based experiences. Life, art making, process, and environment

combined. This change seeped into American art forms of dance, music, performance, poetry, literature, visual art, and multimedia. The institutions of the 1950s did not support these explorations, which forced artists into experimental, out-of-the-way venues.

Transmission, Lineage, and Thought

Early Buddhist influence in the American arts passed from teacher to student in a manner similar to how Buddhist teachings spread throughout India, China, Japan, Korea, Tibet, and other Southeast Asian countries. This raises the thorny questions of lineage, transmission, and influence. Since this book is about art, not religion, authentic lineage and transmission are not deeply investigated. What are examined are a social and artistic milieu and a sense of the cultural zeitgeist. According to the Tibetan lama Chögyam Trungpa, one receives the lineage's *adhisthana* or energy when it directly passes from one individual to another. This is done through word of mouth, although dreams and visions can play a part. Lineage's adhisthana can manifest in a style called *crazy wisdom,* in which things just seem to happen as if out of nowhere, or by accident. Energy can move through direct "thought" or "mind" realization instead of an actual teacher, although it is rare. Trungpa likened transmission to "receiving a spiritual inheritance ... the extension of spiritual wakefulness from one person to another,"[9] the "meeting of two minds," where true initiation is "exposing oneself." Transmission transcends normal cultural boundaries, and emotions, depending on the particular school being studied, play a part in receiving a transmission. It all depends on the preparedness of the student, the trust in the teacher, and "causes and conditions." In the 1950s in New York, the causes and conditions were ripe for change.

D. T. Suzuki: Philosophical and Spiritual Foundations

It took America dropping the atomic bomb for the West to become interested in Zen.
—GARY SNYDER[1]

Kensho

"Thwack!"

The flat wooden *kyosaku* stick stung first his right shoulder, then his left. Sitting still beneath its sharp blow, the young man gracefully lowered his palms, folding them on his lap in prayer position. His thumb tips, joined at the navel, formed a perfect O shape.

I have always thought *mu,* but I have never been *mu.* I live, breathe and eat *mu,* but still I do not know *mu,* he thought.

Twenty-seven-year-old Teitaro Suzuki had requested the harsh blow to keep him from falling asleep during his early morning meditation practice at Engakuji monastery. All his focus was centered on the koan "What is *mu?*" *Mu, mu, mu.* For four years he was obsessed by this question every hour of his waking life. Now was his last chance before leaving for America to assist Dr. Paul Carus, a friend of Roshi's, in translating the great Chinese classic the Tao Te Ching.

The floor in the zendo was cold that winter morning, and the sun had not yet risen from its berth beneath the moon. The young man's thin, dark robes did not afford much warmth, but he was determined to push on through this, his fifth day of sitting a weeklong *sesshin*, a grueling and intensive Zen meditation. Again he motioned for the attendant monk to strike him. The pain was slight—and it served to push him further toward discovering *mu*.

The food he ate was terrible—thin rice gruel and pickles—and the meditating sessions excruciatingly long. Suzuki at first naively believed the answer to *mu* was found in books. He read prodigiously. One passage in "Whips to Drive You through the Zen Barrier," written by a deceased Chinese master, particularly moved him: "When you have enough faith, then you have enough doubt. And when you have enough doubt, then you have enough satori [mental force] to solve the koan. Sit up straight regardless of day and night concentrating your mind on the koan."

Stretching himself even further, Suzuki walked *kinhin* meditation, placing one foot in front of another as the cold nipped at his bare toes. Tabi socks, his only source of warmth, were forbidden inside the meditation hall. He placed all his concentration onto the polished, creaking floor. The morning light broke through the soft mist and birds chirped, greeting the dawn. Sitting down ramrod-straight on a round black pillow, he redoubled his effort. *Mu, mu, mu.*

Then, suddenly, miraculously, *mu* merged into him. He lost track of time, pain, light, *mu*, Roshi, zendo, body, stick, floor, fingers, toes, birds, mist, cold, robes, pickles, posture, everything. Startled by the "ting" of a little bell, he emerged from his *kensho* realization, his satori. He did not know if a minute, an hour, or a day had passed.

I see, he thought. *This* is it.[2]

During his interview Roshi grilled him with test questions about *mu,* the great secret riddle. Though Suzuki answered all but one perfectly, Roshi still threw him out the door. But by dawn he had correctly answered all of the new questions Roshi had challenged him on. Roshi Soyen Shaku acknowledged his student's awakening, giving him the name Daisetsu, or "Great Simplicity." Later Suzuki humorously liked to say that it really translated as "Great Stupidity."

That night, after sitting was finished and it was time for bed, Suzuki walked from the monastery over the mossy stone path to his sleeping quarters. The gleaming moonlit trees appeared transparent, and he felt that he, too, was transparent. On the last day of his sesshin he felt he was dreaming, and he breezed through the final koan tests. Years later Suzuki said, "Technically speaking, the koan, given to the uninitiated is intended to make the calculating mind die [and] root out the entire mind that has been at work since eternity."[3]

That morning in 1896, on the cusp of the twentieth century, neither Suzuki nor anyone alive could have imagined that a half-century later, "Great Simplicity" would profoundly change avant-garde circles in Europe and America. In 1896, New York had no avant-garde or experimental art. World wars had yet to be fought, and there was no nuclear threat or bomb. There was no knowledge in the West of Zen or Buddhism outside of a small, highly elite circle.

The arts had already been touched by wisps of Buddhist thought. The Swiss-born French writer Jean-Jacques Rousseau and the Romantics had declared that civilization innately corrupted human nature. Vincent van Gogh, in his 1888 "Self-Portrait Dedicated to Paul Gauguin," painted himself in the likeness of a Japanese Buddhist monk. But this was more in line with the current rage in Europe of Orientalism.

In February 1897, a few months after his kensho, Suzuki leaned over the railing on the deck of his steamer docking at San Francisco harbor. He held his leather valise tightly to his chest, picking his way as carefully as possible among the swells of people. He boarded a train to La Salle, Illinois, to begin his new job translating the Tao Te Ching into English for his sponsor, Paul Carus, the editor of the *Monist* and Open Court Press. He was a long way from home.

Early Years in Japan

D. T. Suzuki was born in 1870 in the Kanazana part of Ishikawa Prefecture into the shizoku samurai class of physicians just thirteen years after Commodore Perry opened up Japan to the West and Emperor Mutsuhito introduced shocking reforms abolishing samurai warriors. Suzuki's father, Ryojun, a learned man fluent in the Confucian classics, died when Teitaro—the youngest of five children—was six years old, leaving Teitaro's mother, Masu, in dire financial straits. A year later one of Suzuki's brothers died. There were still three older sons to support the family, but by then civil unrest had broken out, causing tremendous inflation and a severe financial depression. The family scrambled to make ends meet.

By the time he reached his teens, Suzuki wondered why he was so unfortunate. The codes of *bushido* from the samurai warriors and the ordered world of Chinese literature were no comfort. He contemplated karma, or universal cause and effect. The family belonged to the Rinzai sect of Zen in the style of Rinzai Gigen (also known as Lin-chi) from ninth-century China. Enlightenment based on *zazen* sitting practice and koan practice was supposed to come in a flash. At an early age he was taken to his local temple, where he approached

the resident priest, or Roshi, and asked why his life was so difficult. The cleric only offered rote responses. Suzuki then asked his peers, "Why is it necessary for rain to fall?" which they could not answer. Underneath the relentless questions he was actually asking, "Why should the same rain fall on the deserving and the undeserving?" And why should such a hard rain fall specifically on him?

An eloquent math teacher and seasoned Zen practitioner who studied under Master Imakita Kosen (1817–1893) became a role model to the fatherless boy. The math teacher handed out complex Zen sutras to his curious students. Suzuki did not understand their meaning but sought answers at the Zen temple Kokutaiji. Knowing only that the temple was located somewhere near Takaoka, he squeezed into an old horse-drawn carriage as it rocked back and forth over the mountains of the Kurikara Pass. He was dropped off beyond the pass and stoically continued alone on foot.

Walking up the stone path of the monastery, he introduced himself to the monks, who told him that Roshi was away but taught him to sit and breathe. After two days the master returned, and Suzuki was brought for an interview. Grasping a copy of the Zen book *The Ortega,* Suzuki asked questions like a school child. Roshi bellowed, "Why do you ask me a stupid question like that?" and threw him out. Moping into his little room, he sat zazen. No one talked to him; they just brought him his meals. After five days he returned home.

In 1890 Suzuki's mother died. Through mutual friends he met Kosen, the abbot of Engakuji Temple, in Kamakura, the most influential temple in Eastern Japan. According to the poet Gary Snyder, the entire lineage of Rinzai Zen that migrated to the United States came directly through Kosen:[4] "There is no other line in Japanese Rinzai Zen which has even looked towards the West." Kosen

allowed lay disciples and encouraged his monks to study at universities, a liberty unheard of during that time.

Suzuki walked the thirty miles from Tokyo to Kamakura, leaving at sunset and arriving early the next morning. Stepping through the Outer Gate of Engakuji, a steep stretch of stone stairs flanked by fir trees and rare miniature red and gold Japanese maples, he proceeded into the Inner Gate, an imposing double-decked wooden pagoda with a winged balcony decorated with lattice windows that housed a magnificent statue of Eleven-Headed Kan'non, the goddess of compassion. He passed the Main Hall, built from intricately carved wood sheltering a large statue of Sakyamuni Buddha covered in flowing carved robes. On the ceiling were panels painted with beautiful white dragons. He had never seen such a beautiful or elaborately decorated monastery. The "guest master" monk escorted Suzuki to meet Roshi. They passed the Hojo living quarters for the main priest, whose courtyard contained a seven-hundred-year-old juniper tree, its seeds brought from China. Along the garden wall were a hundred different statues of Kan'non, each with a unique expression on her face.

Suzuki offered special "incense money" of ten *sen* to Roshi. Kosen, who was seventy-six, was huge in both body and personality and had recently suffered a stroke. Suzuki told Kosen he was just twenty-one years old and came from Kanazawa. Roshi nodded with approval, as people from Kanazawa had a reputation for being patient and steady. Roshi assigned him the koan, "What is the sound of one hand clapping?" Completely overwhelmed, Suzuki had no idea of what to do with it. Each time he approached Kosen for his interview, the Zen master stuck his left hand straight out, confusing him even more. He tried to find a facile answer but felt he was spiraling down a dead end.

A huge bell swung back and forth producing a deep, haunting ring, summoning him to his first dharma lecture. It started with monks reciting the Heart Sutra in perfect synchronicity. Roshi entered and prostrated himself beneath the statue of the Buddha. His attendant followed, carrying a small reading stand. When the chanting ended, Roshi spoke. One phrase in particular struck Suzuki: "Fine snow falling flake by flake, each flake falls in its own proper place," a harmonious and encompassing view of the universe. The idea that everything could and should rest in its own place, just like the snowflake, stayed with him throughout his life.

Though enlightened, Roshi still indulged in bad habits. At the Toji winter solstice festival monks made special holiday cakes that were one of Kosen's weaknesses. He dipped them in grated daikon sauce and gobbled them up. His attendant tried to stop him, saying he would get a stomachache if he continued, but Roshi pushed him aside. He said he was fine and would take "digestive medicine" if needed. On January 16, 1892, Suzuki was in the room next door with Roshi's attendants when they heard a loud thud. The main attendant found the master unconscious on the floor. He had suffered a lethal stroke and fell down, hitting his head on the chest of drawers. A doctor was summoned, but it was too late.

The head mourner at the funeral was the young monk Soyen Shaku (1859–1920; also referred to as So-en Shaku), a brilliant intellectual who already received his official certificate (or *inka-shomei*) as a Roshi. He had also taken a radical step for a traditional Zen priest by attending Keio University to study the West and was widely criticized within the Zen community for his daring innovation.[5] He had traveled to Sri Lanka (Ceylon) to study Pali, the ancient pre-Sanskrit language of India along with Theravada Buddhism, the prevalent Buddhist path of Southeast Asia.

7

In the spring of 1892 Soyen Shaku became the new abbot of Engakuji and changed Suzuki's koan to *mu,* but Suzuki was no closer toward solving the riddle. He spent the next four years working on *mu,* growing so desperate that he mentioned committing suicide to Nishida Kitaro, his friend who later founded the Kyoto School of philosophy. Suzuki commented, "It often happens that just as one reaches the depths of despair and decides to take one's life, then satori comes. I imagine that with many people satori may have come when it was just too late. They were already on their way to death."

The inability to answer his koan could not continue forever. The crisis came to a head on December 17, 1895, when Soyen Shaku decided Suzuki should move to America to translate the Tao Te Ching for Paul Carus and Open Court Press. This change brought on a crisis, and Suzuki delayed his departure twice. Resolving to sit one last sesshin, he said, "I realized that the rohatsu *sesshin* that winter might be my last chance to go to *sesshin* and that if I did not solve my *kōan,* then I might never be able to do so. I must have put all my spiritual strength into that *sesshin.*"[6]

That cold winter night he experienced satori. "After *kensho* I was still not fully conscious of my experience. I was still in a kind of dream. This greater depth of realization came later while I was in America, when suddenly the Zen phrase *hiji soto ni magarazu* ("the elbow does not bend outward") became clear to me ... This phrase might seem to express a kind of necessity, but suddenly I saw that this restriction was really freedom, the true freedom. I felt that the whole question of free will had been solved for me."[7] His friend Nishida wrote, "Suzuki was making progress in his practice and attained the initial awakening, *kenshō,* in the December 1895 *sesshin.*"[8]

Kensho, Satori, and Lineage

The term *kensho* is interchangeable with the word satori. Both derive from the Sanskrit "to know," the realization of the ultimate nature of reality. In Zen there is a term, *Den'e,* which translates as "handing on the robe" as part of *denbo,* or "dharma transmission," a "mind-seal" of enlightenment passed from teacher to student all the way to the Buddha. In koan transmission one receives an official inka-sho-mei giving a student permission to be a dharma teacher. *Inka* literally translates as seal. This does not in itself mean that others outside of this specific lineage do not experience enlightenment. Bodhidharma said, "A direct transmission outside of scriptures, apart from tradition / Without dependence upon words or letters. / A direct pointing to mind. / Seeing into one's nature and awakening."

The concept of direct lineage in Zen came from the medieval Chinese model of filial piety linking children to parents and students to teachers. Zen arrived in China from Bodhidharma, considered the twenty-eighth Indian patriarch and the first Ch'an or Chinese patriarch. In AD 475 his teacher, Prajnatara, the twenty-seventh Indian patriarch, told him to go to China. Legends say that he spent nine years in meditation in the Mount Sung cave, and he is popularly depicted in paintings as having cut off his eyelids to stay awake while meditating. Bodhidharma is credited with inventing Kung Fu for the Shaolin Temple monks. He died around the year 536.

The Soto school of Zen Buddhism does not use inka certification. Suzuki never received inka, nor was he authorized to officially teach zazen. But it is irrefutable that something had happened to him. He experienced mind-to-mind transmission, replete with his teacher's verification and recognition. Though there was no formal empowerment ceremony, did this mean he had no enlightenment

experience? Did having no official inka mean whatever he taught or wrote in future years on Zen was invalid? There are some who think so, but Suzuki never presented himself as a master, only as a scholar and translator.

World Conference of Religions

Suzuki's trip to the United States was a direct result of the 1893 World Parliament of Religions Conference in Chicago, part of the Chicago World's Fair. He wrote Soyen Shaku's acceptance letter and translated his entire speech into English but did not himself attend. Present at the conference were three other Japanese priests and two Japanese laymen.[9] There were nationalistic currents swirling around the conference. Japan suspected an attempt to establish Christian supremacy, as Christianity was being heavily promoted inside Japan. According to Gary Snyder, "They said it was beneath the dignity of a Zen priest to go to a barbarian country."[10] Two years after the conference Shaku, the first Zen master to set foot inside the United States, representing the views of the Meiji era of Japan, outlined the accomplishment of the Japanese delegation, saying they had "fulfilled [their] mission by propagating Buddhism." He cautioned that this position should be kept from "the public" so as not to give offense.

The conference lasted sixteen days, and Soyen Shaku met the German émigré Paul Carus, editor of the *Monist* and Open Court Press, and the millionaire zinc manufacturer Edward Hegeler, a German who financed Open Court. Carus needed a translator and editor for a new line of books on Oriental themes, starting with the Tao Te Ching. Soyen Shaku suggested Suzuki.

In 1894 Carus sent the translated proofs of "The Gospel of Buddha" to Soyen Shaku for comment. The book describes the Buddha's

first sermon as "The Foundation of the Kingdom of Righteousness" and "Truth the Savior," stating, "Blessed is he who has attained the sacred state of Buddhahood." Suzuki later commented, "In those days, Buddhism was viewed, even in Europe, as an unusual religion, studied primarily as a subject of scholarly inquiry."[11]

At the conclusion of the eleven years Suzuki spent working in the United States with Open Court, Hegeler sent Suzuki to Europe to copy Sanskrit documents at the Bibliothèque Nationale in Paris and to London to translate Swedenborg from English into Japanese. Hegeler supported him financially until his death in 1910.

First Return to Japan

At age thirty-eight Suzuki returned to Japan to teach English at Peer's University (Gakushūin University) in Tokyo. On December 12, 1911, his bachelor life ended when he married Beatrice Erskine Lane, a Scottish-American (1878–1939) from Radcliffe College. Theirs was a rare and true meeting of the mind and heart. The couple even adopted a son whose father was Scottish and mother Japanese. They named him Alan Masaru.

On July 30, 1912, Emperor Mutsuhito died, which marked the end of the Meiji era. For the next decade Suzuki and his family lived in a house on the compound of Engaku Monastery, and he continued his Zen studies with Soyen Shaku until his master's death in 1919. Beatrice died of cancer on July 16, 1939, at St. Luke's Hospital in Tokyo. Years later Suzuki told his student Albert Stunkard that when Beatrice died, he shed "bitter tears," but that his tears had "no roots."

His sorrows dovetailed with the outbreak of World War II. The Japanese police suspected he was a foreign agent, since he had

traveled to the West and married an American. He ignored them, devoting himself to study and translation. He subtly criticized the war, saying kamikaze pilots were overly sentimental. He wrote on bushido, the samurai code, with its underlying Zen-like emphasis on acting in the present moment. Unfortunately, bushido was used to manipulate soldiers' actions. Zen priests from all sects supported the war effort, and Zen was used by military officers to commit atrocities in the same way Christianity was being used to justify the Holocaust in Europe. Even though he was in his seventies, Suzuki had to walk a very fine line while living in a censored environment. Openly opposing the war would have landed him in jail on accusation of treason. According to his secretary, Mihoko Okamura, "He kept saying, with the risk of being arrested, that they [Japan] should not have gone to war with America . . . Dr. Suzuki was not brainwashed . . . the militarists came and told all the university students you must go to war and die for your country. Well, Dr. Suzuki got up and said, 'No, you come back alive because without you Japan will not have a future.' He was able to say that with the militarists right there, and if they dared to arrest him, they could have done that . . . The fact that they did not arrest him does not mean that he was pro-militarist. And I know from my own experience that he was against the militarists."[12]

On August 6 and 9, 1945, atom bombs destroyed Hiroshima and Nagasaki, ending the war. It was a difficult time for all Japanese. Food was scarce, and after Suzuki's housekeeper died, he did not look after himself. Christmas Humphreys, the distinguished lawyer and judge who worked with the war crimes tribunal, discovered Suzuki in fragile health, as did Robert Aitken, who later became the Roshi of the Diamond Heart sangha in Hawaii. Aitken brought Suzuki rations from the American canteen. Philip Kapleau, author

of *The Three Pillars of Zen,* also visited him, as did Richard de Martino, who became his assistant for a number of years.

Second Trip to the Unites States

In 1949, at age seventy-nine, Suzuki attended the second East-West Philosophers' Conference at the University of Hawaii in Honolulu and then taught their fall semester. He also taught at Claremont Graduate School in Pasadena in 1950, lecturing on "The Logic of Zen Buddhism." Jonathan Greenlee, a student at UCLA, witnessed Suzuki's unorthodox teaching style for himself in a lecture at Regents Auditorium. As Suzuki walked on stage, he was smaller than many people expected. Leaning over, he tapped the microphone. A ping ricocheted out of the loudspeaker. "Zen Buddhism. Very hard understand. Thank you," he said and walked off. Chaos broke out; the audience began screaming. The chair of the Oriental Department dragged Suzuki back out onto the stage, along with some other professors. They set up a row of seats and sat Suzuki down, plying him with questions for an hour so everyone would shut up.

In 1951 Suzuki was jointly sponsored by the Rockefeller Foundation and Union Theological Seminary to lecture at Yale, Harvard, Cornell, Princeton, Chicago, Northwestern, Wesleyan, and Columbia on "Oriental Culture and Thought." UCLA, the University of Hawaii, and Columbia all offered him teaching positions. He chose Columbia, saying, "I accepted the invitation of Columbia University to lecture there this coming semester on Kegon philosophy, thinking that this will help arrange the material in such a way as to make the Western people understand what they want to know most in Eastern thought and also who is most needed in the elucidation of Kegon

philosophy to the Western mind."[13] In March 1951 Suzuki presented three lectures at Columbia—"The Development of Buddhist Thought in China," "Kegon Philosophy," and "Kegon Philosophy and Zen Mysticism"—drawing 150 to 300 people for each talk. There is no record of Jack Kerouac, Allen Ginsberg, or John Cage ever attending these talks. Ginsberg mentions in retrospect that he knew Suzuki was at Columbia but made no use of the fact at that time and did not attend any of his classes.

Suzuki became a visiting lecturer in the Chinese department of Columbia University in the spring of 1952. He told his class, "All other Buddhist teachings were given by the Buddha to his disciples after he had come out of the enlightenment. In Kegon he made no such accommodation to his hearers."[14] He based his talks "The Development of Buddhist Thought in China" on the Avatamsaka Sutra, emphasizing the interdependence of all things.

Cornelius Crane, son of the family who manufactured Crane's bathroom fixtures, paid a large part of Suzuki's salary, stipulating that "outside auditors must be allowed to attend these seminars in addition to the Columbia body." This generosity opened it up to the curious and interested New York public. Crane's gesture had far-reaching psychological, religious, artistic, social, and philosophical consequences. Psychoanalysts Erich Fromm and Karen Horney sat in on the class, as did future Buddhist teacher Philip Kapleau and Buddhist writer Lenore Friedman. John Cage brought the composer Morton Feldman and the painter Philip Guston. Mary Farkas, the female master of the First Zen Institute of New York; Ad Reinhardt; the philosopher and critic Arthur Danto; and the gallery owner Betty Parsons dropped in as auditors. The poet Jackson Mac Low remembered, "I attended them [Suzuki's classes] from 1955, until Suzuki returned to Japan, in 1958. Besides Cage and myself, the only

other artist I knew who occasionally showed up at Suzuki's classes was the late visual artist...Sari Dienes."[15]

Two years before she died in the early 1990s, Sari Dienes said, "I took some seminars up at Columbia University with Daisetsu Suzuki, and John Cage used to come to this seminar. I even made Isamu Noguchi come, and I think that really opened his eyes to Japan."[14] Later in his life, Noguchi noted that Suzuki "was a much older man, much older than anyone . . . He was not a stranger, but I came to see him more in Japan."[16]

Suzuki's classes are legendary. He wrote on the blackboard in Japanese, Sanskrit, Chinese and Tibetan; his command of languages was extraordinary. While there is no direct account of what he actually taught, tantalizing hints have come from different sources. He wrote about sumi-e ink painting, "The artist must follow his inspiration as spontaneously and absolutely and instantly as it moves; he just lets his arm, his fingers, his brush be guided by it as if they were all mere instruments, together with his whole being, in the hands of somebody else who has temporarily taken possession of him."[17]

He wrote on the blackboard in Japanese, Sanskrit, Chinese, and Tibetan. Suzuki's classes are legendary, but there is no direct account of what he actually taught. Tantalizing hints have come from different sources. In a memorial issue of the *Eastern Buddhist* dedicated to Suzuki, A. W. Sadler says, "In a classroom at the Lowe Library building on the Columbia campus in a big Victorian building, with his soft voice and jaunty eyebrows he [Suzuki] said, 'This will be a course on a philosophy of timelessness and spacelessness which have no beginning,' and then said quite deadpan, 'Therefore this course will have no beginning.'"[18]

However, there are records. Ibram Lassaw, a sculptor in the abstract expressionist movement, and poet Jackson Mac Low, who both

took notes in Suzuki's class. Born to Russian Jewish parents in Egypt, Lassaw (1913–2003) came to New York when he was eight. In 1936 he founded and later served as president of the American Abstract Artists, an organization that included Ad Reinhardt, Ilya Bolotowsky, and John Ferren.[19] In 1948 he was one of the founders of The Club, an informal meeting place for downtown artists. Lassaw attended Suzuki's lectures from about 1953 to 1957 and kept extensive daybooks.[20] Mac Low (1922–2004), a proponent of "sound poetry," influenced many of the Language poets, and was a pioneering member of the art movement Fluxus. One of his detailed notebooks of Suzuki's classes, though partially burned and charred, survives.

What Suzuki Actually Taught
Lassaw's Notes, 1954–1957

In 1954 Lassaw brought his daybooks to class, jotting down personal revelations and quotes from books he was reading[21] as well as logging fragments of Suzuki's lectures. In the spring of 1954 students were taught about Buddha nature, the pitfalls of using reason to obtain it, and the impossibility of the dualistic mind grasping the essence of the Zen teachings. They had to read the Lankavatara, Diamond, and Heart Sutras but were warned against overreliance on sutra texts.

The Lankavatara Sutra, a core text of Mahayana Buddhism, translates as "Sutra on the Descent to Sri Lanka" and focuses on the *tathagata-garba* or "womb of suchness" that resides in every person. These teachings shaped Chinese Zen or Ch'an but are relevant to Zen in the West as they examine the nature of mind and enlightenment, stating that words, letters, and ideas are not essential to enlightenment. Teachers can only point the way, but the students

must experience it themselves. The Diamond Sutra, often described as the oldest printed text in the world,[22] emphasizes "nonabiding" or continual practice, what some schools refer to as the "postmeditation" experience of moment-to-moment awareness. The Heart Sutra or "Perfection of Wisdom" records a dialogue between the Buddha and his disciple Sariputra and elaborates on the relationship between "emptiness" and "form" as well as the six senses (sight, sound, touch, taste, smell, and consciousness) and their lack of solid perceptual reality. Suzuki taught the notion of emptiness, and though he relied on texts, he emphasized that one should not "depend on words or letters" and that words were "coarse."

What would lead to enlightenment was "wall gazing" coupled with discipline or *dhyana*. The subject of meditation could be anything, not just wall gazing; it could be the earth, air, or the moon. What was important was to fix one's consciousness intensely on a single object to experience the merging of subject and object. Suzuki suggested wearing loose clothes, sitting quietly, meditating on the Sanskrit letter A, and trusting in one's own "direct personal experience." It is safe to conclude that not one student had previously practiced wall gazing. Instructing that "affirmation implies denial, denial implies affirmation," Suzuki asked them to look at their definition of moral good and bad. He taught Pure Land Buddhism, with its emphasis on the mantra of Amitaba Buddha making the "recitation, reciting, and reciter become one." He brought it up to date by saying that all atoms connected with all other atoms and their subatomic parts "in eternity."

The poet Ira Cohen, then an undergraduate at Columbia, remembered that in the class, "There was the guy who was lecturing for him, his assistant. The American was talking about this certain period where there was a very big increase in the number of monks

as if to signal a kind of strong rise in the spiritual nature in Japan, like a movement. Suzuki interrupted in a very whimsical way to say that was because they could avoid military service. So he was very whimsical and very amusing. It made a certain impression on me, and I think it was just beginning to make an impression on a lot of thoughtful people at that time."[23]

On May 7, 1954, and possibly May 14, Suzuki presented Dr. Cheng Chi Chang, a Chinese scholar of Tibetan Buddhism, as a guest to lecture on the pundit Nargajuna and teachings of Mahamudra.[24] Chang had written *The Six Yogas of Naropa and Mahamudra,* which at the time were extremely esoteric texts, as well as *The Practice of Zen,* and was awarded a Bollingen Foundation grant for his translations of classical Tibetan literature. Lassaw mentioned that tantra, coupled with compassion and wisdom, could be a path of liberation. Chang's teachings in Suzuki's class were possibly one of the earliest publicly accessible teachings on Tibetan tantra in New York.

However, Tibetan Buddhism and the Dalai Lama were not unknown in America. The April 23, 1951, cover of *Life* magazine showed Heinrich Harrer's exclusive photos of the Dalai Lama's perilous escape from Tibet. The cover of *Life,* with a circulation of over 5.2 million, read, "Historic trek over the Himalayas to escape the Reds . . . Lama reaches safety," and showed a color photograph of His Holiness in maroon robes. It is impossible to know what Americans thought of the description of the Nechung Oracle, the Dalai Lama's personal oracle, going into a trance and insisting that His Holiness be enthroned at age fifteen instead of eighteen. The article reported, "The oracles were consulted and they went into their epileptic-like, slavering trances. The consensus of their disjointed prophetic mutterings was that the Dalai Lama should be installed at once."

After fleeing 284 miles over the treacherous Himalayas, the party reached the Indian trading post at Gyangtse. A report was filed to the news media over the town's only telephone line, saying, "He was reported to be a *Life* magazine reader [in translation] and wanted to see the New York skyscrapers." The article mentioned that after the death of the thirteenth Dalai Lama, who had been embalmed with salt, his face had miraculously turned toward the northeast and "rainbows and clouds of a certain formation were seen to be moving in that direction, indicating where the new lama would be found." The article was immediately followed by ads for bras and prune juice.

Zen Buddhism was difficult enough for the participants in Suzuki's seminars; to understand Tibetan tantric practice was just too much. It was not until a decade later that Tibetan Buddhism became more widespread, even though in 1955 the first Tibetan Buddhist (Kalymuk) Lama, Geshe Wangyal, had moved to America, settling in suburban New Jersey.

Suzuki's fall 1954 semester emphasized the pragmatic daily methods of Zen. Saying it was not "spiritualism," he cautioned that one should not rely on "mere sense data." It was concerned with "now," not with the concept of the now. Lassaw learned from his spring 1955 class that China was the "real birthplace of Zen" and that the "Fa-yen school of Buddhism" was a melding of Chinese and Indian thought. Suzuki explained that inner mental struggle was the real sin for man, because one's experience consisted of "what goes on in our mind." Revisiting Tibetan Buddhism, he said that Mahamudra, the great seal of perfection, "sounds like Zen but [was] not really Zen." Then he added, "It is; it is not," affirming that both points of view were true. He warned students that Zen was similar to a sharp sword, and if "touched" they would lose their life. Zen had

the capacity to come at them from every direction as a "whirlwind" and defeat them.

Poetically intertwining Taoism into his talks, Suzuki said that the Golden Flower of Taoist literature was the same as the flower the Buddha handed to his disciple Mahakasyapa, who passed it to the disciple Ananda. He addressed stream of consciousness, which artists were depicting through literature, poetics, music, and visual art, explaining that reality was never static and that the mind fed on thousands of stimulations involving both objective and subjective reality. Transcending the dualism of objective and subjective did not mean creating a third state of transcendence, a common pitfall of logical analysis his students should avoid at all costs.

He discussed the debate between Bodhidharma and the second patriarch. The patriarch told Bodhidharma he had succeeded in ceasing his worldly affairs. Bodhidharma accused the second patriarch of using wall gazing "as mere annihilation." The patriarch disagreed, saying he knew that "thusness" was true, and Bodhidharma swiftly retorted, saying that once you called something "this" or "that," you were already cut off from direct experience.

Hindrances were viewed as empty and a "reservoir of infinite possibilities." Suzuki spoke about mantra recitation and prayer's usefulness in focusing the mind. In a first for New York City he taught his students the Tibetan mantra of *Om Mani Padme Hum*, translated as "the jewel is in the lotus." "*Om* is composed of three (Sanskrit) letters, A, U, and M. These symbolize the practitioner's impure body, speech, and mind; they also symbolize the pure exalted body, speech, and mind of a Buddha."[25] *Mani* means jewel, *Padme* is lotus, and *Hum* is the union of wisdom and method.

That November Lassaw ingested ten capsules of peyote with his friend Denise Delaney.[26] He experienced "suchness" that melded

into "prime reality." Was this enlightenment? Hardly, but it did open the way toward the possibility of experiencing enlightenment by loosening the grip of repetitive conceptual thinking, as psychedelic drugs were to do in the 1960s and 1970s.

Lassaw continued to study with Suzuki until his last class on May 17, 1957.

Lenore Friedman's Recollections

In February 1956 Lenore Friedman was studying dance with Martha Graham and attending Suzuki's seminar. She first became interested in Buddhism while listening to Alan Watts on KPFA, a radio station in Berkeley, California. While living in New York, she saw Suzuki's name in a Columbia course catalog. Recognizing it from Watts's show, she signed up.

She remembers that Suzuki taught about Hui Neng's doctrine of the oneness of *prajna* (knowledge) and *jnana* (pure wisdom). The seminar was held at "night and [it was] dark . . . a classic seminar, it was people sitting around a table."[27] She sat on one side of the table and Suzuki sat across from her. Only ten students were there, and she didn't know any of them. The lectures were "dry," and as Lenore recalled, "It wasn't a dynamic class. We just sat and took notes and listened to this wizened man. As I recall he was bald, and he had a ring of gray, unruly hair, but he was wryly funny. There seemed to be little discussion or interaction between students."[28]

But she vividly remembered his discourse about the famous Zen (Ch'an) master in China, Hui Neng, who introduced the school of "sudden awakening." "Hui Neng the sixth patriarch was not even a monk. The monastery was choosing the next Roshi and there was a test. The monks had to write about satori, and the head monk who was favored to win wrote, 'There is a mirror of understanding and

you have to keep it clean and polish it every day to reflect the truth.' His answer was placed where everyone could read it. The next day an anonymous verse appeared: 'There is no mirror, there is no dust, there is just the truth, just see and it is right here.' The cook's assistant wrote it, and he was recognized as the heir to the teacher. Because of his lowly stature his life was in danger, which is why he posted it secretly. He fled but was brought back and proclaimed heir. This was a very dramatic story and I absolutely remember Suzuki talking about it. That is what I filled my notebook with."[29]

Jackson Mac Low's Notes

The poet Jackson Mac Low attended Suzuki's winter 1956 class, and his extensive and detailed notes for that class begin with an analogy of a sword as the symbol of mind. The sword must strike before the moment of preconceptuality arises from the *alaya vijnana,* the storehouse of consciousness referred to as the "eighth consciousness" before the mind splits into subject and object. It is from this storehouse that all other consciousnesses arise, including the five that make contact with the sense objects of the eye, ear, nose, taste, and sense perceptions. The sixth consciousness is where reality, fantasy, and memory come from. The seventh consciousness discriminates and calculates actions. Since it discriminates so well, it becomes attached to ego and the notion of permanence. It is this ego identification with permanence and an idea of a fixed self that leads to unwholesome acts and the creation of *samsara.* Chögyam Trungpa, a Tibetan master, said about the alaya vijnana: "Generally all religious traditions deal with this material, speaking variously of alaya vijnana or original sin or the fall of man or the basis of ego. Most religions refer to this material in a somewhat pejorative way but I do not think it is a shocking or terrible thing."[30]

An entire class was spent on Shuzki Shōsan, the seventeenth-century samurai warrior under the Shogun Ieyasu Tokugawa. Shōsan wrote the *Moanjo* ("A Staff for the Blind") about the superiority of Buddhism over Confucianism. He attained enlightenment at the age of forty-one and gave up his warrior ways to become a monk. This put him and his family at risk of execution as he was not given formal permission to resign. However, the shogun spared him and his family. Shosan's Roshi, Zen Master Daigu Sochiku, believed that his student was so advanced he didn't require a special Buddhist name. Having spent so many years as a warrior, he was able to confront death at any moment and lived each day as if it was his last.

What did Suzuki's students think when he urged them to have the "courage to jump into the valley of emptiness"? Those with Judeo-Christian beliefs thought of heaven or hell. The atheists and agnostics found the idea refreshing. Existentialism and Sartre's name came up in the context of the way an existentialist might face death, and the "courage to be." But Suzuki challenged that statement with, "We are," saying that there was no need to *become*. He taught about *mu-nen-mu-sō* and *mu-shin*. Mu-nen-mu-sō describes the energetic mind ready to spring into action, and mu-shin a detached mind free from delusion. A sword or calligraphy brush embodies mu-shin through one's arms and hands.

Not a Roshi

Suzuki was quite aware of the effect his teachings on Buddhism were having on American culture, and he knew he needed to be as clear and concise as possible. He presciently said, "I wish to refer to a certain literary movement started on the western coast of America. I have no firsthand contact with it, and to that extent I am far from being qualified to comment on the movement. But it is possible to

gather something of what moves in the minds of these writers from what some critics have to say. An Eastern proverb has it: 'Just one leaf falling and we know autumn is with us.' Can I not then take the literary movement in San Francisco for a leaf falling from the paulownia tree, as auguring a possible change in the psychological climate in Western culture? I may be going too far, but I will leave it to the judgment of the reader."[31]

Abe Masao, one of Suzuki's students, recounts "There was, without a question, a strong sense of mission behind Suzuki Sensei's efforts to transmit Buddhism and Zen to the West . . . He was a citizen of the world who intensively lived the first of the Four Buddhist Vows: 'However innumerable living beings, I vow to save them all.'"[32]

According to Mihoko Okamura, his secretary, Suzuki was not a proselytizer. "He could see that people could be quiet without meditating. In human history, in Christian history for instance, you can be quiet without sitting down in a particular posture, although he did say that that is the best posture for being quiet. He felt the Indians had done very well in showing that folding your legs up and putting your body in one place, in one form, and your spinal cord being straight, is probably the best way for a human being to reach serenity, and yet he did not think that that was the only way to arrive at that."[33]

By now Suzuki was becoming so renown that the *New Yorker* magazine wrote a generous profile about him, and *Vogue* also published a profile. His gentle, modest, and unassuming demeanor endeared him to many, and he felt extremely responsible for representing authentic Buddhism, not the "Beat" Buddhism taking hold in the public imagination. Suzuki never attempted to portray himself as a Roshi, or enlightened lineage holder of zazen or koan practice;

nor at that advanced age did he feel that as Japanese he was superior to anyone else. He did believe that Zen, which is difficult to grasp without sitting meditation, was widely misinterpreted, and he felt that monastic and sesshin practice belonged with the proper lineage authorities. But *some* kind of mind transmission did happen between him and his students, even though it did not result in any form of enlightenment. The formal context for authentic mind transmission in Zen is within a sesshin conducted by a Roshi with an inka certificate. But in the 1950s, unless one journeyed to Japan, studied Japanese, and lived in a monastery, this encounter was just not available. Suzuki was as close as most students could get.

Retiring from Columbia in 1957, Suzuki said about teaching, "One ought not to be in a hurry. It takes one hundred, two hundred, three hundred years to have Zen really planted in the West."[34] Suzuki died at the age of ninety-six in Japan on July 12, 1966, from an inoperable intestinal obstruction.

John Cage: Experimental Composition and Time-Based Performance

How do we get elegance? By paying attention—particularly to what we do.

—John Cage[1]

The Silence That Changed Everything

The pianist David Tudor opened and then gently closed the curved lid over the black and white ivory piano keys. A slim dark-haired man, he shifted on the piano bench on the stage of Maverick Concert Hall, a latticed dome structure nestled in a lush grove in Woodstock, New York. Staring at his stopwatch, he again read the musical score, which read "Tacet," Latin for "it is silent." Opening and closing the lid twice more, he produced no music. The audience coughed and sneezed in between the uncomfortable pauses. The first movement lasted only thirty-three seconds, the second two minutes and forty seconds. The third movement lasted one minute and twenty seconds. Tudor then rose from the piano bench and stood in front of the visibly perturbed audience.

On August 29, 1952, composer John Cage had Tudor play the world premier of his composition *4'33"*, a simple, elegant, and startlingly revolutionary piece. Using nothing more complex than periods of silence, it changed everything. Before, silence was used as a momentary lapse between sounds, a tasteful pause or a moving finale. No one had ever conceived of it as an end in and of itself. Silence was not the purification of noise, but the recognition of the *purity* of noise. Cage wanted "each observer to have his own experience of the sound in the auditorium" and envisioned the first movement as breezes in the trees, the second as the sound of rain, and the third as that of the audience talking.[2]

The evening, part of a benefit for the Artists' Welfare Fund, included compositions by Pierre Boulez, Earle Brown, Henry Cowell, Morton Feldman, and Christian Wolff. Cage played *Water Music,* and the program notes incorrectly listed *4'33"* as *4 pieces.* The concert was held during the height of the McCarthy era, and a year later Ethel and Julius Rosenberg were sentenced to death by electrocution for spying for the Soviet Union. Some have suggested that Cage composed a piece about total silence as a political reaction to the repressive times. This idea may have some validity, but this piece, so indicative of his oeuvre, was arrived at through tremendous personal and philosophical struggle. It did not occur in a vacuum. This chapter attempts to show how certain events in Cage's life mixed with his philosophical, musical, and spiritual understanding to produce profound breakthroughs in modern music and, by association, in other forms of modern art.

In the 1970s Cage reenacted and filmed *4'33"* smack in the middle of Harvard Square in Cambridge, Massachusetts. Sitting at a piano next to a news kiosk in the tiny triangle bisecting Massachusetts Avenue, he told the assembled crowd, "This is Zen for TV." As traf-

fic roared by, he flipped open the lid over the piano keys. Except for periodically checking his stopwatch, he did nothing but open and close the cover twice more. Immediately afterward, workmen picked up the piano and carted it off as Cage loudly keened like a distressed Japanese monk. The keening was not part of the original piece. William Anastasi, the conceptual artist and friend of Cage who played chess with him during the last fifteen years of his life, noted that "the favorite piece of music from his hand was 'Four minutes and thirty-three seconds.' He said that to me more than once and went so far as to say that all the music that he wrote afterwards, he tried in his mind to make it so that it didn't interfere with that piece. That's how important he thought that piece was. That was then a permanent part of his thinking when he was putting together an idea for a piece of music. So it was then central; it was absolutely central."[3]

During a concert tour of Japan in 1962 Cage wrote an electronic version of *4'33"* called *0'00"* (or *4'33"* *[No.2]*), dedicating his performance to artist Yoko Ono and her then-husband the composer Toshi Ichiyanagi, one of Cage's former students. Cage composed a "solo to be performed in any way by anyone."[4] His version was to hang a microphone around his neck, turn the volume up, take a drink of water, and swallow. The sound of his swallowing ricocheted throughout the concert hall. The performance notes indicated "disciplined actions" with "maximum amplification" and no feedback. It stated that all interruptions should be included. "No attention should be given the situation" to blur the distinction between composition, performance, and listener. These instructions resembled the framework similar to sitting an intensive Zen sesshin. He included a note at the bottom of the score, grouping three of the compositions with Basho's haiku of a frog jumping in a pond, from a Suzuki translation of the poem:

The old pond, Ah!
A frog jumps in:
The water's sound!

The old pond was his *Atlas Eclipticalis* (1961) for orchestra; the frog jumping was *Variations IV* (1963), a later work with as many players as possible doing as much as possible; and the water's sound referred to *0'00"* (1962).

4'33" was born at a lecture Cage delivered at Vassar College in 1947, "A Composer's Confessions," where he shared his fantasy about a piece written entirely without sound, which he went on to actually compose in 1951. He mentioned to his audience that he was studying both Oriental philosophy and medieval mysticism and was certain the European-influenced creative world would never allow a piece on silence. According to Anastasi, *4'33"* was an idea that he had shared with some friends: "He told me who but I don't remember, probably Maury [Morton] Feldman begged him not to do it. I guess [they] felt he already was considered a charlatan by the world at large, and this would only make matters worse. So he thought about it for a couple of years, and I think it was Bob Rauschenberg's all-white paintings that gave him the shove to actually make the score. But he had the idea before Rauschenberg did the white paintings."[5]

Western music is traditionally written by a composer, played by musicians, and listened to by an audience. Leaving empty space in a musical composition pushes the listener to become more aware of the ambient environment all around. Did Cage's study with D. T. Suzuki at Columbia University have anything to do with this? How did Cage conceive of this breakthrough?

Beginnings

John Milton Cage Jr., a seminal composer of the late twentieth century, also made visual art, wrote literature and philosophy, and collaborated on theater and modern dance pieces. Born in Los Angeles on September 5, 1912, he was admitted to Pomona College at age seventeen. Toying with the idea of becoming a writer, he dropped out of school, traveled to Europe, and studied piano at the Paris Conservatory. After eighteen months he returned to the United States and studied music composition with Henry Cowell and Adolph Weiss and twelve-tone composition with Arnold Schoenberg at the University of California in Los Angeles.

He married Xenia Andreevna Kashevaroff on June 7, 1935, during the height of the Depression. Desperate for work, he taught a class in dance composition at the Virginia Hall Johnson Schools in Beverly Hills. He also taught a course at UCLA in musical accompaniment for rhythmic expression that explored unique ways to produce sound and music, including percussion. His percussion ensemble caught the attention of the more adventurous modern dancers around UCLA, and he composed an underwater ballet, *Trio* (1936), for them. He struck a gong underwater so the swimmers could hear it and move accordingly. Traveling to San Francisco to solicit more commissions, he was introduced to the composer Lou Harrison, who taught at Mills College and secured Cage a teaching job at the school. Cage then began working with the dancer Bonnie Bird, a former member of the Martha Graham Dance Company, and she moved from California to be on the faculty of modern dance at the Cornish School in Seattle.

The Cornish School and Zen Dada

In 1938 the Cages moved to Seattle, and John signed a contract from September 12, 1938, to June 10, 1939, as a dance accompanist in Bird's classes for $720 a semester. There he met Merce Cunningham, a sylph-like dancer, a "creature of the air" who eventually became his lifelong companion. Cunningham, born in Centralia, Washington, on April 16, 1919, had been dancing since the age of twelve.

Cage first heard about a strange Asian practice called Zen at a 1938 talk, "Zen and Dada," given by Nancy Wilson Ross, a faculty member. A writer, lecturer, and Asian expert, Ross had studied at the Bauhaus in Germany, as well as with the theosophist Alice Bates. The Dada movement burst onto the world in 1916 at a meeting in Zurich's Café Voltaire Cabaret of dissatisfied artists and war resisters, "during and directly after the [First] World War among conscientious objectors in exile in Switzerland, and among men returning from the war in France and Germany."[6] Dada was a "derisive comment" on a world that had lost its mind. During the war everything had been destroyed, and the sacred had been profaned. People lied when they said they believed in religion and morality, so the only truth was unintelligibility. The Dadaists did things to provoke and shock people, though their antics were mild compared to living through a horrendous war. The name was chosen by Tristan Tzara, the movement's charismatic leader, who threw a paper knife into a French-German dictionary. It landed on the word *dada,* or "hobby horse." Tzara's Dada manifesto declared that everything was equal to nothing, and nothing was essentially good, interesting, and important. As mentioned earlier, another member, Marcel Duchamp, turned a urinal upside-down and declared it art by signing it "R. Mutt." These acts ridiculed any

individual's ability to produce art. Tzara smashed the idea of the artist as genius and championed an anti-aesthetic. Dada fell out of favor when its three major figures, André Breton, Tzara, and Francis Picaba, squabbled among themselves. In 1924 Breton published the surrealist manifesto, signaling Dada's declining influence.[7]

Ross stated that the artist was a prophet who could see so far in advance of "the mass mind of his period" that he was doomed to be misunderstood, but history would validate him. Cage leaned into those words. He had so much to work out for himself—his artistic voice, identity, and sense of place in the world. Ross said that art was never an isolated phenomena but a product of its time, and she delineated two distinct trends over the past fifty years. One concerned science and the influence of machines. Claude Monet, she explained, had painted thirty-two studies of one haystack in different light, weather, and circumstances, mimicking the rigors of a scientific study. Marcel Duchamp's painting *Nude Descending a Staircase* was a perfect mathematical transcription of a body moving through space. But, Ross continued, there was another side of pure subjectivity: intuition, fantasy, vision, and dreams. It was illustrated by the work of Paul Klee, Marc Chagall, Giorgio de Chirico, Max Ernst, and the surrealists.

Cage, having traveled in Europe, knew about the surrealists and Dadaists. What he didn't know was that Dadaism and surrealism had much in common with a school of Buddhism called Zen. Ross told her audience that Zen had influenced the art and culture of Japan; and if one wanted to understand Japanese tea ceremony, gardens, the seventeen-syllable poem called haiku, or the enigmatic Noh drama plays, then one had to understand Zen. She discussed the Japanese aesthetics of the room or "the abode of vacancy," with its emphasis on "inner" rather than outer space. A Japanese room

remained as empty as possible and was capable of filling all purposes, from writing to eating, entertaining, and sleeping, using just a table and cushions. Futon beds, stored behind folding doors, were used at night for sleeping. A hanging picture and an alcove with a simple flower arrangement were the only decorations and changed according to the season.

She quoted D. T. Suzuki, the "one man who has written at length on it," and gave the classic analogy that words were mere fingers pointing at the moon. One should never mistake the pointed finger for the actual moon. Suzuki said words led away from the truth. The only way one could grasp the truth and "make it his own" was through riddles, negations, and special questions called koans. Zen broke the grip of logical thought. To illustrate her point she asked if her audience could hear the sound of one hand clapping. Probing further she questioned, "Can you make me hear it too?"

Ross relayed the story of a monk asked by the emperor to teach an important sutra. The monk sat in a chair and said nothing. The emperor asked him why he didn't speak. The monk's attendant politely informed the emperor that his master "had finished discoursing." When another Zen master heard this story, he cheerfully quipped, "What an eloquent sermon it was." She compared this story to a meeting of the Dadaists. Tristan Tzara read a newspaper article out loud while an electric bell kept ringing, blocking out what he said. When it was over he explained that all he needed to do was show his face because if the audience gazed at his movements, it would satisfy their curiosity. Anything he said or did had absolutely no significance whatsoever.

Ross said another Zen master showed his walking stick to his disciples and shouted, "Call this a staff and you assert; call it not a staff and you negate. Now do not assert, nor negate, and what

would you call it? Speak! Speak!"[8] One of the disciples stepped forward, took the stick away from his master, and broke it in two over his leg, shouting back, "What is this?" Ross compared his direct action to "preceding twelve volumes of philosophy" and being very Zen. Cage was astonished by these radical perspectives on gesture and logical thought, but it would be years before he integrated them into his oeuvre. Merce Cunningham has said, "I would say primarily he came into contact with Zen through a lecture in Seattle that Nancy Wilson Ross gave."[9]

Though Zen was interesting and new, it was not uppermost on Cage's mind. His percussion ensemble of both professional and amateur musicians was more important. In 1939 he wrote *First Construction (in Metal)* for six percussion players using Japanese temple and water gongs, brake drums, anvils, and tam-tams. On December 9, 1938, the ensemble performed *Quartet and Trio* in its first concert. Morris Graves, the towering six-foot-four artist who painted stark objects and animals in muted pastels, brought a bag of peanuts and assorted knickknacks, intending to mock the performance. Instead he loved it and cried, "Jesus in the everywhere!"[10] He was hauled out by a group of men who had been warned in advance that he might try something provocative. Outside he danced alone to the quickened pace of the last movement of *Quartet.*

Cage and Graves met the next day, and Graves became a part-time player in the ensemble. Boisterous and eccentric, he became good friends with the Cages, living in the same building on the same floor. He had spent time in Japan in the early 1930s and was deeply moved by the Japanese arrangement of objects and acceptance of nature.[11] According to Ray Kass, director of the Mountain Lake Workshop (where Cage made artworks in the 1980s and early 1990s), Graves "was not a practicing Buddhist or a Zen devotee (he

was more involved with Vedanta), although he did take Zen very seriously, and was particularly interested in 'Zenga'-style spontaneous painting as a form of a 'yantra' or aid to meditation. Later in his life while staying at a subtemple of Daitoku-ji [in Kyoto], he was inspired to paint his variation of the Dragon based on his Zen-inspired sense of 'Seeing the Dragon' as a spontaneous realization in consciousness and action."[12] Cage told Kass, "Graves was a colorful and pivotal figure among a small and adventurous group of young Seattle artists and involved [Cage] in his famous Dada antics as well as introduced him to the Buddhist Temple in the Yesler district, Asian art, and aspects of the Native American culture."[13]

Cage presented a lecture titled "The Future of Music Credo" at a meeting of the Seattle Arts Club in which he discussed the "organization of sound." He said ambient noise could be used like "musical instruments" as dissonance and consonance were no longer important. The real issues in the modern world were between noise and music. He emphasized the materials of the twentieth century that could be used for compositions—mechanical means, photoelectric currents, and film technologies.

The Cornish School had a theater and art gallery and a shed housing the school's radio station, the first one in the nation. Cage decided that turntables could be played as music by variegating the revolutions per minute at which they spun. He performed *Imaginary Landscape No. 1* (1939), written for two variable-speed turntables, two Victor frequency records with one constant note intermixed with variable frequencies, muted piano, and a large Chinese cymbal. The turntables came with a manual clutch so it was easy to shift gears from one speed to another. Cage made sure to use the newest technologies—oscillators, generators, amplification, film, and record players.

Bonnie Bird wanted to choreograph a dance in which the dancers entered the stage by sliding down a brass pole, but the poles were too expensive to purchase. A factory worker gave her a broken piece of a pole, which she brought to class. Cage placed it on his sheet music tray. As he began playing the piano, it rolled on top of the strings and made bizarre sounds. Ever inventive, he let it continue rolling, foreshadowing his use of the prepared piano.

Cage urgently needed sponsors to continue his percussion work and to establish a professional center for experimental music. On December 2, 1939, he wrote to potential donors, "Since this work is new and experimental I may take the liberty of describing it as an exploration of sound and rhythm. It will, I believe, be thought of in the future as a transition from the restricted music of the past to the unlimited electronic music of the future."[14] He sent the letter to Westinghouse, General Electric, Bell Telephone Laboratories, and many universities. Though everyone seemed tantalizingly interested, no one donated any money. At the same time Cunningham moved to New York to dance in the Martha Graham Dance Company, and Cage would not see him again for four years.

Cage's third dance collaboration, *Bacchanale* (1949), accompanied the senior recital of Syvilla Fort, a young African American dancer and choreographer. The piece, though not overtly Afrocentric, was an exploration of Fort's racial heritage and background. Cage wanted a gamelan orchestra as accompaniment, but it was financially out of the question. He tried to find a twelve-tone succession of notes that sounded African but could not, then remembered Henry Cowell once strumming and plucking strings. Inspired, he retrieved a pie plate and placed it on top of the piano strings. It sounded interesting, but the plate slid around too much. He tried to wedge it with a nail, but that didn't work either, so he shoved a

screw wrapped in weather stripping in between the strings, inventing what he named the prepared piano.

Cage mounted four shows at Cornish, hanging the artworks of Paul Klee, Wassily Kandinsky, and Lionel Feininger. The show attracted the attention of another Cornish teacher, the artist Mark Tobey. Tobey had already been introduced to Morris Graves through the Seattle artist Kenneth Callahan, who remembered that "Mark was a Bahai and Morris was a Zen Buddhist and before that a Father Divine disciple."[15] Tobey befriended Cage and even studied piano and music theory with him.

In 1923 Tobey had studied Chinese brushwork with the artist Teng Kuei and in 1934 journeyed to Shanghai to expand his painting technique and join Kuei. He also traveled to Japan, where he met the famed British potter Bernard Leach and was introduced to many influential Japanese. In an unprecedented move he lived for a month at the Enpuku-ji Rinzai Zen monastery, respected for its intensive sesshins and deep koan practice. Enpuku-ji, nestled in the foothills of Mt. Ikmoa among cherry blossoms and azaleas, is an hour outside of Kyoto. The temple complex has three revered statues of Amitaba Buddha and the famous Houkyo-into Pagoda towers. In this refined setting Tobey meditated and developed his intricate white writing, or "light modern calligraphies."

Cage and Xenia accompanied Tobey to a Japanese restaurant in downtown Seattle. He made them stop every few feet to point out a beautiful object, spot, shadow, or arrangement of disparate visual elements. Attending Tobey's art opening, Cage noticed for the first time the setting sun reflecting on the white surfaces and the subtle changes of light. He saw that flat surfaces were not truly flat, but cracked and flaked with many fissures. Tobey had opened up Cage's eyes to the world around him.

Though Cage enjoyed teaching at Cornish, he could not subsist on the meager salary of ten dollars for rehearsals, performances, and compositions. On April 25, 1940, he resigned, citing low pay. He was so impoverished that Bonnie Bird had to loan him money to eat. The Cages left Seattle and moved to San Francisco.

Early 1940s

Cage worked at Mills College with four dance companies and was affiliated with the West Coast composers Henry Cowell, Lou Harrison, Harry Partch, and William Russell. Lazlo Moholy-Nagy, the Hungarian Bauhaus photographer and painter, invited him to teach at the Chicago School of Design, whose other famed professors were Mies van der Rohe and Josef and Anni Albers. He was commissioned to write music for Kenneth Patchen's radio play, *The City Wears a Slouch Hat*. To gather material he took a bus into Chicago's downtown Loop. On the bus he closed his eyes and composed his impressions, writing a score for tin cans, tom-toms, fire gongs, and recordings of sound effects to portray harsh city life as seen by the Christ-like character named "The Voice."

Cage had met the artist Max Ernst at the Chicago Arts Club, and Ernst invited him to New York. After Patchen's broadcast so many letters poured into the studio that Cage and Xenia left Chicago for New York City, thinking Cage could find a job in sound effects for radio and films. Taking Ernst up on his offer, Cage and Xenia stayed at Hale House with the artist and his lover, the heiress and socialite Peggy Guggenheim. Their house was full of visitors, including André Breton, Piet Mondrian, Gypsy Rose Lee, Joseph Cornell, and Marcel Duchamp. Peggy asked Cage to play the opening night concert for her new Art of This Century Gallery. He agreed but also scheduled a performance at the Museum of Modern Art. When Peggy

found out, she threw a fit, refused to pay the shipping charges from Chicago to New York for Cage's instruments, and wanted him and Xenia to move out. Cage, bursting into tears, walked to the back of the apartment to compose himself. Opening a door, he saw Marcel Duchamp sitting in a rocking chair and smoking a cigar. Duchamp calmly asked Cage why he was crying. When Cage explained, Duchamp remained silent and continued rocking. Though he offered no consolation, his presence quickly calmed the younger man down.

For years after that Cage kept his distance from Duchamp, but at a New Year's Eve party in 1966 he realized that Duchamp was growing old. Concocting a pretext for the two of them to spend more time together, he asked Duchamp to teach him chess. Duchamp agreed and taught him to play both sides of the game. Instead of thinking of it as chess, Cage "thought about it in terms of Oriental thought." [16] They rarely talked about Duchamp's artwork. Cage even asked him if he was ever influenced by Oriental thought, and "he said not." [17]

When their housing situation evaporated, Merce Cunningham, who was now dancing with Martha Graham at Bennington College for the summer, came to the rescue. He said that he and the dancer Jean Erdman, wife of the mythologist Joseph Campbell, needed music for their new piece. Erdman offered Cage and Xenia her apartment in the city, which was equipped with a piano. Cage composed *Credo in Us,* which premiered on August 1, 1942, at Bennington College. A collaged work with taped phrases, classical music, and sound interventions, it was viewed as a satire on America. [18]

Perilous Night

The relationship between Cage and Xenia was on shaky ground. Falling in love with Cunningham, Cage was torn by his bisexuality and

infidelity. Compositions from that time were uncharacteristically passionate and erotic, including *Amores* (1943), *Tossed as It Is Untroubled* (1943), *Root of an Unfocus* (1944), *Perilous Night* (1944), *A Valentine Out of Season* (1944), and *Mysterious Adventure* (1945). When writing *Perilous Night* he realized that he was not expressing the "loneliness and terror" that comes from a breakup. The title *Perilous Night* derived from an Irish folktale, and "the music tells a story of the dangers of the erotic life and describes the misery of 'something that was together that is split apart.'"[19] The following year he and Xenia separated, a "painful and bitter" time. Cage's inner turmoil also reflected the outer tensions in the United States, as World War II was in full force. He sought "quiet sounds" in his work, just as he was seeking "quiet sounds" in his own life.

Years later Anastasi shed light on tensions in Cage's marriage. "We were at a party at Dorothea Tanning's house, her New York apartment on Fifth Avenue . . . Jasper Johns was there, and Xenia was there. It was one of the few times I was at a party where John, Merce, and Xenia were [all present]. And Xenia, who I had never met, obviously knew who I was, and came up and asked me to dance. She said, 'Would you dance with me?' Xenia is diminutive, tiny. I said, 'Sure.' I don't remember what music was on, and we began dancing, and practically within seconds, within less than a minute, she was telling me about John picking up sailors on the waterfront, and I assume that had to do with California. I certainly wasn't going to open any kind of conversation. I didn't know her! We had probably been introduced at some point, and that was about it."[20]

Cage consulted a Jungian therapist, who said he could help him write more music. Cage refused, believing his output was already excessive. There was no gay liberation at the time to help him

unravel the complexities of his situation. He "got involved in Oriental thought out of necessity: and felt it was something he absolutely needed . . . he was starved . . . thirsty."[21] He gravitated to Zen because its "flavor . . . appealed to me more than any other."[22] It let him experience his tumultuous emotions without attaching too much emphasis on them. Anastasi said, "Instead of going into psychoanalysis, because Suzuki was teaching, he went that way. He went to those classes. I think he was of the opinion that it saved his life, really, learning about Zen Buddhism and doing his best to follow it. He would talk about it quite regularly. He would bring the subject up. When he had heard I was sitting, he told me Suzuki's thoughts about sitting. And he wasn't discouraging me from sitting but in a way it was the closest he was ever going to get to really trying to guide someone. I think he thought that would have been better for me too, and I think it would have been if it was possible, if I could learn to meditate all the time."[23] Cage realized that "if the wheel is to be brought to a stop, the activity must stop,"[24] meaning the wheel of ceaseless habitual patterns of mind.

This was the beginning in America of the McCarthy era, with its witch hunts against suspected Communists or other "deviants." Modern art and music itself were suspect. A sense of detachment, whether philosophical, emotional, moral, or spiritual, seemed necessary for survival.

The Angel

In 1947 Lincoln Kirstein curated a show dedicated to the Bauhaus and hired Cage to write *The Seasons* for the Martha Graham Dance Company. Cunningham choreographed the piece, and the sculptor Isamu Noguchi designed the costumes. Cage agonized over the purpose of writing music, feeling that it only appealed to a small

clique of self-referential individuals. Noguchi introduced him to his "angel," the Indian musician Gita Sarabhai, who was looking for a teacher in Western composition. Cage wanted to study Indian music theory and techniques, so they agreed to a six-month exchange. Sarabhai restored the meaning of music for Cage, telling him its purpose was "to quiet the mind, making it open to divine influences." She put him back in touch with music's spiritual purpose, which existed before the Renaissance.[25] By the 1960s Cage understood it meant "the ego does not obstruct the fluency of the things that come in through our senses and up through our dreams."[26] Cage incorporated the nine *rasas* of Indian thought (happiness, anger, disgust, fear, sorrow, courage, compassion, wonder, and serenity) into his work through *talas* or rhythmic cycles unique to the Indian musical system.

Cage wrote the sixteen-minute piece *The Seasons* for Graham's company using traditional Indian views of winter (quiescence), spring (creation), summer (preservation), and fall (destruction). His work *Sonatas and Interludes for Prepared Piano*[27] (1946–48) was composed after reading Ananda K. Coomaraswamy. It premiered on January 12, 1949, at Carnegie Hall. Critics said it was "provocative" and explored territory no Western music had considered before.

Nothing Becomes Something

On January 28, 1949, Cage lectured on sand mandalas and the nature of impermanence, but it was his seminal *Lecture on Nothing* at The Subject of the Artists Club in New York that broke the mold. He repeated one particular refrain fourteen times during the course of his lecture: "If anyone is sleepy, let him go to sleep." Jeanne Reynal complained that though she "loved" Cage, she couldn't take it anymore and left. Afterward, he used five prepared answers consciously

imitating Zen koans to respond to questions. At that time it was impossible for him to have studied with D. T. Suzuki, but he had most likely read his books on Zen. In January 1950 he delivered *Lecture on Something* at The Club in New York, though it was not published until 1959, in Philip Pavia's spin-off magazine, *It Is.*

In the spring of 1949, Virgil Thompson, the lead music critic for the *New York Herald Tribune,* helped Cage to obtain a prize from the National Institute of Arts and Letters to send him to Europe. In Paris he met the composers Pierre Boulez and Olivier Messiaen and their Parisian community of experimental musicians. He also received a grant from the Guggenheim Foundation to compose a new string quartet. Returning home in October, he began a fruitful five-year correspondence with Boulez and met the composer Morton Feldman, who became a lifelong friend.

Black Mountain

Black Mountain College, the legendary experimental school situated in the hills of North Carolina, lasted from 1933 to 1956. Josef Albers ran the summer program, and Cage taught there in 1948, 1952, and 1953. Some other faculty members were Merce Cunningham, Buckminster Fuller, Willem de Kooning, Franz Kline, Charles Olson, Aldous Huxley, Ted Shawn, and Henry Miller.

During Cage's first visit in 1948, he was not paid for presenting work, only given room and board. He performed selections from *Sonatas and Interludes for Prepared Piano,* taught a workshop titled "The Structure of Music and Choreography," and lectured on the work of Erik Satie. He also met the young artist Robert Rauschenberg, who had been studying painting in Paris, and renewed his friendship with the sculptor Richard Lippold. Lippold remembers Cage showing signs of a great internal struggle follow-

ing his divorce from Xenia. "That's what projected him into his Oriental studies, because he couldn't find any answers in Western morality," Lippold said.[28]

In a January 1950 letter to Pierre Boulez, Cage wrote that Suzuki's works on Zen Buddhism were soon to be released, though he did not mention which ones. One evening he read the entire text of Huang Po's *Doctrine of Universal Mind* out loud with a friend. It took three hours, and afterward people came up to him saying the reading had changed their lives. Cage also took out a book from the library of the Tibetan tantric master Milarepa. He wanted to write an opera based on his life using a prepared piano, but Cage returned the book and moved to other projects.

Cage asked Morton Feldman to help him find a pianist to play Boulez's *Deuxième Sonate,* and Feldman recommended David Tudor.[29] Cage described Tudor as being "taken from the Buddhist tradition," meaning he had equal feelings toward all experiences, yet still produced a flawless performance. Both Tudor and Cage had strong opinions about letting sound rest in and of itself without manipulation or conceptualization. Tudor, as mentioned, would later premiere Cage's masterpiece of silence, *4'33".*

Proto Happening

Looking at the pristine white paintings of Robert Rauschenberg, Cage saw that white was not a lack of color but a backdrop for color to reveal itself. He applied the same logic to silence, realizing it was not a lack of sound but a change in perception to include all sounds in any given moment. Rauschenberg's paintings did have historical precedent. In 1918 the Russian supremacist Kasmir Malevich stated that "the ideas of the conscious mind are worthless,"[30] and with this in mind he produced the first pure white paintings.

During the summer of 1952, in conjunction with Lou Harrison, who was director of the music department at Black Mountain, Cage created a "proto happening." He was partially influenced by Suzuki[31] and partially by the works of Antonin Artaud, the French poet, playwright, theater director, and actor who argued that sound and action could function independently of text in theater.[32] Cage became aware of Artaud's work through M. C. Richards's translations of his book *The Theater and Its Double*. Too forward-thinking for the time, her translation was rejected by a number of publishers. Deeply critical of the West's emphasis on written and spoken dialogue, Artaud likened his work to a book jumping out into a performance arena, combining the concrete and abstract. He saw non-Western theater and ritual do this though gesture, posture, sound, and signs based on the physicality he had observed in Balinese theater and dance. He concluded that theater came from "organized anarchy." It was liberating when text did not determine activity. Sound, movement, dance, music poetry, and painting could all be independent of one another; and innovative work experienced, not theorized.

Cage sketched out a piece lasting forty-five minutes,[33] though other accounts put it at two hours. It was birthed in the morning and completed by the afternoon. Tommy Jackson printed programs on cigarette papers cleverly rolled into cigarettes. Cage composed a cursory score. Performers were assigned limits, determined in advance through chance operations indicated by "time brackets." Within those limits they were free to do what they wanted. Charles Olson and M. C. Richards climbed up ladders and recited poetry. Cunningham danced in between triangular rows. Cage, wearing a somber black suit, white shirt, and black tie, climbed up a ladder and read from the fourteenth-century mystic and philosopher

Meister Eckhardt. Other accounts say that he lectured on Zen, the Bill of Rights, and even the Declaration of Independence. Francine du Plexis noted in her diary, "Cage talked about the relationship of music to Zen Buddhism."[34] He orchestrated periods of silence, determined in advance through chance operations. David Tudor played piano. Robert Rauschenberg spun Edith Piaf records on a scratchy phonograph, and his four "white paintings" hung from the ceiling at odd angles, covering the space in a crazy canopy. They also doubled as canvases for a black and white silent film by Nicholas Cernovitch that included shots of Cornelia and George, the cooks at Black Mountain. Footage of the sun projected onto the canvases to imitate a sunset. The other side of the dining hall projected abstract hand-painted gelatin 35-mm slides placed between glass.

Each seat had a plain paper cup placed on it, doubling as an ash-tray. At the end of the performance girls marched out of the kitchen holding big pitchers of coffee that they poured into the cups-cum-ashtrays whether there were extinguished cigarette butts in them or not. The whole event appeared random, but it was not. No one imagined that they were making history. Some people thought the whole thing boring, inane, or even "sacrilegious" because of Cage's quasi-ministerial get-up. Most were just amused.

Cage and D. T. Suzuki

Cage stated that he studied with D. T. Suzuki in the late 1940s through 1951. This time frame is impossible, since Suzuki gave his very first lecture at Columbia University in 1951 and did not begin formally teaching there until 1952. Still, Suzuki's lectures had an incalculable and lasting effect on the composer. Cage said, "This doctrine, which I truly adhere to, is what has made me tick in the way that I ticked."[35] Furthermore, Cage remarked, "Buddhism is

so important to so many people now and one of the principles of Buddhist philosophy is that everything causes everything else, and that there is nothing that is not caused by everything else, and that each thing is at the center of the universe, and these centers are in interpenetration and non-obstruction."[36]

Cage once asked Suzuki if he would say something about music. Suzuki replied that he knew nothing about the subject. Europeans, Suzuki said, were concerned with cause and effect, but the Oriental way emphasized the "here and now." "Nowness" extended to the subatomic, as "all of time and space is related . . . to every other thing in all of time and space." There was no real goal to attain, only constant change. Art should "open one's eyes" to this truth. Cage understood this to mean that distinctions of right and wrong, good and bad, beautiful and ugly, success and failure fell away, liberating a composition to be itself. Silence upset the traditional hierarchy of compositional sounds. Music, he realized, was "not a communication from the artist to an audience, but rather . . . an activity of sounds in which the artist found a way to let the sounds be themselves."[37]

Invited by the students of the Juilliard School of Music to play his work, Cage told them they should stop studying music if thinking about it in any way separated them from life. He added, "Living takes place each instant, and that instant is always changing."[38] He urged them to keep their ears open and listen before their overactive, thinking mind interpreted sound. Music was the "springboard" of presence, and sonority was constantly changing instant to instant.

Cage wrote an essay for the catalogue of Robert Rauschenberg's show of his white paintings at the Stable Gallery that was much like the Heart Sutra (one of the core texts of Mahayana Buddhism) in its syntax and tone. Cage wrote:

To whom
No subject
No image
No taste
No object
No beauty
No message
No talent
No technique (no why)
No idea
No intention
No art
No feeling
No black
No white (no and)[39]

When compared with the actual text of the Heart Sutra, it is easy to see how deeply Cage was affected by both the message and the cadence of the sutra.[40]

In the spring and fall of 1952 (though some accounts put it at 1953), Cage and his friend composer Earle Brown quit working on their spliced-tape assemblage *Williams Mix* early in order to arrive at Suzuki's class on time. In one lecture Suzuki approached the blackboard and drew an oval. On the left he drew two parallel lines. The oval, he explained, was the structure of the mind. The parallel lines were the ego. Ego cuts itself off from experience. It does not matter if one is awake, dreaming, or sleeping. The true way lets the lines flow minute to minute, complementing the shape of the oval. Zen allows this unobstructed flow just by sitting cross-legged and following the breath. Ego integrates with mind. This way of

looking at the self and ego was unheard of in the early 1950s and was certainly a startling approach.

The artist William Anastasi remembers in the 1970s that "when he [Cage] heard I had begun sitting and paying attention to my breath, my out-breath, specifically, he mentioned Suzuki was not an advocate of sitting, and he followed that idea of trying to learn to meditate all the time. And that's what John was trying to do."[41] Though he never sat a formal Zen sesshin or became a chanting, meditating Buddhist, Cage identified himself a Buddhist.

Using his own book *Essays on Zen Buddhism* as one of the class texts, Suzuki discussed the meaning of Vimalakirti's silent response when Manjusri asked him to explain the teachings on nonduality. He emphasized the response meant all words and ideas are inherently dualistic at the level of form but that all words and ideas are affirmed through silence. These ideas were profound affirmations for Cage's own thinking on the subject.

The class studied Huang Po's *Doctrine of Universal Mind* as well as the Taoist writings of "Kwang-tse" (Chuang Tzu) and "Lao-tse" (Lao Tzu). Huang Po's doctrine taught, "Speech and silence are one! There is no distinction between them." Another statement Cage found important was, "Imitate the sands of the Ganges who are not pleased by perfume and who are not disgusted by filth."[42] This is similar to *rochig*, or one taste, experiencing neither likes nor dislikes, a practice of advanced Mahayana and Vajrayana Buddhism. Cage took those lessons to heart and reiterated them in his manifestos on music, saying nothing is accomplished by writing, listening, or playing a piece of music—implying that speech and silence were the same.

The painter Philip Guston sometimes accompanied Cage to class, as he too was exploring Zen as an alternative to Kierkegaard's philosophy. One day Cage and the composer Morton Feldman visited

Guston's painting studio. Admiring Guston's spare canvases about "nothing," Feldman quipped that that wasn't the case at all because his paintings were about "everything."[43]

Jackson Mac Low believed Cage's sense of Zen manifested itself by paying attention to what he was doing at any moment. Cage turned his practice of music into as much of a discipline as sitting by using chance operations and indeterminacy to minimize his personal likes and dislikes. He believed his role was to ask questions and have as little input as possible. There was no such thing as a compositional error, and if one listened closely there was no time for extraneous thought. Mac Low compared chance operations to the Buddhist term "skillful means," or *upaya*. Listening to Cage's performances could be compared to *prajna*, or wisdom. "By allowing the experience of sounds perceived in themselves 'in their suchness'"[44] instead of trying to make them a forced form of communication, one could experience their wisdom aspect.

Zen masters perceive freshness in each moment. Instead of collecting his thoughts, holding onto them, and cherishing them, Cage meant to abandon thoughts as soon as they arose. Not allowing concepts to arise meant chance operations cut the primacy of conceptualizing ego.

Years later after his teacher retired, Cage visited Suzuki in Hawaii. Suzuki explained to his former student that music expressed feelings that could also be provoked by using certain Chinese characters. Cage replied that he wanted to "let the sounds just be sounds."[45] Suzuki admonished him that that was not enough. According to Indian thought, Buddhists talk about "emptiness" as absolute silence, but the Western mind only abstracted silence. The Oriental mind did not abstract silence but understood it was "concrete" and part of life. Suzuki told Cage, "You can't take emptiness

or silence in isolation." Otherwise everyone would stay quiet, and that just wouldn't work. Something had to be done, even though it seems nothing is ever done. Cage said he had written a book called *Silence* and wanted to send it to him. Suzuki replied it was a "fine" title and anyway people made too much noise. Cage replied it was necessary to have "silence" in noise, and Suzuki joked he would love to have all the atomic bomb makers experience some silence within their noise.

The Zen writer Alan Watts came to one of Cage's concerts and hated it. He did not understand what the point was in listening to ordinary sounds, and he wrote an article accusing Cage of misinterpreting Zen. Cage believed Watts's understanding of his work was based on a nineteenth-century view of acceptable art. To counter the jab, Cage wrote in the preface of *Silence* that he could not have done what he did with his music without Zen, but he didn't want Zen faulted for what he did. He sent a copy of *Silence* to Watts, who read the book and changed his opinion. He began attending Cage's concerts whenever he had the time.

New School: The Dissemination of Thought

After his studies with Suzuki, Cage taught "Experimental Composition" from the fall of 1956 through the summer of 1960 at the New School for Social Research on Twelfth Street in the West Village. The course was open to all, and the catalog stated, "Inventiveness is encouraged." Besides George Brecht, Dick Higgins, Allan Kaprow, and Al Hansen, others who came were performance artist Florence Tarlow, the poet Jackson Mac Low, the photographer Scott Hyde, and the composer Richard Maxfield. Hansen likened the class to a "little version of Black Mountain College" and invited the filmmaker Harvey Gross, the sculptor George Segal, and the artist Jim

Dine. The musician La Monte Young brought the painter Larry Poons. Poons believed Cage gave his students license by letting them know what they were doing was not "illegal" anymore. "They discovered something that didn't exist before. This license was one of his [Cage's] contributions to the time. He gave people license to dive if they were so inclined."[46]

Cage gave his students freedom, but that freedom did not mean laxness or fooling around. It came at a cost—the tremendous discipline to do away with likes and dislikes. One had to give up music in order to regain music. To prove the lack of separation between music and nonmusic, sound was equal with silence. He suggested reading and listening to the composers Christian Wolff, Feldman, Stockhausen, and Brown and included lengthy comparisons of the similarities and differences between them. He challenged his students with tough questions such as, "If chance implies uncertainty, what are we uncertain about?" In the dictionary indeterminate and ambiguous were synonyms, but were they really? According to Cage, ambiguous derived from *ambigere* (to wave or wander), and indeterminate came from determinate, to limit. Wave and limit were two very different ideas when it came to compositional methodologies, and he wanted his students to think these ideas through. As harmony, counterpoint, and musical form were pitch and frequency based, he encouraged investigations into duration, timbre, amplitude, and morphology by employing magnetic tape, musique concrète, and German *elektronische Musik*.[47]

In his first class Cage discussed his own work. For his second class he asked his students about their projects. After that the class became a lab environment for the exchange and presentation of ideas. Most students were not professional musicians but artists and poets. Each week anyone who had completed a project was

encouraged to share it with the others, who offered their comments and criticisms. Cage emphasized that if they didn't want to change their long-cherished assumptions about what was art, they should leave. Almost everyone stayed. The only time he intervened in a student's creative exploration was if he felt he or she was holding back or being too conservative. If a more traditional style of composition was presented, Cage criticized it from a traditional perspective.

He taught that in notation, a fixed amount of space was equivalent to a certain amount of time. To show how sound could be altered by the simplest acts, he pushed an eraser into a piano's strings, emphasizing the dulling sound of the strings hitting rubber. The only instruments in the room were a grand piano—a "rather poor one"[48]—Oriental instruments left over from Henry Cowell's class "Music of the World's Peoples," including "a closet full of Cowell's musical instruments and other sound makers,"[49] and a "pile of things people brought with them."[50] Also used were mundane items like hair combs and coins. The students were assigned problems such as writing a composition for guitars and paper clips.

Cage's Students: The Legacy of the Avant-Garde

Jackson Mac Low

Jackson Mac Low, whom Cage specifically invited to participate in his class, remembers that Cage's comments were "sparse, to the point, and usually nonprescriptive"[51] and that he did not offer direct solutions. Mac Low first met John Cage in 1948 at Columbia University when Cage played *Sonatas and Interludes for Prepared Piano*. They spoke briefly but did not become friends until 1953,

and they remained friends until Cage's death.[52] Mac Low was also a student with Cage in Suzuki's classes at Columbia.

Mac Low's poetry contained "simultaneities" or "verbal, musical, and/or visual pieces that two or more people, or even every man, can realize together."[53] According to Mac Low, "The kind of art most of us favored and practiced emphasized methods such as chance operations, which helped us make artworks in which phenomena such as sounds, words, colored areas, actions, etc., could fill the attention of listeners and viewers without acting merely as vehicles for the expression of the feelings and extra artistic ideas of the artists. We wanted them to be perceived as much as possible as themselves, for their own sakes."[54]

Mac Low believed people took Cage's class for different reasons; some knew about Cage's work or about his classes at Black Mountain, and some did not. Instead of making art that emphasized the emotions and thoughts of the artist, the students in Cage's class made works focusing on the phenomenal world around them. They deconstructed art forms as solid objects while using Buddhist phenomenology to deconstruct perceptual processes, though Cage did not label their investigations as such.

Toshi Ichiyanagi in Japan

Cage devoted himself to helping those who studied under him discover their talents. However, there were occasional flare-ups. During one semester before Christmas break, knowing he would not see his students for some weeks, Cage wanted to give them some parting advice. He approached Toshi Ichiyanagi and told him that he found his work interesting but suggested a shift in emphasis. Ichiyanagi refused to look him in the eye and softy replied, "I am not you." Cage was delighted.

Ichiyanagi returned home in the summer of 1961 to work with Japanese musicians. According to him, the first time live experimental electronic music was ever played in his country was in late 1961. He performed a composition dedicated to Cage, as well as a piece showcasing IBM computer punch cards, at the progressive Sogetsu Art Center, as part of the Sogetsu Contemporary Art Series. At Sogetsu he also saw the first concert of Group Ongaku (often referred to as "Tokyo Fluxus") and became involved with them though his colleague, Yasunao Tone.

A few years later Cage traveled to Japan and saw Ichiyanagi's piece *Distance,* in which performers climbed into a net raised over the audience and "activated" their musical instruments on the ground below. The distance between the musicians and their instruments produced an ambient echo resembling street sounds. Cage went to a number of these performances and proclaimed they were "as outrageous and interminable as Buddhist services and meditations."[55] It is fascinating that the Japanese-born Ichiyanagi developed experimental Zen-inspired ideas in composition and performance through studying with the American Cage, who studied Suzuki's Zen teachings.

A music festival was organized by the Twentieth-Century Music Institute. Hidekazu Yoshida showcased the work of Cage, Morton Feldman, Earle Brown, Christian Wolff, Stefan Wolpe, and Ichiyanagi. The concert caused an uproar in the staid music circles. On September 15 Japanese composers premiered experimental works,[56] and on October 30 Yuji Takahashi performed Cage's ninety-minute *Winter Music.* On November 30 Ichiyanagi gave a concert of Japan's first "happening" with live electronic music, an idea he derived specifically from Cage's classes.

Allan Kaprow

Allan Kaprow planned events that became known as "happenings." They started rather innocuously as action collages and assemblages "with sounds and smells and tastes" thrown together. Kaprow had initially studied art from 1947 to 1948 with the painter Hans Hofmann, and he read philosophy and art history at Columbia University with one of the greatest art historians of the twentieth century, Meyer Shapiro. Kaprow, a classmate of composer Morton Feldman's at the High School of Music and Art in New York City, was acquainted with Cage socially. One afternoon, Kaprow, Cage, and George Brecht were on an outing hunting for mushrooms.[57] Kaprow mentioned the difficulties he was having using children's toys that made imitative animal calls (moos, growls, and howls). He felt they were boring, and he didn't know how to use their sounds effectively. Cage suggested he stop by his class.

During class Cage explained the use of "music concrete" or music recorded specifically to tape. He suggested that Kaprow buy a half dozen cheap tape recorders, put the sounds together in different orders, hook them up to speakers, and play them in random patterns to deconstruct their sequencing. Kaprow enrolled in the class because he "wanted to make noise, and it was here he figured out his 'proto happenings,'"[58] though Cage beat him to the punch, having actually created the first "proto happening" at Black Mountain College.

Kaprow brought a cache of objects into class: circular saws, hammers, knives, forks, glasses, and pieces of wood. He filled glasses with different levels of water. He then tapped them with forks so each emitted different vibratory pitches, making good use of the Zen idea that everything in every moment is available to

make art. He wrote a prescient article for *Art News*, "The Legacy of Jackson Pollock," which laid out two possible paths the art world could take. Since Pollock had broken the mold by making paintings that were entire environments, one path was to take the action out of action painting and enact pure action itself. The other path was to keep painting in the realm of pure painting. Kaprow stated that painting had broken out of the boundaries of the frame and was poised to join forces with other art forms. For some unknown reason, probably because the idea was too provocative for the time, *Art News*'s publisher, Thomas Hess, did not publish the article until 1958.

Before he enrolled in Cage's course, Kaprow had been constructing "environmental" works using sounds emanating from hidden locations triggered by switches and circuits. His first happenings were performed in class at Cage's urging, and "since it was a very congenial class, everybody wanted to perform them ... and I had no experience ... it was trial and error."[59] The following year Kaprow discovered that the Gutai Group in Japan was also doing live action performances, which he found "refreshing."[60] The composer Earle Brown and his wife Carolyn gathered the journals published in the late 1950s and early 1960s by the Gutai Group and shared them with their circle of friends. Al Hansen thought the Gutai's work looked remarkably similar to their performances and was astounded that a movement had grown up across the globe similar to theirs. Kaprow had never heard of the Gutai until the painter Alfred Leslie mentioned them in 1958, but it was not until late 1963 that he saw their material. Instinctively he knew, as the Gutai knew, "we must become preoccupied with and even dazzled by the space and objects of our everyday life, either our bodies, clothes, rooms, or if need be, the vastness of Forty-Second Street."[61]

Kaprow then wrote the seminal score *Eighteen Happenings in Six Parts,* which he presented in October 1959 at the Reuben Gallery in New York. As a result, a new meaning for the word "happening" forever entered the American vocabulary. Cage was ambivalent about happenings. He was pleased that they were not conventional theater pieces, but he did not like aspects of their overt, almost contrived symbolism. He stated in a 1985 interview, "When I go to a happening that seems to me to have intention in it, I go away saying that I'm not interested. I also did not like to be told in the *Eighteen Happenings in Six Parts* to move from one room to another."[62]

Fluxus: George Brecht, Al Hansen, Dick Higgins, and Alison Knowles

Fluxus is a group movement in intermedia containing a rotating number of members spanning decades. Its genesis began in Cage's class, primarily through the artists George Brecht, Al Hansen, Dick Higgins, Alison Knowles, and on occasion Jackson Mac Low.

George Brecht

In 1956 George Brecht, a chemist for Johnson & Johnson, wrote an essay about chance operations in visual art and sent it to Cage. Cage replied by asking Brecht to join him and David Tudor on a mushroom hunt. Eventually Brecht enrolled in Cage's class, and on June 24, 1958, he began taking detailed notes. He described an early piece for three performers using only cellophane, voice, and a mallet and sketched out numeric charts to indicate the duration and amplitude of each section. The performer tossed a coin to "determine whether sound or silence starts" the piece, an approach inspired by the Lankavatara Sutra, which states, "Things happen gradually

. . . suddenly." He sketched out a futuristic "odor structure" with vanilla, vinegar, gasoline, and floral scents and a tactile structure experienced through closed eyes. He said he wanted to "research into the structure of experience."[63]

Brecht compared his event scores to Japanese haiku poems. Rather than an image of a concrete moment in life, it is "a signal preparing one for the moment itself."[64] Presenting events were immediate experiences, not a timeline bound in past-present-future. Events represented the "now." These events were written out on small cards, which in 1963 were collected and published as an edition called *Water Yam*. Alison Knowles, the first female member of Fluxus, believed the single most important innovation from Cage's classes were Brecht's event scores.

Artificial Crowd is an event score in which Brecht passed cards out to an audience instructing them to make a sound. *Confetti Music* used colored cards (i.e., blue for a gong, brown for a guitar) to determine which instrument should play a sound. Another colored card determined frequency, and another amplitude. Brecht used the simplest objects: sandpaper, the teeth of a comb, Ping-Pong balls shaken in a glass, crinkled film, plastic, paper, sifted sand, broken toothpicks, striking a match, or cutting paper with a scissor. *Drip Music* was presented on October 16, 1959, in EVENTS at the Reuben Gallery located at 61 Fourth Avenue.[65] A performer stood at the top of a ladder held by a second performer. The first performer poured a pitcher of water that dribbled into the open mouth of a French horn.

Brecht's next piece, *Time-Table Music,* had performers walk into a railway station. Picking up a stack of train timetables, each performer randomly chose a listing. For example, a 3:45 p.m. train would translate as three minutes and forty-five seconds. The event was to make a sound within the parameters of the specific time

frame. Hitting their stopwatches, the participants created a cacophony of random sounds, startling passengers in the waiting room.[66]

Brecht even made Japanese tea preparation into a performance event. He focused on the mundane, extending the process to something as plebeian as boiling water. This is similar to the Soto School of Zen, which teaches the classic arts of tea ceremony, ikebana, and calligraphy as part of mind training. He extended this process to smaller, nuanced events. A ringing telephone was fraught with drama; it could ring and ring, the receiver could be picked up, or it could be lifted and replaced, disconnecting the call. A gunshot could become an accompaniment to dance music. For *Incidental Music,* Brecht used adhesive tape to attach a single bean to a piano key. He was also fond of inserting silence into an event. In one short piece he walked onto the stage, put a vase of flowers on top of a piano lid, and then walked off.

He composed *Word Event,* as ephemeral as a haiku and as brief, just three lines:

WORD EVENT
Exit
1961

An exit sign hung on stage along with other artworks. The artist either walked on or off the stage.

In 1959 Brecht toyed with the idea of teaching a course called "The Experimental Performance of Music," though he never followed it up. According to his journals, he thought to include readings from D. T. Suzuki's seminars at Columbia University, "Huang Po Doctrine, Chuang Tzu, Mustard Seed Garden, Suzuki, and Watts." There would be no instruction on the leader's part, a teach-

ing method similar to Cage's. His musical instruments would be simple; flower petals, ground coffee, one thousand tappings of a pencil, tissue paper, matches, and firecrackers. Tea would be brewed, served, then drunk. Guest demonstrators like Paul Taylor and Merce Cunningham would show how objects and people moved, and they would stage new works in "various" places.

Al Hansen

Al Hansen first heard Cage's music at the Museum of Modern Art and was more impressed that people from Black Mountain College were involved than by the concert itself. He registered for Cage's course simply because it coincided with the time of his wife's contemporary philosophy class. After Hansen arrived late for the first session, Cage explained that everyone had already spoken about themselves, and it was now his turn. Had Hansen ever studied rhythm, harmony, counterpoint, piano, reed instruments, brass instruments, or guitar? Hansen answered that he had not. Instead of being exasperated, Cage was intrigued. Why was he in the class? Hansen said he had read Sergey Eisenstein, who asserted that all forms of art met inside the film frame. Since he was an experimental filmmaker at the time, he needed to know about experimental composition. Cage thought that was a good enough reason. What Hansen really learned was that all art forms were *not* contained within the film frame, but instead within the eyeball and cognition itself, all part of Zen's philosophy of no perceiver and no perception. He didn't want to make pictures within the frame, but wanted life to become the frame.

In Hansen's piece *Alice Denham in 48 Seconds,* he broke the name Alice Denham up into alphanumeric equivalents (e.g., A = 1). Alice Denham was 1, 12, 9, 3, 5, 4, 5, 14, 8, 1, 13, further divided into

1 = Number of sounds
12 = Number of seconds they occur in
9 = Number of sounds
3 = Number of seconds they occur in
(and so on)

This means there is 1 sound in the first 12 seconds, 9 sounds in the next 3 seconds, and so on. He used little drums, toy guns, a wind-up army tank, and a meowing shake toy to create sounds. But he couldn't figure out how to start the piece. Cage suggested he pretend he was at a picnic: just arrive when he arrived and stop when he stopped. He did not have to make music all the time—just sometimes.

Dick Higgins

Dick Higgins overwhelmed Cage's class with his documents/manifestos—long, complex instructions lasting three or four hours. The technique wore other students out, but Cage was fascinated. In one class Higgins had barely finished introducing a fifty-page manuscript when the bell rang. Cage asked if it such a long introduction was really necessary. Perhaps Higgins could write little hand notations instead? Then Cage added sympathetically that he, too, used to write too much, and learning to limit himself had been a struggle.

At the end of the semester Higgins, Hansen, and others formed the New York Audiovisual Group, which met on Sunday mornings at the Epitome Coffee Shop at 165 Bleeker Street. The Epitome, co-owned by artist Larry Poons and Donald McAree, gave them a place to perform and tape experimental works. The following spring, in 1959, Hansen's class exercise was performed at the Kaufman Concert Hall of the YMHA. Bottles were broken with hammers and

special rattles made out of nails, tacks, and pins were played. A tabletop was hit with a broom, and debris was swept up according to specific notations.

That wacky concert led to an invitation to appear on Henry Morgan's television show. Hansen played flowerpots using a hammer. Higgins wore a dunce cap and an old-fashioned bathing suit underneath a terry cloth bathrobe. He sat in a tin bathtub and covered himself with ink, stood up, and walked onto a huge sheet of paper and let the ink drip off his body onto the paper. The artists ripped rags, played toy pianos and xylophones, and shot cap pistols. Morgan asked Higgins what it was all about, and Higgins answered "art," pointing to his inky footsteps on the paper. Morgan said since the ensemble was called the Audiovisual Group, where was the sound? Hansen grabbed a flowerpot and tossed it over Morgan's shoulder, where it crashed onto Higgins's footprint "painting." Morgan haughtily asked Hansen if that was music, and he emphatically replied yes, it was the "music of our time."

Alison Knowles

Alison Knowles states she never formally attended Cage's class in experimental composition. "History has put me into the Cage class, and the fact is all I did with John was walk the Mycological Society. We walked the mushrooms in upstate New York with other friends. So it is interesting. I never had any formal teaching from John. For some reason that is a big mistake people make. It is a compliment but it simply isn't true that I was in that amazing class in 1958.

"I remember John said once to me," Knowles continues, "'You will never find me sitting on a black cushion.' But on the other hand he was very drawn to Suzuki and to Buddhism as a practice and used it for principles in Fluxus of finding and using things

that are thrown away or disgorged, finding the value in something that you are told is not valuable. For me it is up to the individual mentality that the artist uses. That, I think, is also an encounter in Buddhism."[67] Knowles said she had been making expressionist paintings before she knew Cage, but afterward she worked with "numbers dictated from a lexicon . . . and organized my first painting and projected that number of objects into each of those areas of a painting."[68]

In 1960 Cage stopped teaching at the New School. Richard Marxfield took over the class, which he taught from his apartment on the Upper West Side. Cage became a Fellow at the Center for Advanced Studies at Wesleyan University. When he called his mother to let her know the good news about his new job, she asked, "Do they know you're a Zen Buddhist?"[69]

Cage, Zen, and the Beats at Sarah Lawrence College

It is not well known that during his stint at the New School, Cage participated in a panel conference titled "Zen Buddhism in American Culture" held on April 18, 1959, at Sarah Lawrence College. The Sarah Lawrence school newspaper referred to Zen as an "obscure warrior religion" of the Beats. Students, faculty, and others from over sixty colleges attended panels on religion, arts, and psychology. The bad-boy beat poet Gregory Corso was there, as was Huston Smith, chair of the philosophy department at MIT. The questions asked then are still relevant today. The religion panel wondered if Westerners and Easterners could really understand one another. Does a Westerner really know what satori is? Can a Westerner ever practice real Zen? Cage, who chaired the arts panel, was paired

with Corso, and the panel asked how Zen had been interpreted in Beat literature. Had Japanese-style poetics and writing influenced American literature? Did Ginsberg and Kerouac really care about Zen? What was so important about it to American writers anyway?

The psychologists on the panel turned that last question around, asking what was so important about Zen for the American mind. How did it relate to Freud and Jung? If one got into Zen, did that mean the values of the West were falling apart? Was the West being rejected? Huston Smith showed a film of an interview between himself and D. T. Suzuki, most likely from an American TV show on world religions. Chen Chi Chang, who had substituted for Suzuki at Columbia and taught on Tibetan Buddhism, was there, as were members of the First Zen Institute.

The morning keynote speech was delivered by Bernard Phillips, chair of the philosophy department at the University of Delaware and a lecturer on Zen Buddhism at the New School. He told the audience that since Zen could not be spoken about, he was "sinning" by discussing it in the first place. But it was the arts panel that really rocked the conference. Corso threw down the gauntlet, insisting he was a poet, not just a Beat poet. Cage mentioned he used to own 125 books on Zen, but now owned only one. However, he did possess 125 books on mushrooms. The two of them were pitted against Peter Fingesten, head of the Pace College art department. A therapist, Vera Brensen, was on the panel probably to head off a nasty encounter between the other members.

Cage separated his work into three areas: composing, performing, and listening. He was pessimistic about whether anyone really communicated because he would say something deep and heartfelt, and the other person would reinterpret it according to his own wishes. This observation disturbed the therapist. Corso annoyingly

added that he had finally figured out that death was real, but he was having a good time nonetheless. Phillips walked in the room, pointed his finger at Corso, and insisted he needed help of the Zen kind, but laced with love. Fingesten insisted that everyone needed to learn about Western culture before learning about Zen. Cage disagreed, while the audience burst out laughing at Corso's continued antics. Brensen, the therapist, didn't understand what was going on.

Phillips thought Zen was all-embracing, a soft, warm, and fuzzy Tao. Huston Smith and a colleague said that might be true, and then again it might not. Chen Chi Chang took a more pragmatic approach. He said Zen was just a sect of Buddhism and couldn't understand what these gentlemen meant when they talked about all-embracing. He didn't know what was being embraced.

In 1962 Cage traveled to Japan with David Tudor (which is when he most likely saw Toshi Ichiyanagi perform) and returned again in 1964 with the Merce Cunningham Dance Company. His 1962 trip was sponsored by the Sogetsu Art Center as part of their Sogetsu Contemporary Art Series, and he also toured through Tokyo, Kyoto, and Osaka. In Sogetsu Hall in Tokyo he collaborated with Yoko Ono, Ichiyanagi Toshi, and Takahashi Yuji. There he gave a musical performance with Yoko Ono in a cocktail dress, black stockings, and black shoes. She lay prone on her back, stretched out over the piano strings, her neck and hair dangling precariously off the piano's edge. Cage and Tudor, dressed in suits, hit the piano strings with various objects, and another man wandered about reading little pieces of paper. After this performance Japan went through "John Cage Shock."[70]

Cage, as noted previously, made sure to visit his former teacher, D. T. Suzuki. Mihoko Okamura remembers taking Cage to see the famous Zen rock garden, Ryonaji. Cage was so moved by the

experience that he composed a musical piece and executed a group of drawings about it. Decades after hearing his first lecture on Zen Dada at the Cornish School, Cage came full circle by traveling to the authentic source and experiencing his own version of Zen Dada.

After the 1960s Cage wrote many compositions and experimented with all types of media and technology. It is impossible in this brief chapter to detail his trajectory and oeuvre, as his influence is still ongoing in the international creative world. What has been traced in this chapter is just one aspect of his development—his embrace of Zen Buddhism and the effect it had on his life, his work, and that of his direct students. There is so much more scholarship and research yet to be done on this subject, and this chapter is just a humble beginning.

John Cage died on August 12, 1992.

Fluxus, Happenings, Judson, and Japan

*I grow increasingly interested in the works of Alison Knowles
... and I find her work more and more, oh, useful.*[1]
—JOHN CAGE

First Fluxus Performance

As noted in the previous chapter, many of the students in John
Cage's New School class became deeply involved in performance
and the enactment of event scores, such as George Brecht, Dick
Higgins, Jackson Mac Low, Alison Knowles, and others. Though
they had already been collaborating informally, their first official
Fluxus event, *Feast of Fluxeses* or *Festum Fluxorum,* was arranged
by George Maciunas with the help of the Düsseldorf critic Jean
Pierre Wilhelm in Wiesbaden, Germany.

A grainy black and white film of this outrageous historic per-
formance has recently come to light. Shot by an unknown camera-
man, it reveals a tall, slender Alison Knowles in a pleated skirt,
thin belt, and a somber mock turtleneck marching onto a makeshift
stage. Her hair is pulled back in a fashionable chignon and her
face framed by thick Buddy Holly glasses. She is followed by three

men: a bristly mustached Dick Higgins, Ben Patterson with wire-rim spectacles, and a bald Emmett Williams. The men wear formal suits, ties, and natty vests. All four artists stand behind a long table and begin rhythmically clapping their hands. The youthful, well-dressed German audience stares at them, not sure where this is going, as clapping is supposed to come from the audience at the end of the performance, not from performers at the beginning.

Dressed as a nineteenth-century gentleman wearing a monocle and bowler hat, Macuinas tips his hat toward the audience. Knowles stands up, then forcefully sits down. She is joined by the Korean artist Nam June Paik, who is wearing an impeccably tailored suit. One man blows a kazoo. Higgins puffs out his cheeks and blows air over a book. Paik plucks the strings of a violin. Someone smacks scissors repeatedly into the palm of his hand and raps his knuckles on a wooden table. Patterson jumps up and down on his toes. Two wooden blocks are smacked. Paik beats a violin with its bow, pinches his cheek, and spits into the violin. The stunned audience nervously laughs.

Patterson grabs a contrabass and attaches wooden clothespins to its long metal strings. Using a screwdriver, he unscrews the instrument's neck, revealing a stash of breakfast cereal hidden within. He spoons out some morsels and chews them. Pulling a nylon stocking over the contrabass's neck, he pumps air into its hollow cavity with a bicycle pump.[2] He energetically shreds a duster's soft fibers against the instrument's hard metal strings, a sly reference to John Cage's 1941 *Work for Prepared Piano*. Williams turns his back to the audience and reads incomprehensible sentences aloud from a book. Knowles shouts out, "Never, never."

Paik unrolls a scroll of paper. He plunges his fist in a plastic bowl filled with sumi-e ink and makes wet, goopy handprints on

the paper. Kneeling, he flicks his striped tie into the bowl and drags it down the scroll's center, leaving behind wispy ink strokes. He then thrusts his head into the ink bowl and crawls on his hands and knees, using his saturated wet hair as a brush to make long, broad, wavy black streaks.[3] "When he got to the end he spit red tomato sauce out of his mouth as if making a wax seal on the paper. These are actual scores."[4]

A grand piano is hauled on stage for Philip Corner's *The Piano Activities*.[5] Williams holds a brick over his head and then hurls it onto the piano strings. The other performers hit the strings with sticks, teakettles, and feather dusters. One person smashes the ivory keys with a hammer. When the inside of the piano is totally destroyed, the performers roll it through a narrow corridor that is labeled *Notausgang* or "emergency exit."

In 2006, forty-four years after this performance, Knowles remarked, "I was thinking of the Zen encounter of the koan and the breakthrough a person makes through their own of understanding of it. It is a metaphor of the piano destruction event, of breaking through into a new kind of music though it involved a destructive act."[6] At another point, Knowles noted, "It was strongly flavored with Eastern philosophy."[7] Paik told Knowles that he had witnessed a Zen monk painting with his hair during the half year he spent in a Buddhist monastery when he was seventeen years old.[8] In his book *Zen and the Comic Spirit,* Conrad Hyers mentions another predecessor for Paik, the eighth-century painter/priest nicknamed Wang-mo (Ink Wang), who got drunk, sang, and made a mess by rubbing ink on his hands and feet, then flailing about on paper. Looking at the messy swirls, he would lift his brush to paint mountains, rocks, clouds, and water and would even dip his head in the ink pot and use his hair as a brush.[9]

In 1964–65 Paik made the provocative *Zen for Film,* a reel of 16-mm film containing nothing but twenty-three minutes of blank leader tape, the ultimate experience of "nothingness." Dust from the lens of the projector and tiny particles adhered to the celluloid. The film is not blank but ripples with tiny fragments of inert matter that mimic the mind's continual activity.

Paik understood long before anyone else that art and TV were melding, and artists would one day work with electronic devices in the same way as paintbrushes and canvas. In 1965 he purchased a Sony Portapak and taped Pope Paul VI's visit to New York City, showing it at the Cafe Au Go Go.[10] He then recorded what is agreed to be the first work of video art, *Button Happening,* a two-minute black-and-white film in which he buttoned and unbuttoned his jacket.

"The principle ideas we [Fluxus] came to share," Higgins stated, "mainly through Cage, were derived from Zen Buddhism, the I Ching, Erik Satie, and Marcel Duchamp." Hanna Higgins, the art-historian daughter of Knowles and Higgins, said that it was the world of experimental music that brought many of the Fluxus artists together. "The most important of these," she emphasized, "was a 1957–59 class in musical composition offered by experimental composer John Cage at the New School for Social Research."[11]

Emmett Williams countered that stance, saying that he had lived at a Soto Zen temple for two months in 1987 and performed Fluxus pieces and tea ceremonies "at the temple of Ryodenji in Machida-shi,"[12] and did not see the direct influence of Zen on Fluxus. He acknowledged the Fluxus connection with the classes of John Cage but felt Cage had studied with many other luminaries besides Suzuki, including Schoenberg, Duchamp, and Buckminster Fuller.

You're in the Army Now

The bright orange poster announcing the *Internationale Fluxus Festspiele Neuester Musik* at the Hörsaal des Städtischen Museum, September 1 to September 23, 1962, typeset in black, bulky letters, was designed by Maciunas.[13] Three participants in the festival (Higgins, Brecht, Ichiyangi) had been in Cage's New School class.[14] Richard O'Regan, a staff writer with the Associated Press, penned a hilarious tongue-in-cheek article about the Fluxus festival for the well-known American military paper, the *Stars and Stripes*. Titled "There's Music—and Eggs—in the Air!"[15] it shows a cartoon of Alison Knowles shaving Dick Higgins hair, Higgins breaking eggs over his newly shaved pate,[16] and a music conductor throwing raw eggs at the audience. Paik is portrayed screaming, covered with shaving foam, and diving into a water-filled bathtub. Some wacky-looking composer is hacking a piano to pieces with an oversized ax. Flying eggs and musical notes whiz all over the printed page, even bleeding into the margins. Regan said, "They write scores that can be read forward, backward, upside down and inside out all at the same time. They perform visible music as well as music that can't be heard."[17] He quoted the *Frankfurter Neue Presse*, which said the festival "put all the others in the shadows" and mused that Fluxus made other new-music program "seem like 'classical chamber music.'"

When one of Germany's "well-known abstract painters" said he didn't know what it all meant, Emmett Williams, described as "a part-time performer and composer of this Very New Music living in Germany," told the artist that "Higgins could play music like Chopin every night, but it would take six months for his hair to grow back."

Regan wondered if he was witnessing "a parody or a protest." Maciunas, described as the "American Promoter," said it was "action music," and although the program had been billed as "New Music," there had been no music whatsoever. Maciunas remarked, "In previous performances in this festival, there has been much electronic music and concrete music. What you saw tonight was action music, happenings, and anti-music." Its purpose was to train people to listen to "the sound of rainfall, the babble of a crowd, a sneeze or the flight of a butterfly." Knowles remembered, "The event scores were strongly flavored with Eastern philosophy because there were no designated players with parts, no costumes, no sets, no scenarios; there was simply an action to be performed."[18] The scores were "koan poems to be worked out to perform for people."

The second night people yelled at the performers and tossed eggs and tomatoes on stage. The next morning the Hausmeister insisted they clean up the mess in the concert hall. Knowles remembers spending hours scraping dried egg yolks off the back wall.

Make a Salad

Fluxus was booked in Copenhagen, Düsseldorf, London, and Paris. Ben Vautier lived in a storefront for a week, calling it "a work of art." He filled the windows with slogans that said, "I was young and wanted fame," "Whatever you do I did it before you," "To be a failure is art," "I am repeating myself," "This is not a work of art," "*I am* contains ambition," "Artists think too much of themselves," "Anti-art is art," "I like being the first," and "I want to be."

Knowles made a salad and soup for her piece *Proposition*.[19] It created havoc in Copenhagen. The audience of two hundred held their breath as a dozen participants mixed a salad together in a big

container. Not only could you see the performance, you could smell and taste it. Performers cut and chopped vegetables, "a statement concerning the importance of daily life" and "a further breakdown of a nineteenth-century isolationist mentality in art."[20] The local paper ran a photograph of a pile of chopped vegetables and asked if it was art. Eric Andersen, a student who bought the vegetables with funds from his music academy's performance budget, was expelled from school for squandering money.

Was making a salad an artwork or artistic folly? What did it really have to do with Buddhism? In terms of *Proposition,* Knowles observed that every person on earth eats a meal, but when the meal is eaten in a Zen monastery, it is an event in itself. In the greater society, the meal becomes an act empty of its own inherent nature. In *Proposition,* the perceiver, cutter of cucumbers, and shredder of lettuce all act from their own inherent nature.

Cage's music stripped away everything but duration, coupled with an appreciation of the present moment. In Fluxus, structure was also stripped away. The only thing left was action (and its implied duration) cued by Brecht's invention, the event score. The concentration, intentionality, and focus of the performer were the only things that distinguished the event from a completely random act. Event scores seemed spontaneous but were never made up on the spot. Knowles said, "The events were written up and rehearsed beforehand if at all possible, [because we wanted to know] what would happen before the public. The event score was preceded by concrete and visual poetry."[21]

What role do randomness and improvisation take in these kinds of performances? How does this art form relate to Buddhism? Knowles defined the differences by noting that improvisation involves one's individual feelings and one's personal tastes and

proclivities. Randomness, coupled with chance operations, predetermines what sounds and actions will be picked before the event comes into being. One's personal tastes are not involved. Knowles likens randomness to meditation practice because it cuts through habitual patterns, enabling fresh new perceptions.

Europe was so receptive to Fluxus that Al Hansen and George Brecht eventually moved to Cologne, Emmett Williams resided in Berlin, Ben Patterson and Joe Jones stayed in Wiesbaden, and for periods of time Dick Higgins, Alison Knowles, Geoffrey Hendricks, and Philip Corner all lived in Europe.

New York City Incubation

Fluxus may have been hatched in Cage's class, but it incubated in the nests of New York's downtown loft scene. In 1960, when Cage stopped teaching at the New School and composer Richard Marxfield took over, Marxfield's assistant was La Monte Young, a musician and composer. Young met George Maciunas and invited him to Yoko Ono's loft at 359 Canal Street.[22] Maciunas quickly befriended Higgins, Mac Low, Henry Flynt, and Brecht and produced a series of Saturday night *Flux Theater* events. From December 1960 to May 1961 Young curated concerts of music, poetry, and "other new art forms."[23] He even presented thirty different works on May 19 and 20.

In *Composition 1960 No. 7,* the B and F♯ notes continued for a "long time," using just one chord or a "sustained drone." The composition used a "system of tuning in which every frequency is related to every other frequency."[24] The piece has been credited as the very first sound installation in the United States. There was no great desire to attract the public, but word leaked out, and even the esteemed Marcel Duchamp found his way downtown.

Ono performed *Cut Piece* in 1961, sitting passively on the floor while spectators cut off swaths of her clothing with a pair of scissors. *Cut Piece* is open to multiple interpretations. Ono asks the audience to undress her, a voyeuristic act and one more personality-based than most Fluxus performances. In a black-and-white film of the performance she clutches her severed bra to her chest in a show of fragility and modesty, unmasking layers of self in a particularly brutal way.

Jackson Mac Low believed Fluxus grew out of these concerts at Ono's loft, though the group did not become the known entity of Fluxus until they performed in Europe. Much about Fluxus was strongly influenced by certain aspects of Cage's work.[25] As early as March 1961, the Living Theater presented a concert of new music featuring Cage, Kaprow, Brecht, Hansen, Rauschenberg, and Marxfield,[26] but the name Fluxus was not used. No one agreed on what Fluxus was—or was not—but generally it had four aspects. At its core it was a floating, mixed community of 351 individual artists. There were publications by various members in different countries. New forms emerged, and there was a strong undercurrent of theoretical considerations. Mac Low said, "I have never really known what the group of artists who identify themselves as Fluxus artists has in common, even though some are [or were—several have died] friends of mine for many years. There is a certain simplicity, and Zen-influenced emphasis on the nature of materials and in many Fluxus works a certain kind of wry humor. Objects themselves, often 'natural,' but some man-made are given for their own sakes rather than for any symbolic or other meanings."

Mac Low's piece *Verderous Sanguinaria* was composed through chance operations with text from twenty-six different dictionaries with twenty-six words and phrases in various combinations recited

by four different actors. Mac Low felt the power of working with performers came from Buddhism and "the teaching that highly conscious work with and through the ego [as against the ego's uncritical expression] can lead to enlightenment." He also conceived of *Tree Movie*,[27] in which a tree would be filmed over the course of many hours. His idea was published in a Fluxpaper in February 1964. Mac Low gave a copy to Gerald Malanga, a good friend of Andy Warhol's. In April 1964 Warhol made *Sleep* using the reclining figure of the poet and future tantric Buddhist practitioner John Giorno. It is interesting that a similar idea was employed for the movie.

Maciunas and fellow Lithuanian Almus Salcius ran the AG Gallery at 925 Madison Avenue. They held benefits for a magazine of experimental music notation, *Fluxus*,[28] and sponsored eight additional evenings of literary readings by writers Leroi Jones (Amiri Baraka) and Diane DiPrima, Iris Lezak, Young, and Mac Low.[29]

Maciunas wanted to publish all these artists together in an anthology but had so little money that he could not pay the electric bill, so the final concert was held by candlelight. Though they started in May 1961 and finished in May 1963, Mac Low and Maciunas did compile everyone's work into the book *An Anthology*.[30] Paul Williams, who had financed John Cage's *Williams Mix,* helped pay for it. To further defray costs, two benefit concerts were held at the Living Theater on January 8 and February 5.[31] Mac Low burned ten holes in a rectangular piece of cardboard and placed a ladder on stage. He spread books, magazines, and newspapers all around him on the floor, dropped the cardboard over the assembled papers, and read aloud the words peeking through the holes.[32]

An Anthology was released to the public on May 11–12, 1963, or what Fluxus called YAM Day.[33] Mac Low wrote an essay about the Buddhist term "choiceless awareness," which means to perceive

phenomena without attachment or bias. The artist's tastes and passions intervene much less than when artworks are made in more traditional ways.[34] Views like this helped Mac Low (and Emmett Williams) lay the foundation for concrete and sound poetry.[35] Mac Low's first theater work, *The Marrying Maiden, a play of changes,* was produced for the Living Theater on the floor right below Cage and Cunningham's loft, on Fourteenth Street and Sixth Avenue. Cage contributed taped scores. Directed by Judith Malina with sets by Julian Beck, the play ran forty-seven times and derived its characters and scene titles from the I Ching. The asyntactical text was particularly challenging for the actors, as scores were manually stopped, slowed, or sped up at random. During rehearsals Cage recorded the points at which people paused to breathe and then cut up those moments. The cut segments were rearranged and inserted in between chance-determined splices of tape. The completed taped piece played while the actors talked. The play was started and stopped by Malina whenever she threw the dice and got the lucky number seven.

How did Cage, the inspiration and teacher of so many these artists, view their work? He found Maciunas's control annoying and believed that it had "a great deal [of ego]... in the case of some others there's not."[36] George Brecht said, "In Fluxus there has never been any attempt to agree on aims or methods; individuals with something unnamable in common have simply naturally coalesced to publish and perform their work... individuals in Europe, the U.S., and Japan have discovered each other's work and found it nourishing."[37]

Alan Watts, the great midcentury popularizer of Zen, who wrote the controversial "Beat Zen, Square Zen, and Zen" article, visited New York in the spring of 1961 to teach a religion and language

course at the New School. Unlike the hoopla surrounding D. T. Suzuki's course at Columbia, Watts's course barely registered a blip on the radar of the New York art world. Despite the lack of interest, Brecht diligently cut the course description out of the Columbia catalog and pasted it into one of his many notebooks.

Maciunas promised Higgins he would publish his enormous *Jefferson's Birthday,* chronicling an entire year of his life from April 13, 1962, to April 13, 1963, but he never did. Upset, Higgins went to a bar, knocked back a few drinks, and told Knowles he was going to start his own imprint, Shirtsleeves Press. She thought that was a terrible name and said, "Why don't you call it something else?" Higgins incorporated Something Else Press on February 2, 1963, and published Fluxus works under the Great Bear label. The pamphlets were distributed in alternative book stores and galleries and through the mail. The order desk employed the young dancer, choreographer, vocalist, and future Buddhist practitioner Meredith Monk. Something Else Press published approximately ninety-seven books on happenings, Fluxus, and concrete poetry. It went bankrupt in 1974.

On February 8, 1965, Knowles performed an action poem with Robert Filliou, an economist turned artist. Titled *Yes,* it was a rather grisly rendition of all the active body functions of "the poet." *Yes* was divided into Alimentation (it passes down the gullet), Blood (5 to 7 percent of the body weight), Breathing, Brain, Excretion (small tubules filter off waste material), and Reproduction. When it came time for part two of the poem, called "Le Filliou Idea," Filliou stated that he would not decide, nor want, own, or be aware of self, but would just "do nothing." Mind was aware, he said, awake and receptive, and it had no need to choose between dualisms like yes and no. Filliou, who had been in contact with different forms of Buddhism in Japan and Korea during the 1950s, was

making the same kind of statement a Zen master might make during a sesshin. Filliou's Tibetan teacher Sogyal Rinpoche told him, "Art is tantric (i.e., turns poison into nectar), but artists themselves remain very confused."[38] Years later, in 1984, under the supervision of his Tibetan Buddhist teacher Dudjom Rinpoche (the head of the Nyingma lineage), Filliou and his wife Marianne undertook a three-year, three-month, and three-day retreat in the Dordogne, close to the prehistoric caves of Lascaux. Tragically, Filliou was diagnosed with liver cancer and died four months before his retreat ended in 1987. In 1990 a deep wish of the artist Joseph Beuys and Filliou was realized when scientists, artists, and spiritual leaders convened in Amsterdam for a conference titled "On Art Meets Science and Spirituality." Participants included His Holiness the Dalai Lama and artist Robert Rauschenberg.

In 1967 Knowles turned her daily meals into performance pieces by eating the same tuna fish sandwich at the same place, Riss Foods Diner in Chelsea, at the same time each day.[39] Like the contemplative three-bowl meal practice in a Zen monastery called Oriokyi, an ordinary event was turned into a unique activity as well as an event score and a journal. Knowles noted "the main value of this work is to transform our daily actions into art actions and thereby transform both."[40] That same year she built the sculptural installation *Big Book,* in which the viewer became the actor by walking and crawling through the book's enormous contours and corners. The critic Harold Rosenberg discussed the work in his book *Artworks and Packages,* noting that no two people can occupy the same space in the same way at the same time, so everyone's experience of crawling through a hole is different. There were eight movable pages in the book that came equipped with ladders, tunnels, furniture, cooking facilities, a toilet, coffee, a gallery, a guest book, mirrors,

colored lights, a practical space for skills like carpentry and welding, and—in keeping with Knowles's recent motherhood—a telephone to call the babysitter.

Allan Kaprow and Happenings

"Something to take place: a happening," was the way Allan Kaprow described the "proto score" he developed in Cage's class in his article "The Demi-Urge" in the Rutgers University literary magazine, *The Anthologist*.[41] Furthering his need to break free of constraints, he told the newly created Judson Gallery on November 2, 1959, that he needed "freedom to be free," and that "Abstract Expressionism is dead." It was time to "go In(to) instead of look(ing) At" art, and that a Happening involves time—(and a) more intense environment."[42] For the Autumn 1959 issue of Philip Pavia's arts publication *IT IS,* Kaprow wrote "The Principles of Modern Art" shortly after he presented his piece *Eighteen Happenings in Six Parts* at the Reuben Gallery.[43] The gallery invitation promised, "You will become a part of the happenings: you will simultaneously experience them."

A dilapidated third-floor walk-up was sectioned off into three rooms rimmed with clear plastic walls, allowing events in other rooms to remain visible.[44] Participants were assigned ticketed seats, and the audience stood up and changed rooms during two intermissions. Performers lit matches, painted a canvas, and squeezed oranges in a hand juicer. The performance was divided into six parts, each containing three happenings (thus *Eighteen Happenings in Six Parts*). The beginning and end of each part was indicated by the ring of a bell.[45] During certain times the audience moved around, and at other times they remained seated. Applause was allowed only at the very end, and there were no curtain calls.

Despite appearing random, it was actually highly scripted, with detailed diagrams for the actors to follow. Cage did not like it, even though Robert Rauschenberg and Jasper Johns were performers. Kaprow was "quite disappointed by Cage's reaction."[46] Ted Berrigan even called Cage "the spiritual daddy of the Happening," and Cage retorted, "Happenings are boring. When I hear the word 'Happening,' I spew wildly into my lunch!" Berrigan replied that Kaprow had called Cage "the only living Happening." Cage retorted, "Allan Kaprow can go eat a Hershey bar!"[47]

Eighteen Happenings in Six Parts investigated the fragmentation of time, notions of simultaneity, emptiness, presence, and spatial dislocation. Materials in Kaprow's pieces were made to be destroyed. Why should they last? Why should anyone pay for them? Using newspaper, string, adhesive tape, grass, or food showed a willingness to jettison craft and salable permanence. Kaprow believed there was no reason to make art if it was going to be locked up forever. Art could be "renewed in different forms, like fine cooking or seasonal changes." Experiencing change and impermanence by using debris, waste products, toilet paper, or bread became a "constant metamorphosis."

In January 1964 Kaprow presented the extravaganza *Eat* deep inside the old Ebling brewery caves in the Bronx. Reservations, booked through the Smolin Gallery, were limited to twenty people at a time, both to inhibit crowding and to allow air to circulate freely. The caves had rivulets of running water, piles of dirt, and old charred wooden beams. They smelled musty and abandoned. There were two seven-foot towers with seated women; one held a bottle of red wine, the other a bottle of white. If asked they would pour a cup; if not they remained motionless. Apples dangled from strings and could be pulled off and eaten, or partially bitten, or left

dangling. A woman fried bananas on a hot plate. Participants could climb an eight-foot ladder to eat a piece of sliced bread and strawberry jam. Nestled within a small cave, a man shouted "Get 'em!" A ladder allowed one person at a time to reach him. If successful, they were handed a boiled, salted potato. The audience was led out after an hour.

"We know very little and are hardly aware of the implications of our procedures,"[48] Kaprow wrote. In 1978 he moved to California to become a formal Zen student under Roshi Charlotte Joko Beck at the Zen Center of San Diego. He refined his work to just the breath of an exhale, or only one mark on a paper, an idea from ancient Chinese practices based on a bird landing and quickly taking off. The mark captured a fraction of a moment of the bird's flight.

Toward the end of his life Kaprow decided "activity" best described his work, not "happenings," and he adopted the same stance as a calligrapher or haiku master in a Zen monastery using the concept that "a moment picked out of the stream of activity serves as a poetic kernel of a work of art."

Judson Church as Artistic Incubator

The Judson Church off Washington Square in the West Village was built by Edward Judson to honor his father Adoniarm, who had preached in distant Myanmar (Burma). A copy of the Bible in Burmese was laid into its cornerstone. In the 1960s the church became a central clearing house for artistic innovations and gave rise to the Judson Gallery, the Judson Poets' Theater, and the Judson Dance Theater.

Judson Gallery

Judson Gallery, originally the church's basement recreation room, hosted many innovative events and exhibits. It debuted with the extravaganza *Ray Gun Specs,* which was "a three-month period of experimental constructions derived from American popular art, street art, and other informal sources" and used props like those in Cage's class: guns, dolls, cutouts, and posters.[49] The gallery harnessed the talents of Claes Oldenburg, Dick Higgins, Allan Kaprow, Red Grooms, Robert Whitman, and Al Hansen. *Time* magazine wrote that the event, held in "an obscure basement gallery in Manhattan's Greenwich Village," was an "improvised circus" with slogans like "Dirt is indeed deep and very beautiful" and "I love soot and scorching." In an obvious put-down the magazine chided, "Last week's Manhattan Happenings were ignored by the serious critics but thoroughly enjoyed by uncritical crowds."[50]

Judson Poets' Theater

On a "bright and gusty spring day" in 1961, poet Diane di Prima founded the New York Poets' Theater with her lover, the poet Amiri Baraka (Leroi Jones); her soon-to-be husband, the actor Alan Marlowe; Jimmy Waring; and John Herbert McDowell. Its purpose was to give poets a greater voice within theater and the performing arts. Di Prima, a Beat poet who later became a serious practitioner of Tibetan Buddhism, felt she was both an artist and a "bhikshuni," or renunciate nun, and dedicated her life to both art and the "holy." Written across her apartment wall was the slogan, "Sacrifice everything to the clean line," meaning that everything should be sacrificed to art and beauty. She said of that time, "Worlds overlapped in a million ways and places. The art world, the worlds of jazz, of

modern classical music, of painting and poetry and dance, were all interconnected."[51]

In March 1962 the Poets' Theater sponsored a Poets Festival at the Maidman Playhouse on Forty-Second Street. It included new music by Richard Marxfield, La Monte Young, Philip Corner, and Joseph Byrd; a happening by Kaprow; works by Robert Whitman, George Brecht, and Ray Johnson; and experimental films by Stan Vanderbeek and Nicola Cernovich.[52] Shortly thereafter Di Prima moved to California after dropping LSD with Timothy Leary at Millbrook, his upstate experimental commune, and became an early student of Tibetan lama Chögyam Trungpa. She taught poetry at Naropa Institute with Allen Ginsberg and Anne Waldman, and her poems stressed a worldview of emptiness and interdependence.

Judson Dance Theater

Judson Church also housed the Judson Dance Theater Workshop. Art forms morphed freely from one into another whether it was fine arts, poetry, acting, dance, or music. According to Dick Higgins, "Judson and Fluxus overlapped somewhat—Philip Corner danced in an Yvonne Rainer piece and Meredith Monk was in mine (and I in hers)...Ono? Who knows? She was mostly off in England, or on Long Island. I never saw her at the Judson Church (she may have been there though), and she certainly didn't take part in any of the major events."[53]

Starting in the fall of 1960 the musician and choreographer Robert Dunn taught four courses at the Merce Cunningham Studio, and they continued until 1962. The dancer Deborah Hay remembered that the "classes were based on Cage's approach to musical composition, so we were actually learning Cage's methods of indeterminacy and chance, which were very freeing technically

in making dance."[54] Any sound could be music and any movement, including stillness, dance. Ideas were neither good nor bad in keeping with the Buddhist concept of neither accepting nor rejecting experiences.

Dunn did give out assignments. "Make a five-minute dance in half an hour," he would say, or, "Make a dance about nothing special." Dancers were vaguely aware of the Zen ideas underlying the class, and that stillness was as much a part of dance as movement. Yvonne Rainer made shapes with her body while sitting on the floor. Steve Paxton went through a "why-not" phase. Why not do this (e.g., eat a sandwich), why not do that? Anything and everything that had been taboo or inconsequential was explored.

When the class ended in the fall of 1962, the dancers continued to meet at Rainer's studio on Second Avenue and St. Marks Place in the East Village. Rainer and Paxton met with the Reverend Al Carmines and asked if they could use the Judson Church on Tuesday nights. They showed their project to him, and he agreed. Rainer said, "I think it was my idea to inquire at Judson because I had already been to its art gallery to see works by Allan Kaprow, I think, and perhaps Claes Oldenburg, and I had attended the Poets' Theater for Joel Oppenheimer's *American Dream*."[55]

Dunn stepped in to curate *A Concert of Dance #1*, a three-hour marathon featuring twenty-three dances by fourteen choreographers, on July 6, 1962. It was free and open to the public. These experimental performances kicked off a six-year-long wave of postmodern dance that questioned the entire tradition of dance aesthetics and ballet and spawned contact improvisation and the use of cameras and alternative technologies. The choreographers called their cooperative Judson Dance Theater, and it produced over two hundred dances.[56]

The *New York Times* noted the profound and far-reaching influence of Dunn's classes in a June 1963 review: "The nucleus of the Judson Dance Theater was formed in some classes Mr. Dunn held in dance composition. The classes did not last long, but the cooperative working association of the members did."[57] *Esquire* magazine discerned that "dance is any movement to which a dancer gives that name. These dancers make pieces from seemingly ordinary actions like ironing clothes or washing their hands. But in many dances out of ordinary movements, the Judson Dancers usually succeeded in turning those movements into the reverse of the ordinary."[58] In an undated self-evaluation, Judson Church congratulated itself for hosting such a wide group of arts activities, noting that the success of one venture depended on the success of all of its ventures. The evaluation stated, "Judson has thrown itself open to dance particularly. This influences the theater and vice versa. Also there are 'Happenings' and performances . . . there are ties with all these people . . . this is tremendously important . . . just to keep open to all these events is priceless."[59]

Concert #14 on April 24, 1964, showed Rainer in a black dress dancing with a spool of unwinding white thread. Gesticulating randomly, she privately noted the thoughts that arose in her mind before she performed any action. Though no one else was aware of it, this notice was part of the performance. The noting of thought is similar to the process of meditation, when one notes one's thoughts. Was Rainer practicing Buddhist meditation while performing? No, but she was using the same techniques to arrive at her artistic output.

In May 1964 the Cunningham Company went on tour for six months, accompanied by the dancers Barbara Dilley and Steve Paxton. Dunn taught his choreography class one last time at the

studio to Meredith Monk, Lucinda Childs, Phoebe Neville, Sally Gross, Robert Morris, and Rainer. Dunn was studying the philosophy and psychology of the Abidharma, the definitive Buddhist text on the nature of mind, part of the Tripitaka, the three main texts of the Buddhist pantheon. Though he was not teaching Buddhist philosophy and cognition in his class, those ideas certainly crossed his mind. Monk presented *Break,*[60] and Childs performed *Street Dance,* in which she disappeared down a freight elevator. Through a tape recorder she told the audience to look through the window. When they did, Childs could be seen down the street squeezing into a doorway and vanishing. The Judson dancers touring with Cunningham returned to the United States, but the Judson Dance Theater's collective spirit was diminishing, and it soon fell apart.

By the mid-1960s the ideas that Suzuki's classes had unleashed were also dissipating. Too many people were involved for there to be direct sustained contact among a small group of individuals. Asian teachers migrated to the United States, and different forms of Buddhism became accessible. Social conditions changed, and the United States became involved in an unpopular war with Vietnam. Civil rights and political protests were exploding along with women's rights and the use and abuse of psychedelic drugs. Artistic disciplines were merging, and the use of interdisciplinary media was rising. Modernism was giving way to postmodernism, and issues of genre, identity, gender, power, subjectivity, time, and even cognition were changing. Though Suzuki did not spearhead these changes, he offered some artists the foundation of a theory and practice to explain and contain the different notions of self, perception, time, and cognition. His teachings and the transmissions of those teachings allowed them the freedom to explore these ideas in ways that suited their unique personalities and disciplines.

Japanese Dissonance and Consonance
Group Ongaku and Hi Red Center

When Toshi Ichiyanagi returned to Japan after taking Cage's New School class, he met the composer Yasunao Tone when Tone's experimental Group Ongaku (Music Group) performed at the Sogetsu Art Center. Originally founded in 1927 as the Nageirebana and Moribana School by Sofu Teshigahara, it was at the forefront in presenting cutting-edge arts in Japan.[61] Tone had formed Group Ongaku along with Mieko Shiomi, Takehisa Kosugi, and Syuko Mizuno, making "event music," or discovery of new forms. Tone and Group Ongaku's pieces focused on the precise moment when perceptible auditory phenomena change into sounds that could be identified as music, such as tossing a key chain full of keys into the air. They named this process "object sonore," or sound as object. Kosugi used music to "open consciousness" and took Bodhidharma, the first Zen patriarch, as his role model. Group Ongaku recorded their endeavors using "kitchen sounds, bottles clinked together, wild spaced-out women's voices, Hoovers, insane pianos, shortwave radio, and voices."[62] Tone and Ichiyanagi both participated in the first Fluxus Festival in Wiesbaden, Germany.

Group Ongaku quickly established itself as a hotbed of groundbreaking artists. In 1962 Kazekura Shō declared in his performance *The Real Thing* that he was the actual work of art. To prove his point he stood completely naked in the august chambers of the Tokyo Metropolitan Art Museum, thus causing quite an uproar. In September of that year Natsuyuki Nakanishi lectured about art while smoking a pipe, shocking the traditional audience. In November a group of artists at Waseda University painted the toilet seats of the school bathroom red, then wrapped string around

the waiting audience, who did not understand that *they* were the performance. These experimental leaps mirrored developments in the West, but in Japan they were not perceived as Buddhist- or Zen-inspired. In fact, young Japanese were going out of their way to distance themselves from Zen because of its strong associations with militarism and the emperor.

Jiro Takamatsu, Genpei Akasegawa, Natsuyuki Nakanishi, and on occasion Yasunao Tone also formed Hi Red Center, a mix of the English translation of the first Chinese character of each member's name; Taka (high), Aka (red), and Naka (center). It lasted from 1963–1964, starting with the three-person show *Fifth Mixer Plan.*[63] Guest members included Yoko Ono and Nam June Paik. Hi Red Center used the Tokyo Metropolitan Art Museum's Yomiuri Independent Exhibition, a prominent unjuried venue, to bring to the public art emphasizing nonsense, absurdity, and rumors. Akasegawa was arrested by the police when he printed counterfeit 1,000 yen notes. Artists dropped objects from a roof and pinned ten thousand clothespins onto thousands of museum visitors. In January 1964 they staged *Shelter Plan,* joined by Paik and Ono. The piece consisted of renting a hotel room in Frank Lloyd Wright's Imperial Hotel and helping volunteers make their own bomb shelters.

Robert Rauschenberg visited Sogetsu Hall in Tokyo just before the 1964 Tokyo Olympics. He performed *Twenty Questions to Robert Rauschenberg* while constructing one of his combines, *Gold Standard.* It took four hours. The artist Ushio Shinohara kept asking Rauschenberg questions, but Rauschenberg ignored him. Frustrated, Shinohara walked on stage holding a life-size papier-mâché doll called *Thinking Marcel Duchamp.* The doll showed the venerable Duchamp dressed in an Olympic uniform holding a bottle of Coca-Cola in one hand and a pamphlet about himself in

the other. He spun the doll's head around and around while peppering Rauschenberg with questions like, "What do you think of my imitation of your Coca-Cola Plan?" and "In some ways your pieces inherit the power of Picasso's brush, but shouldn't modern art deny the originality sought in the power of the brush?"[64] Rauschenberg did not respond. Shinohara finally wrote his question on a piece of paper, which the American stuck on his combine and covered with paint. It is interesting to note that Rauschenberg, who participated in the first proto happening at Black Mountain College with John Cage, found himself in Japan using the "Zen" techniques of silence and direct action to deflect artistic attacks from a Japanese artist.

Hi Red Center staged a *Movement to Promote the Cleanup of the Metropolitan Area (Be Clean!)* in Tokyo on October 16, 1964. Wearing Hi Red Center armbands and dressed in surgical masks and gowns, the group scrubbed the pavement on Namiki Street, which had just been cleaned up for the Olympics. Paik then introduced George Maciunas to Kuniharu Akiyama, the most important critic of new music in Tokyo, as well as to all the artists of Hi Red Center, leading to a collaboration two years later. On June 11, 1966, Hi Red Center recreated the same event with members of Fluxus at the Grand Army Plaza in New York. They industriously cleaned the sidewalk with different fluids and brushes.[65] They also recreated *Shelter Plan* at the Waldorf Astoria Hotel. Instead of denying or decrying the differences between Zen- and Dada-inspired action pieces, they jumped cultural barriers by combining them.

The Gutai

In December 1956 Jiro Yoshihara published the manifesto "Gutai Bijutsu Kyokai," or "Concrete Art Association,"[66] in the art jour-

nal *Geijutsu Shincho*. The Gutai insisted things were fake, affected, counterfeit, and fraudulent. "Lock these corpses into their tombs," Yoshihara declared, saying he would bring them to life and the material and spiritual would work as one. All individuals signed their work "Gutai," which translates as "tool-body." Yoshihara insisted that they had to create pieces no one had ever thought of before and that it was the new generation's job to redefine Japanese "culture," no matter how absurd the forms might appear.

Kazuo Shiraga performed *Challenge to the Mud* at the first outdoor Gutai exhibit in Tokyo in 1955. He buried himself in a dirt pit and spread a pile of mud around in an arc. The impressions of his thrashing to get out of the soft mud were his artwork. In 1956 the second Gutai exhibit, *Experimental Outdoor Exhibition of Modern Art to Challenge the Midsummer Sun,* went on twenty-four hours a day for thirteen days. For that exhibit Shiraga placed a lump of pure paint on a piece of paper and violently painted with his feet to unite "his own spiritual dynamics." Saburo Murakami performed *Laceration of Paper,* tearing through a series of paper screens. He then framed the sky, saying it was his creation, a slyly fresh and futuristic gesture.

Shozo Shimamoto fired cannons filled with paint against canvases, a rebellion against the technical aesthetic principle of *fude no chikara* (or *fude no ikioi*), the strength of the brushstroke. The group then published the first issue of the *Gutai Journal,* setting the typeface in a wooden galley, spreading the ink, printing by hand, and mailing the issue to interested readers around the world. Atsuko Tanaka made *Electric Dress,* a dress of glowing lightbulbs. Because the flashing lights threatened to electrocute her, she could only wear the dress draped over a protective vinyl covering for no more than five minutes at a time.

Yoshihara was aware that the Gutai would inevitably be compared to Dada. In his manifesto he expressed his appreciation to the Dada artists, acknowledging their contribution but insisting the Gutai were different. They called "the material to life" and created a "tremendous scream in the material itself," with slashing, smashing, hacking, and crackling electricity. The artists fully embraced their Japanese identity and the Japanese nature of their art. Much of their work, according to Allan Kaprow, presaged happenings.

Copies of the *Gutai Journal* were found in Jackson Pollock's library after his death.[67] Shozo Shimamoto had sent a letter to Pollock on February 6, 1956, letting him know of the Gutai's existence and enclosing copies of their magazine. Larry Miller, a member of Fluxus, stated that the Gutai was certainly noticed by Alan Watts, Allan Kaprow, and George Brecht.[68] Al Hansen, another Fluxus artist, stated, "Throughout this period—1958, 1959, 1960—in New York City many of us were aware of parallel things taking place in foreign countries. Through composer Earle Brown and his wife Carolyn, I saw many foreign art publications. Brown had magazines and booklets that showed the work of the Gutai Group in Japan."[69] However, Dick Higgins stated this information entered into their creative process much later. Though he was aware of Gutai, he did not see anything specifically about their work until they were published in the 1970s journal *Lightworks*. Dick Higgins was specifically asked if Japanese experimental groups had any influence on Fluxus. He emphatically denied it. The Gutai group with its resemblance to Fluxus was only a distant rumor, and the *Gutai Journal*s published in Japan between 1955 and 1965 were too inaccessible to read. In 1958 the Martha Jackson Gallery held an exhibition of paintings of the Gutai. Kaprow was so impressed by what he saw that he included pictures of their artwork in his book *Assemblage,*

Environments, and Happenings,[70] helping them gain international recognition in the non-Japanese-speaking world.

Because of the groundbreaking work already done by Pollock, the Gutai's painted abstractions were considered imitative, and the show did not generate much attention. Initially Gutai was not concerned with products from their performances, but as the market grew they began to sell and exhibit their work. They loosely stayed together until 1972, the year Yoshihara died.

Zen Manipulation

The Japanese created art on two levels. *Yoga,* or Western, modern-style painting, represented their external self, the image they wanted to project to the world. *Nihon-ga,* or Japanese-style painting, showed their internal self, or who they were in their essence. These differences continually pervaded their sculpture, literature, music, and theater.

In America abundant articles about Zen Buddhism showed the Western version of *Yoga* or the external self, where the West imitated Eastern styles and techniques deemed culturally fresh and acceptable. Then along came Gutai, just as the New York art world was embracing Zen and traditional Japanese culture. Western artists had absolutely no idea that the Japanese were so vehemently attacking their own Zen roots.

Kaprow and Fluxus did intersect with Gutai, Group Ongaku, and Hi Red Center, but from completely different ends of the spectrum. The Japanese groups were emerging from war, death, devastation, and a militaristic emperor-centric culture steeped in feudalism. They distanced themselves from Zen, but it was not as easy as they would have liked. Kaprow and Fluxus were part of

an American postwar national boom teetering on a generation's explosive investigation of drugs, sex, women's liberation, and radical politics. They embraced Zen as something in tune with their philosophy and were unaware of its repugnant connotations for young Japanese.

The existentialism following World War II and its resultant lack of faith and malaise hit the Japanese differently. They did not adopt any new point of view per se but strove to throw off all points of view. Zen monastic culture had proved corrupt and downright shameful. According to the Fluxus composer Yasunao Tone, "Zen Buddhism and nationalism had a historical relationship in Japan,"[71] and certain Buddhist monks had actively cooperated and aided the military. Until the 1970s artists and intellectuals felt tremendous shame and were not comfortable talking about it. The Gutai believed Zen had been manipulated by the military the way Nietzsche had been manipulated by the Nazis. Tone suggested Americans never felt that way about Zen and added, "Also Nam June Paik. I am sort of surprised, when he talked about Zen in the 1960s, practicing Zen. I [too] was tempted [to go to a sesshin and practice meditation]."[72] But Tone never went.

Japanese artists were sarcastic when the subject of Zen and the "contemplative" arts came up. They felt it akin to saying Americans were "Christian" about their art. Oddly enough, in the 1950s and 1960s young Japanese were fascinated by the Beats and their freewheeling road trips. Kerouac's book *The Dharma Bums* was particularly well received. Tone noted that D. T. Suzuki's writing also influenced young Japanese: "His writing itself is very ambiguous . . . very theoretical . . . we are kind of fascinated . . . [He] probably intrigued some Japanese audiences."[73]

Keenly aware that Zen had gone to the West, young Japanese noticed it was now coming back to haunt them. Tone said, "We understood Cage's ideas ... he got some influence from East Asia and he sent it to Europe."[74] Japan was rejecting its innate culture while parts of avant-garde America were adopting it. Tone suggests that savvy Japanese took advantage of this fact. "They think mentioning Zen is more exotic or authentic for Americans ... so some people use Zen, some Japanese do."[75]

What is clear is that American art and Japanese Zen Buddhism and aesthetics intersected in the 1950s and 1960s. Like a pebble dropped into a still pond of water, the first ripple was small and contained yet radiated out into larger and larger circles.

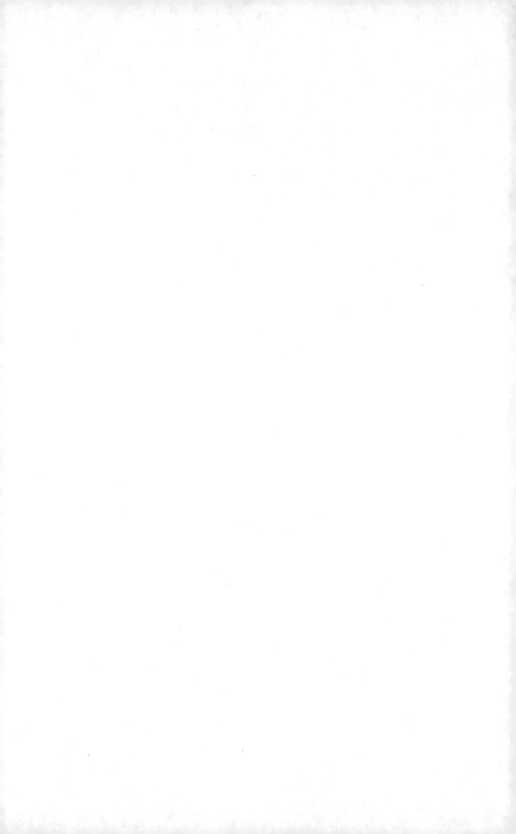

New York Ascending:
The Founding of The Club

In the late autumn of 1942, the sculptors Philip Pavia and Ibram Lassaw and the painters Jack Tworkov and Esteban Vincente were hanging out on wooden benches in the northwest corner of Washington Square Park. They argued about art for hours, focusing on fine points such as the difference between symbolism and abstraction in painting. When the weather grew colder, they moved inside to the cheapest place they could find, which was the Waldorf Cafeteria at Eighth Street and Sixth Avenue,[1] where they sat around and drank endless cups of coffee.[2] According to the artist Ludwig Sander, the Waldorf was a "degrading" place. Everyone had to have at least two nickels in their pocket to pay for at least two cups of coffee, or they would be asked to leave. The unfriendly staff did not allow more than four chairs at any table, even though the artists occupied most of the seats. If they pulled up a fifth chair, the manager would remove it. The staff locked the restrooms so the "bunch of kids" would leave. The cafeteria also doubled as a hangout for a gang of pickpockets that resembled "a reunion for the boys from Sing Sing." Painter Willem de Kooning said, "These gorillas started making trouble. It wasn't good anymore, hanging around the Waldorf."[3] In a 1967 interview with the *Partisan Review* de Kooning

noted, "We always wanted not exactly to start a club but to have a loft and for years I had it in mind. The Greeks and the Italians each have their own social clubs along Eighth Avenue. We didn't want to have anything to do with art. We just wanted to get a loft, instead of sitting in those goddamned cafeterias. One night we decided to do it—we got up twenty charter members who each gave ten dollars [for key money] and found a place on Eight Street. We would go there at night, have coffee, a few drinks, chew the rag. We tried but couldn't get a name so we called it The Club."[4]

The loft on East Eighth Street was used by a commercial artist from New Zealand willing to unload it for the $500 fixture or "key" fee. The painter Franz Kline and others met at Lassaw's loft at 487 Sixth Avenue to try to scrounge up the cash. The artist Al Copley remembered, "The meeting at Lassaw's was the only one of its kind. It included a discussion of the type of 'organization' we were to have and our policy regarding membership. It was contended that members should not include women, Communists, or homosexuals—a strange kind of package, with which some of us did not agree. A heated discussion ruled the evening, until Franz reminded us that we must make a decision about the loft no later than the following day."[5]

Six of them looked over the loft. It had a cozy fireplace and partitions plastered with porno and girlie photographs. Copley threw $20 on the table and said, "Let us start the key money," but they only raised $50. Pavia put up the remaining $450, an enormous sum at that time.[6] The next day they fixed the kitchen, fashioned a storage area for folding chairs and tables, painted the walls white, and mounted loudspeakers.

The Club held their first meeting in the fall of 1948 with a quorum of twelve members.[7] Questions of who was and was not a

member remained contentious. According to Elaine de Kooning, wife of Willem, no one really dropped by even though a pot of coffee was always brewing. According to Pavia, "Myself, Resnick, de Kooning, Lewitin, Marca-Relli, Navaretta, Kline, Reinhardt, and Lassaw attended The Club on an average of five nights a week, and we each had a key...We would light the fireplace and wait for the others. Only the original nineteen charter members were allowed to bring guests . . . which kept The Club within reason. By Christmas 1948 the membership had increased with another eighteen members honored with the title of voting members."[8]

Pavia oversaw the two-dollar monthly dues collection and initiated a lecture series and parties. According to Ernestine Lassaw, wife of Ibram Lassaw, "Philip did EVERYTHING for The Club. He paid the rent, the electric—he took all responsibility—organizing the meetings, parties, etc. Ibram loved The Club but he didn't do anything. Bill [de Kooning] loved The Club and he just washed dishes. Macarelli loved The Club and did nothing; Milton Resnick never had any money so he couldn't pay dues . . . Philip was the only one who loved to organize events and activities and he was really good at it. Without Philip there wouldn't have been any Club because no one else would have taken the time to do it. No one wants to give him credit but he was the force behind The Club."[9]

On Wednesday nights issues of critical inquiry were raised. Friday nights were for panel discussions and invited guests. Sunday nights were for socials, dancing, and singing. Formal meetings adjourned around three in the morning for breakfast at a nearby cafeteria named Rikers. Married men sent their wives off to bed early so they would not be late for their day jobs. Pavia remembered Will Barrett, who wrote for the *Partisan Review* and compiled D.T. Suzuki's *Zen Buddhism: Selected Writings of D. T. Suzuki,* arriving

at midnight to just "shoot the breeze" and drink coffee. Artists came after having spent the whole day working alone in their studios, seeking each other's company. It was "noncompetitive," respectful, and cohesive.

The Friday lectures included a number of innovative thinkers such as Hannah Arendt, Joseph Campbell (who lectured on "Myth and the Creative Art"), and Kurt Seligmann (whose talk was on "Black Magic"). One evening the Juilliard String Quartet played music composed by David Tudor. There were upward of 220 panels at The Club on a wide variety of subjects. Following the talks were questions and answers. The membership soared from fewer than twenty to a hundred and ten or more.[10]

The artists were anti-ideological and anti-rhetorical, disagreeing on practically everything. This led to just one rule: if more than two charter members were against an applicant's admission, that person was not allowed to join. Landis Lewitan always voted against everyone, so in reality only one "no" vote was necessary. This policy kept the organization quite exclusive. Landscape painters were frowned upon, as were "strict geometricians." There was a lot of grumbling that no women were admitted, so finally the painters Elaine de Kooning and painter Mercedes Matter were invited to join.

The members believed in absolute autonomy from any museum, gallery, critic, collector, or sponsor. Despite those restrictions, the art critics Harold Rosenberg, Clement Greenburg, and Thomas Hess and Alfred H. Barr Jr., the director of the Museum of Modern Art, showed up at some of the meetings and were treated just like everyone else. Ideologically sympathetic dealers like Leo Castelli, Betty Parsons, Sidney Janis, and Charles Egan also stopped by.

The Club held a 1949 New Year's Eve party. Pavia, who had called the downtown artists the "Rejected Americans," proudly pro-

claimed that although Paris had claimed the artistic epicenter for the first half of the twentieth century, New York would now claim the second. As if on cue, critic Greenberg chose ten younger sculptors, many from among The Club, who he thought were poised to make a difference,[11] including Isamu Noguchi, David Smith, and Lassaw, who also served as president of the American Abstract Artists from 1946 to 1949.[12]

According to the artist Herbert Ferber, "Lassaw was really the first abstract artist [sculptor] in America and preceded David Smith. He never produced anything even vaguely representational. He was outstanding in that regard."[13] He sculpted using solder and copper, building up his material drop by drop. Applying Harold Rosenberg's dictum of "action painting," he called his method of working "action sculpture" as the molten metal grew spontaneously.

In the spring of 1951 the budding gallery owner Leo Castelli organized a show of sixty-one artists called *The Ninth Street Show* at 60 East Ninth street. The building was an empty wholesale store with high ceilings and rented for $50 for two months. Castelli fronted $200 of his own money for expenses. It was an exhausting enterprise lasting three days. Castelli remembered, "I hung the show twenty times. Every time I hung it, an artist would come in and demand a change."[14] Franz Kline and Pavia built the sheetrock walls, and Kline made last-minute adjustments to the hanging of the works.

Sander and a friend stuck a 200-watt bulb in a flagpole in front of the building to announce its location, and a banner was stretched across Ninth Street. Robert Rauschenberg, Ad Reinhardt, Jackson Pollock, Helen Frankenthaler, Grace Hartigan, Hans Hofmann, Lee Krasner, Joan Mitchell, Robert Motherwell, and David Smith were some of the artists who exhibited. Cabs arrived five or six at a time,

and people in expensive and glamorous evening clothes poured into the gallery. The artists took turns manning the exhibit during normal working hours. Despite the hoopla and enthusiastic response, only one piece sold. However, the show did put Kline, Pollock, and de Kooning on the map of the critical art world, fulfilling Pavia's prescient New Year's Eve prediction.

The Club became *the* place where critical dialogue and its eager audience convened. Artists, architects, musicians, choreographers, composers, filmmakers, philosophers, sociologists, urban planners, and writers convened. Poets John Ashberry, Barbara Guest, Kenneth Koch, and M. C. Richards spoke on Artaud, James Schuyler, and Dylan Thomas. The composers David Amran, John Cage,[15] Henry Cowell, Lucia Dlugoszewski, Morton Feldman, Virgil Thompson, Edgard Varèse, and Stefan Wolpe stopped by; the philosopher Heinrich Bluecher and dancers Merce Cunningham and Erik Hawkins were also involved.[16]

The Club then became a victim of its own success. The bonhomie and camaraderie were infiltrated by the lucre of commerce and the stink of fame. In 1955 Pavia stepped down as director. The Club continued under the direction of John Ferren until 1963, when it disbanded.

In 1958 Alfred Barr Jr. and the Museum of Modern Art organized *The New American Painting,* an exhibit of eighty-one paintings by seventeen artists, all abstract expressionists. The show was a hit, especially in Paris, where it became *the* show, further cementing Pavia's New Year's prophecy of the "American century."[17] Alfred Barr wrote in the catalog that some painters were exposed to "Japanese Zen philosophy" with its "exploration of the self through intuition,"[18] but it was unlikely they had truly been exposed to Zen.

Pavia published the influential journal *It Is: A Magazine for Abstract Art* for only six issues. It was filled with critical inquiry about new art and featured writings by John Cage, Robert Rauschenberg, Barnett Newman, and others.[19] In 1952 the Sidney Janis Gallery had given Pollock three solo shows and heavily supported other abstract expressionist artists like de Kooning and Gorky. By 1962 it began showcasing new pop artists Andy Warhol, Roy Lichtenstein, Claes Oldenburg, George Segal, and James Rosenquist with its exhibit *The New Realists,* and abstract expressionism's star status declined.

The Club and Zen

Ad Reinhardt discussed the "spiritual plane [and] Zen"[20] in his December 22, 1950, talk at The Club titled "Detachment and Involvement." On July 8 John Stephan, an artist who published the journal *The Tiger's Eye* from 1947 to 1949 with his wife, the writer Ruth Walgreen Stephan (a Walgreen heiress), used the term "hereness" in his talk "Painter as Editor."[21] John Cage spoke about Zen in his "Lecture on Something and Nothing" on February 9, 1951, though Cage had previously lectured on "Nothing" in 1949 at Subject of the Artists, a short-lived artists' society.[22]

Zen specifically made an appearance at The Club in 1950 and 1951 through four Friday-night lectures.[23] Because of Suzuki's ongoing classes at Columbia University, there was so much buzz about Buddhism that Pavia's notes for 1952 summed up his new influences as "John Cage and Zen thinking."[24] In 1954 he organized a three-panel series on Zen. James Brooks remembers, "Zen came in pretty strong to The Club, and a good many members were very receptive to it because it emphasized the pure confrontation of things rather

than intellectualization. A great many people were interested in it. I certainly was at the time. There was a general feeling that we couldn't quite do it, that we were too Western. Some people thought it was silly, but I think it was taken pretty seriously at the time."[25]

The first lecture on February 26 was by the Japanese artist Saburo Hasegawa, who was introduced by Franz Kline. Hasegawa accompanied his talk with a slide show. The second lecture on November 5 was nicknamed "Hasegawa Zen" (or Zen I), presented by Mitsumi (Mike) Kanemitsu, an American-born Japanese painter who had studied with Fernand Leger in Paris. Kanemitsu painted gorgeous sumi-e ink paintings that were part traditional calligraphy and part abstraction.[26]

Zen II was presented on November 19 by Ibram Lassaw and moderated by Harry Holtzman.[27] The final lecture of this series, Zen III, took place on December 10, again moderated by Holtzman. John Cage and Ibram Lassaw sat on the panel with John Ferren. Though Lassaw had been attending Suzuki's classes since at least February 24, 1953, he did not practice Zen and felt he was not qualified to speak from experience. Instead he read from Suzuki's *Living in Zen: A Synthesis of the Historical and Practical Aspects of Zen Buddhism,* about the nature of satori. He chose a section in which a young monk begs his master to utter just one word about enlightenment. The master, after dropping a slight hint, turns around and, in that harsh way Zen has of breaking conceptual mind, castigated the student for being "deaf."

Suzuki's book emphasized that dualistic views were false. The idea that one's own consciousness creates one's universe was such a radical idea that it basically fell off the philosophical and religious map. Judeo-Christianity believed in "I and Thou," certainly not "I created Thou through my perception of Thou." Dr. Martha Jaeger,

introduced by John Cage, delivered a final lecture on Zen on January 14, 1955, titled "Zen and Psychoanalysis."

Lassaw's Investigations and Buddhist Phenomenology

Ibram Lassaw's personal journal entries were filled with insights from the psychedelics he was ingesting, something very few were involved with at the time. They chronicle his understanding of the dissolving of borders between subject and object placed squarely in the context of classical Zen "nowness," emphasizing no receiver and nothing to be received, as well as no hierarchy and no non-hierarchy. He felt he was an embodiment of action encased in form acting according to his own nature and karma. This does not imply he was enlightened; nor did it mean psychedelics were his sole means of inquiry. He knew that his role as an artist was to reveal this universal connection to others. Each sculpture was a representative, just like a calligraphic brushstroke, as *the thing as it is*. *The thing as it is* also paralleled the literary technique of "first thought, best thought," meaning the moment before conceptuality arises. When welding a sculpture with a oxy-acetylene torch, Lassaw focused exactly on what was in front of him so "no conscious ideas intrude themselves into the work."[28] He developed sculptural space as "greater and lesser densities of concentration."[29] He explored the lattices in Indra's net with a sculpture called *Akasa;*[30] made *Mandala,* a piece about "interiority" made out of polychrome plastic; and called another long, wiry piece *Mantra.* He sculpted *Tathata,* with freestanding forms locking and holding each other in a precariously balanced moment of time, and even wrote in his daybooks the "Sutra of Ibram Lassaw, the aesthetic appreciation of thusness."[31] In 1956, when he exhibited in Alfred Barr's *Twelve Americans* show at

the Museum of Modern Art, his statement in the catalog described how conceptual mind made him "blind" and in a "fog" as to the reality that was omnipresent all the time.

What did Lassaw mean that conceptual mind blinded him to the "now"? According to Buddhist phenomenology and psychology, there are five *skandhas* (heaps), or five stages of ego that stack on top of one another in about a sixtieth of a second in reaction to an experience. The first skandha occurs when the mind is absolutely open and spacious. Perception is fresh and direct, and there is no rigid self. This is *tathagata*, or "suchness." The second skandha quickly arises, trying to fill the space or void. This is the moment a person "feels" and solidifies the discrimination of "this and that," shutting down tathagata.

The third skandha, "perceptions and impulse," is when the ego strategizes on how to fill space through the filter of passion, aggression, or indifference. Indifference works like armor, numbing sensitive spots. Passion consumes, and the more impoverished one feels, the more it consumes. Aggression comes from feeling you can't survive and must ward off everything harder and faster. This happens rapidly, and intellect, cognition, and language aid the decision about what to accept and what to reject. The fourth skandha, "concept," categorizes the impulse or perception colored by an individual's environment, culture, and upbringing.

The division of all this mental labor needs a container, which is the fifth skandha, "consciousness." For many artists, this is the realm richest in fantasy, subconscious thoughts, and dreams. Meditation practice cuts through the cascade of all of these skandhas, enabling one to arrive back at "thusness." Thusness does not mean that form, feeling, perception, and consciousness disappear and the individual becomes a blob unable to do anything. Thusness is actually the abil-

ity to tie everything together without the distraction of background chatter and the thinking process, so things become what they are.

What need was Zen addressing for artists? Why was this happening at a time when American art had so recently formed its own identity? For many, belief in God had evaporated after the atrocities of war revealed the debased actions man could inflict on his fellow man. European existentialism spread its tentacles to America, proclaiming that every person was responsible for his or her own actions. Many despaired about the meaning of life. The East and particularly Zen offered a fresh way out of this dilemma. No one really knew how to meditate, but stories of enlightened Zen masters held a mystical and compelling place in many artists' imaginations. Instead of struggling for weeks in their studios to come up with the exact balance of form, color, and surface, the idea of "no thought" was compelling.

This brings up a thorny issue this book will not address: the relationship between mind, art, and neurosis.[32] For some artists, art was the way they climbed out of their neurosis and connected with the world. What Zen, or the idea of Zen, offered was a way to integrate life and art that did not buy into their neurosis. Chögyam Trungpa said, "Being an 'artist' is not an occupation, it is your life, your whole being. From the time you wake up in the morning, when the buzzer in your clock rings to get you up, until you go to bed, every perception you experience is an expression of vision—the light coming through our window, the hot water kettle boiling to make tea, the sizzling of the bacon on the stove."[33]

It Is

When Pavia stepped down as director of The Club, he published the magazine *It Is*. Zen thought was an important part of the magazine's

writings on art and critical theory. The first four volumes of *It Is,* from the spring of 1958 to the autumn of 1959, read like a "who's who" of the New York art world, with articles by Willem de Kooning, Ibram Lassaw, Philip Guston, Harold Rosenberg, and Morton Feldman. There were photos of work by Jackson Pollock, Arshile Gorky, Sari Dienes, Hans Hofmann, and Al Copley; unpublished writings of Piet Mondrian; essays on art and the role of the critic; and a review of Antonin Artaud's book *The Theater and Its Double.* In the second issue Stanley Breul wrote an essay called "Kill the Buddha," which asserted, "Zen is not Zen—Zen begins in Zen; passes through no-Zen; ends in neither Zen nor No-Zen."[34] The autumn 1959 issue featured Allan Kaprow's essay "The Principles of Modern Art," which explained his happenings. The painter Sari Dienes wrote an essay describing her recent trip to Japan and the country's deep-seated Zen sensibility. Cage, as a homage to Morton Feldman, published the entire text of "Lecture on Something."

Everyone in the art world read the journal. What were they to make of the statement, "Naked mind stripped bare. Undressed. Denuded of all its coverings—ideas, affectations, illusions, supports"?[35] With everyone jockeying for position and power, shows, sales, and prestige, the statement "if one attachment remains—bondage—the way of no way"[36] was certainly enigmatic. Zen had lodged into the substrata of the New York avant-garde.

Later in his life even de Kooning described his work with a Zen flavor: "I just didn't like those hard colors anymore; I had to come from No-color to Color, from No-paint to Paint, No-form to Form. Perhaps this connects me with Zen, where you come from No-mind to Mind. Maybe that's why I never keep track of my work. It actually keeps track of me; it haunts me; it's embarrassing. I don't keep catalogs. You have to start, over and again, from No-painting to

Painting. And as far as I'm concerned, other people can scribble whatever they want about it."[37]

The autumn 1959 issue of *It Is* featured Allan Kaprow's essay "The Principles of Modern Art," which explained his happenings. The painter Sari Dienes wrote an essay describing her recent trip to Japan with its deep-seated Zen sensibility. Cage, as a homage to Morton Feldman, published the entire text of a "Lecture on Something." Zen had lodged into the substrata of the New York avant-garde.

The Trinity: Saburo Hasegawa, Isamu Noguchi, and Franz Kline

Besides the Gutai and other Fluxus-style groups, there was an active and intentional exchange between the Japanese artist Saburo Hasegawa; the Japanese American sculptor Isamu Noguchi; and the American painter Franz Kline. It was a friendship that had produced deep and long-lasting implications.

Saburo Hasegawa

Saburo Hasegawa was born September 6, 1906, into a wealthy Japanese family. He learned English with a private tutor and started painting when he was thirteen years old. While still a high school student, he formed the "White Elephant Painting Group" to discuss theories of modern art. Graduating from Tokyo University in 1929, he wrote his senior thesis about Sesshu Toyo, the foremost Japanese sumi-e master and a Zen Buddhist priest. His interest in Zen deepened after he studied Sesshu, as did his appreciation of Western artists like Paul Cézanne. He believed Western artists expressed their search for the absolute through abstraction.

After graduation he traveled to New York, and from 1929 to 1932 he visited Italy, Spain, and England. With his new French wife, Viola, he lived *la vie bohème* in Paris. In 1932 he returned to Tokyo, becoming one of the first Japanese to write about the history of modern Western art. His own oil paintings were influenced by Europe, and he launched an artistic movement that broke from traditional Japanese styles by incorporating collage, photos, and assemblages. In 1937 he founded *Jiyū Bitjutsu,* or "Free Artists Group," and published *Abstract Art,* the first book in Japan on the subject. He wrote extensively about the relationship between the West and the East in terms of painting styles with essays on Mondrian, Kandinsky, Klee, Miro, Picasso, and Rousseau, as well as Japanese folk paintings and traditional classics. He also wrote on the Chinese artist Shih Tao and the Japanese master Sesshu.

During the military buildup of Japan, Hasegawa, adamantly against the war, refused to paint propaganda posters for the government. They retaliated by demanding that his "Free Artists Group" drop the word "Free" from their title. In 1944 the *Kenpeitai,* or wartime military police, briefly arrested Hasegawa for being "disloyal." Upon his release he went to a remote farm in an impoverished village on Lake Biwa, where he studied Zen, Taoist classics, and tea ceremony and painted haiku poems. After the war he returned to his European-influenced work and showed his pictures at the second "Modern Art Exhibition."

Isamu Noguchi

In 1931 Isamu Noguchi returned to Japan, where he had lived from the age of two until he was an adolescent, to see his estranged father, the famous Japanese imagist poet Yone (Yonejiro) Noguchi. The

elder Noguchi remarried when Isamu was quite young and had mixed emotions when dealing with his half-American, half-Japanese son. Isamu saw contemporary Japanese artists first embrace and then reject all things Western, a behavior that mirrored that of his own father, who had embraced America, had an American wife and a half-American son, and then rejected them.

Noguchi traveled to Zen temples and gardens throughout Japan accompanied by Sasamura, a young student who discussed Zen practice with him. He moved to the Higashiyama district of Kyoto, living modestly for five months and immersing himself in ancient ceramic techniques with master potter Uno Jinmatsu. He exhibited those works at the eighteenth Nikaten Exhibition in Tokyo.

In September 1931 Japan invaded Manchuria, and heightened political tensions forced Noguchi to return to New York. He turned his attention to sculpture, set design, furniture design, lamps, and public spaces, supporting himself as a portrait sculptor. When World War II erupted he was designing innovative theater sets for the Martha Graham Dance Company. In 1947 he created the set for *The Seasons,* choreographed by Merce Cunningham, magically recreating the illusion of dawn changing into dusk and evoking early spring by using magnesium flashes. But in 1948, when his good friend the painter Arshile Gorky committed suicide, Noguchi felt trapped in New York. He applied to the Bollingen Foundation for a grant to investigate "a reintegration of the arts toward some purposeful social end"[1] and was awarded a grant to view sites around the world that embodied principles of the "communal, emotional, and mystic."

Noguchi Meets Hasegawa

Noguchi arrived at Haneda Airport in Japan on May 2, 1950, as part of his Bollingen Foundation grant. Saburo Hasegawa was hired by *Mainichi Shimbun,* a Japanese newspaper, to translate for Noguchi and act as his guide. He was warmly received both as a famous American artist and as the son of a famous Japanese poet. Noguchi immediately handed Hasegawa a brown envelope containing nine photographs of the work of the New York–based painter Franz Kline that bore a striking resemblance to Japanese brush art. Hasegawa liked them so much he published them in Shiryu Morita's *Bokubi: Journal of Sumi Painting and Calligraphy,* a new magazine about contemporary Japanese calligraphy he was involved with. He went so far as to put Kline's painting *Hoboken,* with its bold and dynamic style, on the cover.

This meeting profoundly affected both men. Hasegawa wrote, "I had spent many hours worrying about the similarities and differences between modern art—especially abstract art—and *chado* [the art of tea], haiku, and calligraphy. The moment I met Noguchi, this worry vanished; I felt that a large path opened before my eyes."[2] Before that meeting Hasegawa had been in crisis, trying to "find something that can rescue us in the treasure box of Far Eastern tradition."[3] He struggled to incorporate the tea ceremony and flower arranging into contemporary art for the next generation. Before his encounter with Noguchi, he doubted himself and his ability to move forward.

At the end of May Noguchi was hospitalized with amoebic dysentery he had picked up while traveling through India. In the hospital he read R. H. Blyth's book on Basho's haiku and D. T. Suzuki's *Zen and Japanese Culture.* Hasegawa delighted in bringing his

new friend scrolls of paintings by Sesshu, the subject of his Tokyo University thesis.[4] When Noguchi recovered, they visited temples and gardens and engaged in long talks about Zen arts—calligraphy, poetry, literature, architecture, and tea ceremony. Noguchi delved into his Japanese heritage, and Hasegawa was brought up to date about developments in the United States. Noguchi's keen interest in Zen and classical arts spurred Hasegawa to reexamine his own culture with a fresh perspective.

Hasegawa introduced Noguchi to the calligraphy and poems of the esteemed but controversial Soto Zen priest Ryokan (1757–1831), who humorously referred to himself as Taigu, or "the great fool." His name, given to him by his Roshi Kokusen at the Entsu-Ji temple in Tamashima, translates literally as "good" *(Ryo)* and "wide" *(Kan)*. For twenty years Ryokan lived in a tiny hut at the base of Mt. Kugami in northern Japan. At age seventy he fell in love with the twenty-eight-year-old nun Teishin, also a poet. During their brief and infrequent three-year relationship they exchanged many verses, and Teishin tenderly held Ryokan in her arms as he was dying. Noguchi was thrilled to learn about Ryokan because he understood no-mind or "mu-shin."

Who says my poems are poems?
These poems are not poems.
When you can understand this,
then we can begin to speak of poetry.[5]

The two men also visited the Hōryūji Temple in Nara. Built in AD 607, it housed the world's oldest-surviving wooden structures and provided a glimpse of how Japan might have looked 1,300 years earlier. The Golden Hall had been painted with frescoes similar to

those of the Ajanta caves in India. Unfortunately, the frescoes had been destroyed in a recent fire. Hasegawa was too upset to gaze at the charred ruins, but Noguchi thought they were lovely and poignant. A reverent attitude for the scorched remains of a venerable site was an example of the Zen aesthetic of *sabi,* better known as *wabi-sabi.* *Wabi* is the yearning for simplicity, even ugliness. *Sabi* is an aching solitude coupled with imperfection and historical profundity. *Sabi* also means rust and *sabi-ya* loneliness. Hasegawa was touched by Noguchi's sensitivity to *sabi,* so much greater than his own. Embarrassed by the compliment, Noguchi quickly changed the subject. He spoke about the purity of heart of the painters Arp, Brancusi, Mondrian, Miro, and Klee. Hasegawa felt in that moment that the spiritual purity Japan had once prided itself on had now been transferred to the West.

They visited the "withered landscape," a dry Zen monastic garden *(karesansui)* of rocks and raked gravel at Ryōanji, built in the late 1400s. Enclosed by a Chinese wall, this small garden has only fifteen rocks and embodies the perfection of balance and harmony. Ryōanji inspired Noguchi to create his own garden and sculptural pieces, one named after the garden and the other, cast in bronze, titled *Lessons of Muso Kokushi* after the founder of the Zen garden.

Noguchi was so lost in reverie during his observations he felt "transported into a vast void, into another dimension of reality."[6] His friend observed Noguchi's absorption daily. One night, Noguchi relentlessly practiced brushstrokes with ink on rice paper. He asked Hasegawa to unroll a scroll painted by Sesshu "one more time," saying he wanted to sleep but instead staying awake to study the scroll. Though not a formal Zen Buddhist Noguchi realized, "With Zen, there is a more direct linkage [to art] than through other mystical forms. It is the spiritual as direct appreciation of the thing itself.

It is like a reverse linkage: you can't say whether art came from the spiritual or vice versa."

In August Noguchi worked at the Industrial Arts Institute close to Tokyo preparing works for a solo show, including the ten-foot-tall sculpture *Mu,* named after the koan. Resembling the base of a mushroom with the letter U on top of it, it was positioned on a cliff to exactly capture and highlight the rays of the setting sun. He called this effect "isometric triangulation," in which the eye was carried from one spot to the other until it seemed to encounter infinity. The Zen principles of emptiness, space, and tranquility came through its spatial interplay and sparse lines. Pulled between the need for robust form and reductive space, he felt that "an anti-materialist revolution is necessary, but I am not too sure that we need ... retire into yogihood ... When artists seek a reality beyond actuality, how many depths and how many truths separate the aesthetic and the religious?"[7]

Within a year after he met Noguchi, Hasegawa stopped painting European-style oil paintings and took up the traditional Japanese forms of ink, woodblocks, rubbings, and rice paper. He etched ink monotypes and abstractions into such unlikely surfaces as wooden tableware for fish-paste seasoning. Fascinated by traditional mediums like thatched roofs, bamboo fencing, house siding, and hammered bark woven into pillows, he searched for cast-off weathered wood to make India ink and paper rubbings. He wrote to Noguchi on January 12, 1951, "You were the first to encourage me in this line,"[8] adding that he felt this new way was his true destiny. On January 18 he wrote Noguchi that it was up to the two of them to "maintain the tradition and deliver it to our descendants. What used to be done by Religion has to be done alone by Art."[9] Within a small group of enthusiasts his return to tradition materials was

welcome. But in Japan it was seen as a step back to a more militaristic, nationalist time—certainly not his intent.

Kline Meets Hasegawa

Spurred by Noguchi's introduction to each other, Franz Kline and Hasegawa started corresponding. Hasegawa sent Kline the calligraphy magazine *Sho-no-bi* (Beauty of Ink), founded in 1948 and edited by Shiryu Morita. It showcased calligraphy in a modern light. In the May 1948 article "Like a Rainbow," Morita predicted that West and East, like the two "legs" of a rainbow, would one day meet at the highest arc and become one. Hasegawa wrote articles in *Sho-no-bi* about Noguchi, Mondrian, Jean Arp, and the French avant-garde. He launched his own column, "Alpha Section," dedicated to exploring the secrets of pure form in works that were not strictly calligraphic.

Kline wrote back expressing his deep admiration of Japanese and Chinese masters. He told Hasegawa he collected Japanese prints and books and loved to browse through the reproductions. He singled out the work of Hokusai (1760–1849), best known for his *Thirty-Six Views of Mt. Fuji,* and mentioned how moved he was when he saw a print for the first time in 1931 in the Boston Museum of Fine Arts as part of the collection assembled by the famed Orientalist Ernest Fenollosa.

Bokubi Magazine

Bokujiin-Kai (Human Ink Society) was formed on January 5, 1952, when five calligraphers met at Ryoanji Temple. Among them was Shiryu Morita, publisher of *Bokubi: Journal of Sumi Painting and*

Calligraphy. They wanted calligraphy to rise from its humble origins and take its place among the highest arts. *Tzai-bashi,* an ideological and artistic bridge connecting Eastern and Western culture, was birthed on the grounds of this esteemed Rinzai Zen temple in Japan.[10] Morita brought Hasegawa's "Alpha Section" column to encourage different "ways of seeing and creating" that would be useful for calligraphers. He was immediately opposed by reactionary factions of the *shodo,* or calligraphy establishment.

Hasegawa discussed Kline in an article titled "The Beauty of Black and White," explaining that the very instant Noguchi and he first met, Noguchi handed him nine photographs of Kline's "black-and-white gesture," telling him he could use the pictures whichever way he wanted but suggesting he put all of them in a "calligraphy magazine." Kline's work had changed dramatically between 1948 and 1950, breaking into wide swaths of swinging line and motion. The art historian April Kingsley refers to Kline's sparse painting style as "one corner" or "thrifty brush," a Zen style that stimulates the most pictorial space with the least amount of information. Kline used house painters' enamel brushes and sought to purify the white space in his compositions and simplify the black structures by removing any traces of gray. Was he trying to paint a Zen aesthetic? Hardly. Was he trying to refine a mature style for himself? Absolutely. He broke away from the caricatures and more illustrative drawings he had made in the early 1940s and refined the essence of line and gesture.

Hasegawa also wrote about the work of the painter Jackson Pollock, making reference to how he used the Japanese *gyo-so,* or "crazy quick stroke," type of calligraphy. Hasegawa reviewed Kline's second art show at the Eagan Gallery in *Bokubi* and kept Kline up to date on what was being said about him back in Japan.

Kline felt like they were "collaborating."[11] Morita personally sent Kline each new issue of *Bokubi,* and one of Kline's letters, published in the May 8, 1952, issue,[12] acknowledged receipt of the previous issue of the magazine. He said he had shown it to his friends, who had all clamored for his copy, and had given extra issues to his dealer, Charles Egan, and to George Wittenborn, the owner of a bookstore on East Fifty-Seventh Street.

In his article "On Looking at Mr. Kline's Latest Works: Impressions of a Calligrapher," Morita said that Kline's stroke was "concise" and fresh and that he was able to express exactly what he wanted to say—unlike Japanese calligraphers, who were "complicated," a bit jaded, and not as pure with their black-and-white work. He believed Kline pointed to the future. Kline was thrilled to be appreciated in Japan.

The Japanese were acutely aware of the similarities between Kline's work and their own experimental calligraphy. Inoue Yuichi, a member of Morita and Hasegawa's circle, questioned why *Bokubi* was having such an impact in America. He was stunned to see the West's fascination with ancient Eastern arts, especially simple ink paintings and calligraphy. Why were they so interested? He suspected Kline was influenced by the work he saw in *Bokubi*—an obvious misread since Kline's work had already graced the first cover of *Bokubi.*[13]

Western art critics, most notoriously Clement Greenberg in his 1955 essay "American-Type Painting," denied that any link existed at all between Kline and Japanese calligraphy. Later on in his career, Kline, too, vehemently and consistently disavowed any "Oriental" influence in his large black-and-white brushstroke paintings—a surprising denial, considering how involved he had been with Japan's new calligraphy movement.

Pure Stroke

Hasegawa understood his function as a bridge between the West and East. He believed Japan should be exposed to modern art and America should see the great masters of calligraphy. Calligraphic art was *Sei Do,* loosely translated as "living movement" or "silent movement," and is a principle also used in the martial arts. *Sei Do* embodied the contemplation of the artist upon the object with which he would interact. He had to see into its essential nature, which is the same discipline an accomplished martial artist uses when facing his opponent. In calligraphy once the brush touches the painting surface, there is no possibility of second guessing the stroke. It *must* be executed, and the artist cannot change its momentum. Referred to as a "controlled accident," it is also known in literary technique as "first thought, best thought."

The Japanese use two terms for art: *gei-jitsu,* meaning both aesthetic art and "skillful mastery," and the more ancient term *gei-dō,* or "the way of art," which implies an experience leading toward emptiness. Duality between subject and object disappeared, as did separation between art and the viewer. The Japanese were fascinated by modern art and debated it endlessly. Except for a handful of Americans, the same could not be said the other way around. Morita publicly railed against Jackson Pollock for his "physical intoxication" and complete misunderstanding of *gei-dō.* He felt Pollock was attached to the "materiality of paint" and had no concept of *mu* or "nothingness."[14] Thus, he was doomed to extinguish "the passion involved in his creative work," an astute assessment considering that Pollock died in a car crash while driving drunk. Pollock did not know what *mu* was; nor did he care. However, the question can be raised: if he had trained in the nature of emptiness

and *mu*, would he have continued on his path of self-destruction? We will never know.

Hasegawa in New York

When Hasegawa visited New York in 1954 to represent the Japan Abstract Art Club and to lecture at The Club, Kline hosted him in his own studio. Hasegawa delivered his first talk at The Club, about pre–Meiji era art, in February and was introduced by Kline. He spoke about the relationship between the "controlled accident" in Zen and spontaneous "action" painting, all the rage in the West. He believed one form could learn from the other: Japan could pick up on modernism, and the West should learn about the bare attention and mental focus that Zen offered. This bare attention manifested itself as the simple, direct stroke freed from pretension and technical dazzle. After he spoke he was peppered with questions from the eager audience. In November the printmaker Matsumi (Mike) Kanemitsu gave a talk at The Club about Hasegawa's relationship to Zen.

Hasegawa had a solo show at the New Gallery in January 1954 that was well received. It was noted how he used traditional Japanese designations of spatial design in a unique way. He was deemed an important figure in contemporary Japanese art and black-and-white figure-ground interface.

The Museum of Modern Art

On March 16, 1954, the Museum of Modern Art, in conjunction with the American Abstract Artists, presented a panel on Zen and abstract Japanese art called "Abstract Art around the World

Today."[15] It was described as "the first broad selection of contemporary nonfigurative works from the Orient to be shown in the United States." Hasegawa, dressed in a traditional kimono, was flanked by Josef Albers, Alfred H. Barr Jr., Sam Hunter, Franz Kline, Aline Louchheim, and George Morris. Henry Botkin moderated the discussion, saying, "I am inclined to believe that he did come from Tokyo, in a kimono." Hasegawa replied, "Ladies and gentlemen, I came here this evening in a costume almost perfectly formal."[16]

Barr said Japan had influenced Whistler, Monet, and van Gogh and added, "The calligraphic tradition of beautiful writing in Japan has been very much appreciated by some of our painters such as Mark Tobey and Mr. Kline himself."[17] Barr noted the "parallel between the rectilinear structure of Mondrian and Japanese architecture." Hasegawa told the audience a Zen story. "Once" he said, "two young monks on their way to buy iron noticed a flag flapping in the wind. One said, 'The flag is moving,' and the other said, 'No, the wind makes the flag move.' A senior monk who was on his way to buy gold walked by and overheard them talking. He intervened. 'You are both incorrect,' he said. 'It is your heart, your mind, which is moving.'"[18]

Hasegawa said the gold in the story was like abstract art, and when the story was repeated to other Zen monks, one of them just could not figure it out. He thought about it for several years as he pounded rice. One day he understood the meaning, and it caused him to stay in the same position for seven years. Hasegawa compared abstract art to that one moment of understanding the actual meaning. He said, "Zen was one of the philosophies that influenced the development of all abstract art." At the same time, he rued the waning of Zen influence in his own country, attributing it to the "modern Japanese."

Kline acknowledged the difficulty of interpreting abstract art. He agreed with Hasegawa's stories. He shared his own struggles of trying to find out where art was located. He believed it did not live in the museums, but in the center of one's being: "The reality that comes from the Zen Buddhist ... [also] comes from the calligrapher."[19]

Someone asked Hasegawa if there was an audience for abstract art in Japan. He replied he had been trying to expose the Japanese to the modern art of Mondrian for the past twenty years but still hadn't succeeded. He attributed this difficulty to Japan's being "a very enclosed country for a long time." When asked if there was any ancient abstract art of Japan, Hasegawa mentioned white sand gardens with little walkways and "calligraphy, especially by Zen priests." He explained he had shown Noguchi around Japan after a twenty-year absence. They were at a rock garden, and Noguchi was so moved he could barely breathe. He whispered, "Mr. it is terrific."[20] At the Tokyo Museum, they admired a particular calligraphy. Hasegawa could read the Japanese inscription, but Noguchi could not. After leaving the museum, Noguchi asked what the words meant, and Hasegawa told him "death." Noguchi added that it was "great death," emphasizing just how magnificent the calligraphic interpretation of the word was.

Barr summed up the panel by saying cultures intermingle and art is the expression of society and its complex forces. It was a hastily conceived and simplified coda to an intricate question that the panel raised but did not have time to answer.

From June 23 to September 19, 1954, MOMA showed forty works by the thirty-five leading abstract calligraphers of Japan for the first time in America. The exhibit focused on the freestyle stroke over the literal calligraphic word and was referred to in the museum's press

release as "word paintings."[21] In *Arts Digest*, critic Dore Aston said that the East was a "new way" that was "permanently with us," and that the West had an "embarrassing ignorance of Oriental culture."[22]

Hasegawa exhibited in a solo show at Gallery Contemporaries in the spring of 1954, though it was not widely written about. He lectured extensively around New York and New Jersey,[23] thrilled to be explaining the great works of Japanese masters like Basho and Sesshu and discussing techniques of spontaneous brushstrokes. Everywhere he went—especially downtown—someone would talk his ear off and occasionally ask him about Zen. He spoke about Japanese art with those who were interested in it and about Western art with those who were not.

Although his Japanese friends found his interest in tea ceremony quaint, Hasegawa graciously demonstrated the ceremony taught to him by So-shu of the Kankyu-an school. John Cage and Ibram and Ernestine Lassaw were invited to participate in Hasegawa's tea ceremony and were moved by its precision and delicacy. Of all the people he had met in New York, he felt Lassaw, Kline, and Cage were the ones who most understood Japanese culture and art. He was fully aware that Lassaw was both a devoted student of D. T. Suzuki and an avid reader of all things Zen and that Cage was becoming known among a small group of progressive Japanese.

When he left New York to return to Japan, he intended to come back. According to Noguchi, when he did return to Japan, he discussed Zen practice with artists. Because of its association with the militarists and the war, however, they asked him, "What are you talking about?"[24] Feeling out of step with his country, he wound up in San Francisco, teaching at Alan Watts's American Academy of Asian Studies. From 1955 onward he lectured in art history at the California College of Art and Crafts.

The Chinese American painter Bernice Bing studied with Hasegawa at the California College of Arts and Crafts starting in 1957. Hasegawa prodded Bing to think what it meant to be an Asian woman artist. He always wore traditional Zen robes to class, and "he would tell stories about how he would sit zazen and how he would get whacked on the back for falling asleep."[25] He made everyone sit in the same seat for the whole semester and even made the class's model stay in the same position all semester. They drew the same thing over and over until it was "etched" in their brain and learned color theory from origami paper.

Alan Watts introduced painter Gordon Onslow Ford to Hasegawa. Wearing a brown kimono, Hasegawa went for a silent two-hour walk with Ford in Muir Woods, the redwood forests of Mill Valley. They wound up at Ford's studio, and Hasegawa said he wanted to paint calligraphy. From the sleeve of his kimono he removed "a two-hundred-year-old ink wrapped in a brocade, an ink stone, a roll of paper, and a brush."[26] Placing flat stones on paper to hold it down, he spent a long time just grinding ink. Suddenly and decisively he painted the character for infinity. Ford invited some friends to visit, and for a week Hasegawa kept painting, leaving Ford exhausted but enthralled with calligraphy.

Hasegawa never saw the fruition of his influence. In 1957 he died prematurely, at the age of fifty-one. His funeral, arranged by Alan Watts and Dr. Kazumitsu Kato, a Soto Zen priest, was held at the Sokoji Soto Zen Temple in San Francisco, California.

The Beats: Remember the Tea

I think American Buddhism is in great debt to the Beat generation.
—GARY SNYDER[1]

Gelek Rinpoche told me, "You people: Burroughs, you, Kerouac, will all go to heaven for introducing the dharma to this country."
—ALLEN GINSBERG[2]

Jack Kerouac first met D. T. Suzuki on his way to a book party that Viking Press was throwing to celebrate the release of his novel *On the Road*. He felt vindicated, that late summer day in 1957, because after years of delay and exasperation, his 120-foot-long, single-spaced, spontaneously typewritten manuscript was finally being published.

He called the Buddhist scholar from inside a glass-and-wood phone booth while his two close friends, the poets Allen Ginsberg and Peter Orlovsky, anxiously paced outside wearing "big serious faces of dharma."

"Hello, I'd like to meet with Dr. Suzuki. This is Jack Kerouac, the writer," he said.

"How long will you be in town? When can we arrange the appointment?" Mihoko Okamura, Suzuki's Japanese-American secretary asked.

"Right NOW!" Kerouac bellowed into the receiver.

Okamura retired into the "big back secret whispering chambers," came back, and told him to be there in a half hour. Elated, the three friends literally skipped down First Avenue to hail a cab.

They located Suzuki's apartment building on the Upper West Side at 172 West Ninety-Fourth Street, wedged between "Puerto Rican slums," found his nameplate on the door, and rang the buzzer. There was no answer. Kerouac rang again, very firmly, three times. Finally Suzuki appeared, slowly descending the staircase, his signature bushy eyebrows flying out on either side of his head like a "bush of the dharma that takes so long to grow but once grown stays rooted."

On the way up to his apartment they passed by entire walls packed with books written in many languages and entered a simple room. Suzuki pulled out three chairs and motioned to them, saying, "You sit in this chair, you sit in this chair, and you sit in this chair." They did, and fell silent. Suzuki pulled out a chair for himself from behind a table piled high with books.

Kerouac couldn't contain himself any longer and blurted out, "Why did Bodhidharma come from the West?" Suzuki said nothing. Kerouac then composed a koan: "When the Buddha was about to speak, a horse spoke instead." Suzuki looked at him quizzically, waited a moment, and replied, "The Western mind is too complicated." He then said, "You young men sit here quietly and write haikus while I go and make some powdered green tea."

He returned with a tray of old cracked soup bowls filled with steaming hot tea that he "brushed." Kerouac mentioned that his two friends from the West Coast, Philip Whalen and Gary Snyder, also drank green tea, but only out of sleek, curved, black lacquered bowls. He said the tea tasted like thick pea soup and made him high.

"That's the weak one, you want some strong ones?" Suzuki asked, mentioning that he drank it daily. Ginsberg shouted, "It tastes like shrimps." He had to yell "shrimps" because the scholar's hearing was so bad, even though Okamura had instructed them not to shout. Suzuki decided the tea tasted like beef and added, "Don't forget that it's tea."

Ginsberg and Suzuki talked about "a famous old print with the crack in the universe," and Orlovsky added, "You have an interesting crack in your wall that looks like the void." The crack was situated behind a statue of the Buddha on the mantelpiece. Suzuki duly replied, "Oh yes, I never noticed it before." He then showed them pictures of different Chinese poets, including Han Shan. Orlovsky laughed his "funny moaning laugh," and Kerouac felt inspired enough to write a new haiku.

Three little sparrows
on the roof
talking quietly, sadly

This spurred all of them into a spontaneous writing session, with Kerouac and Ginsberg choosing the same topic,

Big books packaged
from Japan—
Ritz crackers

because right in front of them was a big red box of Ritz crackers, sitting underneath a shelf of books from Japan.

Feeling more relaxed, Kerouac mentioned that he had experienced "some samadhi—a half hour or maybe three seconds." Ginsberg

asked Suzuki who the "Bodhisattva" was who constructed the first Buddhist temple in San Francisco's Chinatown, and Suzuki adroitly replied, "I think they were all Bodhisattvas."

Finally it was time for them to leave to go to Kerouac's book party. By now Kerouac felt like Suzuki was his "old fabled father from China" and said, "Dr. Suzuki! I'd like to spend the rest of my life with you." Suzuki responded, "Sometime," and pushed them out the door, but once they were out on the sidewalk, he wouldn't let them leave. He shook his finger back and forth and shouted, "Remember the green tea!" Kerouac yelled, "The key?" and Suzuki shouted back, "The tea!"[3]

That moment did hold a "key." Suzuki, an authentic representative of Japanese Zen Buddhism, had met Kerouac, Ginsberg, and Orlovsky, who advanced the Beat craze with its concurrent literary cult through their works. Suzuki, to his credit, understood the importance of these young men. He wrote, "The 'Beat generation' is not a mere passing phenomenon to be lightly put aside as insignificant. I am inclined to think it is somehow prognostic of something coming, at least, to American life."[4]

Suzuki was interested in Kerouac because the American writer had dedicated his previous book, *The Dharma Bums,* to the Tang Dynasty Zen (Ch'an) poet Han Shan, a great figure in Chinese cultural literature. But Suzuki also believed the young men had "not yet quite passed through their experiences of humiliation and affliction and . . . revelation."[5]

The "key" was part of Ginsberg and Kerouac's search for a "new vision," through which they birthed a spontaneous literary form inspired by ecstatic and mind-numbing trips across America, jazz music, sordid swindles, drugs, homosexuality, adultery, suicide, and even murder. They burned for something unique that had never been

realized in the West before, seeking to transform the very fabric of their being.

Suzuki shared his feelings with Okamura about these young men. He thought Kerouac's biggest flaw was that he "misunderstood the essence of freedom . . . Freedom is from Dr. Suzuki's point of view [working] in the harness . . . and [Kerouac was unable] to overcome all of that and to understand it."[6] According to Okamura, the point where the Beats fell short was in misunderstanding the essential Zen point that we are already free, and "it is the human mind that thinks we are not free . . . To look for freedom outside of our own original freedom is already an aberration of the mind . . . We are not apart in the original state." She felt the Beat generation thought they had to "liberate themselves from what was totally unnecessary." Suzuki noted, "They are struggling, still rather superficially against democracy, bourgeois conformity, economic respectability, conventional middle-class consciousness, and other cognate virtues and vices of mediocrity. Because they are still 'rootless'. . . they find themselves floundering in the mud in their search for 'the only way through into truth [which] is by way of one's own annihilation: through dwelling a long time in a state of extreme and total humiliation.' They have not yet passed through their experiences of humiliation and affliction, and, I may add, revelation."[7] The poet Gary Snyder said, "Though it's a charming thought, DTS had almost no influence on the 'spontaneity' element in the writing of Kerouac, Ginsberg, & me. For Jack it came through his understanding of jazz musicianship. Ginsberg picked it up from Jack. I got it from Jack plus R. H. Blyth's view of haiku. Suzuki's writings reaffirmed some of that, but Sokei-an's writings (which I read almost as early as Suzuki) also always stressed traditional hard training—which is what Zen means to most Americans today."[8]

Visiting Suzuki was also part of a long process to find a "new vision." Kerouac expressed this sentiment in a September 1945 letter to Ginsberg: "I was telling Mimi West last summer how I was searching for a new method in order to release what I had in me, and Carr said from across the room, 'What 'bout the new vision?' The fact was I had the vision . . . I think everyone has . . . What we lack is the method."[9] The method he was grappling with was how to drill down deep into the nature of raw consciousness and transform it into a unique literary form.

Decades later Ginsberg addressed this search specifically in an interview with the *Shambhala Sun*. "So we began talking about what, in 1945, we called 'New Consciousness,' or 'New Vision.' As most young people probably do at the age of 15 to 19, whether it's punk or bohemia or grunge or whatever new vision adolescents have, there is always some kind of striving for understanding and transformation of the universe, according to one's own subjective, poetic generational inspiration."[10]

By the time he met Suzuki, Kerouac had begun studying the dharma on his own. He had experienced the innate nature of his own mind numerous times but had no one to guide him, only a few books to read and a smattering of friends to talk to about it. But once Kerouac's literary reputation was assured and fame overwhelmed him, his interest and devotion to Buddhism faded. Through a combination of alcoholism and long bouts of living with his overprotective mother, he returned to the Roman Catholicism of his youth. But before he was through, his inquiry into the dharma changed the lives of Ginsberg, their circle of mutual friends, and generations all over the world.

The Blake Vision, and the "New Vision"

In the summer of 1948, Allen Ginsberg sublet a small sixth-floor apartment from fellow student Russell Durgin on East 121st Street in Harlem and led a retreat-like existence. Most of his friends had departed on their summer vacations or moved abroad. His greatest sustained contact with the outside world came from a menial job two hours a day as a file clerk at the American Academy of Political Science.

In a series of poems, *The Book of Doldrums,* Ginsberg chronicled his overweening existential angst. One early summer evening, having just masturbated, he lay contentedly spent and stared out his open window, surveying the intricate shapes of the rooftops of Harlem. A book by the poet William Blake lay on his lap. Out of nowhere a "deep earthen grave voice"[11] began reciting Blake's poem "The Sunflower," and it became an "auditory hallucination":[12]

Ah Sunflower! weary of time,
Who countest the steps of the sun;
Seeking after that sweet golden clime,
Where the traveler's journey is done;
Where the youth pined away with desire,
And the pale virgin shrouded with snow
Arise from their graves and aspire
Where my sunflower wishes to go.

The "tender and beautiful voice"[13] he heard "was Blake's voice."[14] He understood he was experiencing the exact same perception Blake had experienced a century before, of an unfurling of raw consciousness. Poetry, the language of vision, linked him

135

back though time with other visionary poets. He had been born just for that moment and no other reason. The fact that he existed was proof for his being on earth. He was experiencing the "spirit of the universe."[15] The whole world was contained within the sunflower, expanding outward to contain the poem and all of consciousness itself.

Several minutes later the voice intoned another Blake poem, "The Sick Rose":

O rose, thou art sick!
The invisible worm
That flies in the night,
In the howling storm,
Has found out thy bed
Of crimson joy:
And his dark secret love
Does thy life destroy.

Doom was as necessary as glory; both were valid, and both had their place.

Ginsberg yearned for the infinite. Gazing over the Harlem rooftops and seeing the "intelligent labor" that went into making the buildings, he realized the world was not made of "dead matter" but living intelligence. This intelligence was ancient and connected him back to the beginning of time. But he had no formal or informal vocabulary for what he saw, thinking it was "God" or "Light." He crawled out his fire escape and tapped on his next-door neighbor's window, declaring that he had just seen God. The two girls inside reacted in typical New York fashion by slamming their windows shut, despite the steamy summer heat. None of his friends were in town, so there was no one

to turn to. He read the books strewn about him—Plato's Phaedrus, St. John, and Plotinus—and saw divine messages in all their texts. Trying to control this buoyant feeling, he stood in his kitchen and called upon the "spirit" to make him "dance" like "Faust calling up the devil," but his elation rapidly deteriorated into terror. In an early book of poems, *The Gates of Wrath: Rhymed Poems, 1948–1952,* he tried recapturing these ecstatic feelings in a larger work he titled "Vision 1948." Ginsberg kept trying to recreate his experience from 1948 until 1963, when he met the Tibetan Ningyma Lama Dudjom Rinpoche in India. When he told Rinpoche about both his spontaneous visions and his subsequent psychedelic drug experiences, Rinpoche advised him, "If you see anything horrible, don't cling to it. If you see anything beautiful, don't cling to it." Hearing that, Ginsberg gave up grasping after the original experience, though he never renounced its mind-boggling effect.

The day after Ginsberg's visions, heaven flipped straight into hell. While browsing through Blake's *The Human Abstract* in the Columbia University Bookstore, the shift of consciousness came again but with a different slant. Everyone in the bookstore appeared "wounded" and like a "neurotic pained animal." He felt he was walking around in Blake's London and seeing "marks of weakness and marks of woe." The bookstore clerk's face resembled a tormented giraffe, and everyone appeared to hide a secret awareness of cosmic consciousness and knowledge of their looming death. Habitual conduct and stratified social protocol blocked these revelations from permeating their everyday sensibilities.

About a week later, as he walked to the Columbia library, it happened again. "I started invoking the spirit, consciously trying to get another perception of cosmos."[16] And he did, but this time was more frightening than the last: it was a "serpent fear"[17] comparable

to the "hand of death." It was only years later Ginsberg acquired the vocabulary to describe his experience. "And I had a sense of the black sky coming down to eat me. It was like meeting Yamantaka without preparation, meeting one of the horrific or wrathful deities without any realization that it was a projection of myself or my nature. I tried to shut off the experience because it was too frightening."[18] Yamantaka, the lord of death, is a *Mahakala* or wrathful deity in the Tibetan Buddhist pantheon. Yamantaka is a Sanskrit word consisting of *Yama,* "the lord of death," and *Antaka,* or "one who ends." Yamantaka is one of the eight protectors of the teachings of the Buddha and an aspect of Manjushri, the Buddha of intelligence and wisdom.

In the 1940s there was no understanding of the pantheon of wrathful deities in Tibetan Buddhism. An overweening dread or horror as an archetype could only be described in pathological terms. Ginsberg intuited that his vision was not insanity, but a new perception of reality. However, Ginsberg wept, and Kerouac wrote in his diaries that it was because he believed "nobody wanted to hear his new 'silence and transcendence' visions." Kerouac pointed out that since they were silent, they could not be spoken about, and how could you understand that which was not spoken? However, he admitted "the Big Truth hovered near, touching us almost with its unknown wings."[19]

Ginsberg's intuitions and insights were prescient. In 1959 he told the journalist Alfred Aronowitz that the Beat generation were "prophets howling in the wind" against the insanity and conformity they saw around them. But nobody thought Ginsberg was a prophet that summer of 1948, and many (most notably his father Louis) doubted his sanity. Ten years later Aronowitz gutted the whole meaning of "Beat" when he published his twelve-part series titled

"The Beat Generation" in the March 9, 1959, issue of the *New York Post*. He called them "lost, furtive, not in touch." This became the de facto media definition, but Kerouac clearly stated "Beat" meant "religiousness, a kind of second religiousness." Ginsberg called Beat "a certain nakedness, where you see the world in a visionary way, what happens in the 'dark night of the soul.'" But how could a first, almost-crazed glimpse of the "new vision" lead to the creation of a literary, social, and artistic movement?

I Take Refuge

In 1952 Kerouac crooned the Buddhist refuge vows to Ginsberg in Pali, the ancient language that predated Sanskrit. He recited the words in the manner of a Sinatra love song:[20]

> *Buddham Saranam Gochamee*
> *Dhamman Saranam Gochamee*
> *Sangham Saranam Gochamee*
> *I take refuge in the Buddha*
> *I take refuge in the Dharma*
> *I take refuge in the Sangha*

Later in his life Ginsberg defined the "three jewels," explaining that Buddha was the awakened clear mind, dharma was the intellectual explanation of that awakened mind though sutra discourses, and sangha was the group of "fellow awakened meditators."

Kerouac's Pali crooning session inspired Ginsberg to browse through the New York Public Library collections of Chinese paintings of the Song period. He let himself drift into the spaciousness of the calligraphic brushstroked landscapes and wrote a poem,

"Sakyamuni Coming Out from the Mountain," based on a twelfth-century painting by Liang Kai, imagining what it must be like to emerge fresh from the moment of enlightenment.

he knows nothing
like a god: shaken *like a god:*
 shaken
meek wretch-
 humility is beatness
 before the absolute
world.

He checked out Suzuki's book *Zen Buddhism* and wrote to his friend Neal Cassady that Suzuki was an "outstanding 89yr old authority now at Columbia who I will I suppose go see for interesting talk."[21] He came to the conclusion that satori, or Zen enlightenment, was similar to his initial Blake vision, later saying that it "seemed to be the right fitting word for what I had actually experienced so that I got interested in Buddhism."

The Road

One year after Ginsberg's Harlem vision, Kerouac and his friend Neal Cassady, a former car thief and small-time huckster, drove across America in a frenzied jaunt as "two broken-down heroes of the Western night," searching for, among other things, their version of a "new vision." These trips were later immortalized in Kerouac's books *On the Road* and *The Dharma Bums* as a spontaneous stream of consciousness, an energetic, unedited ramble. Ginsberg employed that same approach in his writing, calling it

"first thought, best thought."[22] He realized that his poetry and Kerouac's prose were rooted in an "examination of the texture of consciousness." He tracked his mind through spontaneous prose and the "actual sequence of thought forms." In 1994, when dedicating the Ginsberg Library at Naropa University in Boulder, Colorado, Ginsberg amended his view on "first thought, best thought." He said "there is a silence which exists through the words. Instead of 'first thought, best thought,' do 'first thought, no thought' and see what comes from that."[23]

According to the musician and composer David Amram, who worked with Kerouac and Ginsberg on the movie *Pull My Daisy*,[24] "Jack was … always looking and searching, and he felt that life was a journey … a kind of endless trip on that road to enlightenment and salvation. When he spoke about the holy path I think that he was thinking almost in terms of the life of Buddha … an experiential way for anyone to live first for themselves, and then in terms of their own journey how to relate to others on the way; with humbleness and love and sincerity and self-effacement and consideration and compassion."[25]

The 120-Foot Long Scroll

Cassady asked Kerouac to teach him how to write fiction. As part of his tutorial Cassady whipped out a stream-of-consciousness missive referred to as the "Joan Anderson letter," named for his girlfriend at the time. The letter was a revelation dropped into both Kerouac's and Ginsberg's laps, containing techniques to capture their nonstop, spontaneous ramblings. The effect on Kerouac was mind-boggling, giving him the internal permission to shed the more formal style he had used in his first novel, *The Town and the City*, and compelling

him to write the book that had been percolating inside him for over four years.

Kerouac mentioned this pivotal letter in a discussion with Al Aronowitz, saying, "I changed my style from *The Town and the City* because of Neal—Neal Cassady. Because of a forty-thousand-word letter that Neal wrote me. He wrote me a *forty-thousand-word letter!* But Allen lost the letter, or Gerd Stern did, actually. Gerd Stern, he lived on a barge in Sausalito. He lost that great letter, which was a work of literary genius. Neal, he was just telling me what happened one time in Denver and he had *every* detail. It was just like Dostoyevsky. And I realized *that's* the way to tell a story—just tell it! I really got it from Neal."[26]

Through Ginsberg Kerouac met twenty-year-old Joan Haverty and in a whirlwind courtship married her. Then on April 2, 1951, he began a nonstop, twenty-one-day typing binge on an elongated scroll of tracing paper helped by prodigious amounts of caffeine and, some argue, speed.[27] He wrote "without consciousness" in a semitrance, using phrases that sounded like ambulating jazz riffs. He typed on one continuous 120-foot roll that he had pasted and taped together from separate twelve-foot-long strips. He typed without paragraphs, occasionally crossing out words, phrases, and even whole lines with a pencil.

Years later he showed Aronowitz the scroll and told him, "It's a hundred feet long. I wrote *On the Road* on another roll . . . a roll of . . . drawing paper that you draw through. For *Dharma Bums* I could afford the teletype roll. Three dollars . . . *On the Road,* I gave that roll to Viking. It was all no paragraphs, single-spaced—all one big paragraph. I had to retype it so they could publish it. Do people realize what an anguish it is to write an original story three hundred pages long?"[28]

In June, after completing his creative maelstrom, he left Joan and moved into his friend Lucien Carr's loft to keep revising *On the Road*. He then joined William Burroughs in Mexico to work on expanding his writing technique. In a letter to Cassady dated May 1952, he mentioned that his friend Ed White had suggested he "sketch in the streets like a painter but with words . . . Now here is what sketching is . . . everything activates in front of you in myriad profusion, you just have to purify your mind and let it pour the words . . . and write with 100% personal honesty both psychic and social . . . and slap it all down shameless, willy-nilly, rapidly until sometimes I got so inspired I lost consciousness I was writing. Traditional source: Yeats' trance writing, of course. It's the only way to write."[29]

By 1953 Kerouac had finished typing his novel *The Subterraneans* in three twenty-four-hour stints of nonstop "bennie" (Benzedrine) popping. Not sure what to do next, he played with the idea of living in nature and went to the library to find out how to do it. At first he read Thoreau's discussions of Hindu philosophy and then accidentally checked out *The Life of the Buddha* by Ashvagosa. It was through this accident that Kerouac discovered his profound and serious interest in his "second new religion." Although he never renounced Roman Catholicism, which was the religion of his birth, all those cross-country journeys depicted in *On The Road*, all that playful Sinatraesque crooning to Ginsberg, blossomed into his "road of dharma," or Buddhist path. His detailed studies of Buddhism were completed before *On the Road* was ever published. He tentatively called his studies "Book of Dharmas," a collection of handwritten and typed pages begun as notes he prepared for Ginsberg to use as a Buddhist primer. Viking Press published these notes posthumously in 1997 as *Some of the Dharma*.

Some of the Dharma

I still remember the first real dharma instruction I got from Kerouac..."All conceptions as to the existence of the self, as well as all conceptions as to the nonexistence of the self, as well as all conceptions as to the existence of a Supreme Self, as well as all conceptions as to the nonexistence of a Supreme Self, are equally arbitrary, being only conceptions."

—ALLEN GINSBERG (NAROPA INSTITUTE WEBSITE)

In 1954 Kerouac went to the library in San Jose, California, and checked out Dwight Goddard's *A Buddhist Bible.* He began a serious reading of that text, as well as readings in the Bhagavad Gita, yoga precepts, Vedic hymns, Buddhist sutras, and the writings of both Lao Tzu and Confucius. He poured over the Theravadin (original teachings) and Mahayana (later teachings) texts and briefly touched on Vajrayana (secret teachings), including those of the great yogi hermit Milarepa. He took notes, quickly amassing a hundred or so pages.

All three of the *yanas* or "vehicles" work with conflicting emotions, referred to as *kleshas,* or "heaps" of obscurations. The Theravadin approach recognizes the kleshas and fights against them by applying different mental antidotes. In the Mahayana the kleshas are taken along the path and worked with by deep examination and using different skillful methods to loosen attachments. But the Vajrayana transforms the kleshas into wisdom by working with them as part of one's nature, a very tricky thing to do without the guidance of an experienced teacher.

Ginsberg, coming from an ex-Communist, Jewish, intellectual background, felt conflicted when he heard about the First Noble Truth. He believed in a vague universal improvement of the human

condition and felt insulted when Kerouac told him over and over again the truth of suffering, though a scant two years later he admitted Kerouac's wisdom. Viewed through the lens of his terrifying experiences at the Columbia University bookstore, when everyone's faces transformed into masks of suffering, it shows tremendous denial. Kerouac was the first one to place Ginsberg's visions squarely into a context other than pure insanity.

Kerouac wrote Ginsberg on May 1954, "I have crossed the ocean of suffering and found the path at last. And am quite surprised that you, innocent, novice-like, did enter the first inner chamber of Buddha's temple in a dream."[30] He began teaching him as if he were the innocent novitiate and told him that he had been compiling notes on Buddhism for Ginsberg's personal edification: "Now Allen, as Neal or Carolyn can tell you, last February I typed up a 100-page account of Buddhism for you, gleaned from my notes, and you will see proof of that in several allusions and appeals to 'Allen,' and I have that here, if you really want to see it, I will send it importantly stamped, it's the only copy, we must take special care with it, right? 'Some of the Dharma' I called it, and it was intended for you to read in the selva."

Kerouac also advised that Ginsberg should listen to his words as if it were "Einstein teaching you relativity," a terribly overblown statement. He assigned him nine books to read, including those of Paul Carus, who started Open Court Press and was the first employer of D. T. Suzuki in the West. He also told him to read the Harvard Asian Classics, Buddhist legends, the life of the Buddha, and even the original *Vissudhi Magga* by Buddhaghoshna, the earliest scriptures of the Buddha translated from Pali. He commented on certain books in the list, making sure to let him know which points he considered essential.[31]

While in California after a silly quarrel with Cassady, Kerouac packed his belongings and moved into a fleabag hotel in San Francisco. Drinking heavily, he completed the poem "San Francisco Blues" but quickly turned his focus back to New York.

Back East

Kerouac moved in with his mother, Gabrielle Ange Levesque Kerouac, who was living in Richmond Hill in Queens, New York. Memère, as she was known, worked in a shoe factory. Kerouac handed over his unemployment checks to her and led a quiet life studying Buddhism and attempting to follow a real spiritual path by reading the early sutras oriented toward monastic practice. Burroughs did not agree with what Kerouac was doing and cautioned if he went too far he would resemble the Tibetan Buddhist monks who walled themselves into a small cell with a slot where their food was pushed in and they remained until they died.

Kerouac's highly attuned but flawed sensibility conflicted with his battle with alcoholism, which eventually caused his death. In another era when teachers were more available, he might have integrated his flaws into his spiritual path. Buddhism's scope is broad enough to encompass the wisdom of the drunk Zen master or the overindulgences of the sixth Dalai Lama, who drank and consorted with women. The tantric tradition allowed for all types of people because it worked with Bodhicitta, the basic nature of mind. But was Kerouac really a Buddhist? According to Aronowitz, Kerouac wistfully mused, "Was I a Buddhist then? Well, I couldn't be—a Buddhist has got to be alone." He laughed at the thought. "A night club Buddhist!" Then he reflected for a moment. "Ahhh, I was a Buddhist, yeah . . ." He added, "I'm not interested in politics. I'm

interested in Li Po. *He* was a Dharma Bum type, a poor poet roaming China. You know, I have some eighteen-year-old writings that are pure Buddhism. I'm thirty-seven now. My birthday's March 12. So I've always been a Buddhist."[32]

In his 1961 *Book of Dreams*, published by City Lights Books, Kerouac mentions waking up to see the ghosts of his dreams fading from consciousness and scurrying to write them down as quickly as possible. He noted that his subconscious mind, which he referred to by its Sanskrit name *manas*, worked through the *alaya vijnana*, or original storehouse of mental cognition. That he could actually discriminate these subtle points was astounding, as his was a perception usually experienced only by long-term meditators.

Kerouac then moved down south with his sister to Rocky Mount, North Carolina. He studied the Diamond Sutra, which said all things, even his asceticism, were a dream not to be grasped. He wrote a list of the stages he would go through to reach Nirvana by the year 2000, starting with a "Modified Ascetic Life." He would stop chasing women, relinquish alcohol, and simplify his diet. The following year he would stop shaving, quit writing for ego gratification, and renounce his name. By 1970 he would have no possessions and go begging in the villages. By 2000 he would be in "Nirvana and willed earth beyond death." But his resolve did not last long. With a scathingly critical eye turned foremost on himself, he said in a letter to Ginsberg he was a "Junior *Arhat*" master. He still possessed ignorance and was only in the "early stages of vow-making," and still capable of using Buddhism for his own devices, instead of purely disseminating its truth.

Tragically, and realistically, this was true. His ex-wife Joan Haverty sued him for child support, and the police issued a warrant for his arrest. Ginsberg's brother Eugene served as his lawyer.

Haverty eventually had pity on Kerouac's severe and disabling phlebitis and excused him from paying child support for their daughter Janet if he agreed never to contact either of them ever again. Kerouac wrote Ginsberg, "So instead of going to jail I come home, memorize the heart of the Great Dharani of the Lord Buddha's Crown Samadhi, on knees recite it, drink wine and take benny and read your letter and tape up legs."[33]

He admonished Ginsberg to sit erect, fold his feet, breathe in deeply, close his eyes, listen to any sound around him, and refrain from even scratching an itch. He would know he was having a successful meditation session when he experienced a feeling of bliss accompanied by slower breathing. Intuition would dawn with an "eeriness, dream-ness like Harlem Vision again." With each out-breath he should realize thinking had stopped and life was only a dream. Despite being frequently intoxicated, Kerouac was coherent enough to relate meditation practice back to Ginsberg's Harlem vision and their search for the "new vision." But visions aside, getting published, or the lack of it, was wearing him down. By early 1955, he was so fed up he asked his agent Sterling Lord to return all his manuscripts. Kerouac announced that he was going to write only "Buddhist Teaching[s]" that had no worldly or literary motives, and that any of his Beat generation writings were only a precursor to his own exalted "state of enlightenment." Or so he believed. Despite his disgust with the literary world, and all his vehement protestations about its materialism, he kept making the rounds, visiting publishers and carrying *Subterraneans* and *Doctor Sax* manuscripts with him. He persisted, and his losing streak finally came to an end in July 1955. Viking Press accepted *Beat Generation*, later changed to *On the Road*, and he even sold a story to the *Paris Review*. The Academy of Arts and Letters then awarded him a grant of $200.

He was now free to write. He left for Mexico City, staying at a fleabag hotel with no electricity, filling it with candles, a railroad lantern, clothes, toiletries, a Christian Bible, his Buddhist Bible, and his manuscripts. With a jazz sensibility Kerouac composed "Mexico City Blues," a gigantic opus of a poem with hundreds of choruses and interspersed Sanskrit words for different states of consciousness taken from the sutras. Ginsberg said it was the work of a "Zen lunatic but with a secret message implied for anyone with Gnostic knowledge to pick up."[34] He had a squalid love affair with an "Aztec" prostitute, Esperanza, believing she epitomized the First Nobel Truth that "all life is suffering." But Mexico's charms soon faded, and Kerouac moved on.

California 1955

San Francisco's North Beach scene, full of musicians, actors, playwrights, and alternative-lifestyle adepts, was burgeoning just as Walt Disney's *The Mickey Mouse Club* was starting its run on national TV. City Lights Books, founded by the poet Lawrence Ferlinghetti, became San Francisco's social and cultural hub just as Bill Haley's "Rock around the Clock" topped the charts. Ginsberg moved to the West Coast carrying a letter of introduction from his mentor William Carlos Williams addressed to Kenneth Rexroth, a writer and poet who hosted an influential salon. Ginsberg met many poets and writers, including Michael McClure, who wanted to organize a poetry reading at the Six Gallery but was too busy; Ginsberg jumped at the chance. Since it was his first time planning such a big event, he asked Rexroth to help him choose readers, and the older man suggested Gary Snyder, a graduate student of Japanese and Chinese at Berkeley.

On September 8, 1955, the same day Kerouac returned from Mexico, Ginsberg met Snyder, whom he described as a bearded "cat" studying "Oriental," a real Zen monk "hung up" on Indians, but a good writer, and a scholar who rode his bike around Berkeley. Snyder remembered Ginsberg "sneaking" up while he was fixing his bicycle, telling Snyder that Rexroth had sent him. Snyder invited him in for tea. In *The Dharma Bums* Kerouac described Snyder as living in a small room filled with straw mats, a rucksack, pots and pans neatly tied up, and a blue bandana containing his "inside-pata socks" worn while padding around the straw matting. His chief possessions were orange crates filled with books of "Oriental" languages, sutras, and commentaries, the complete works of D. T. Suzuki, Japanese haiku, and assorted poetry books. He also had a small table made from orange crates.

Ginsberg told him he was organizing a poetry reading, looked at his poems, and said, "Well, this is all right."[35] He mentioned that Kerouac, on his way back from Mexico, would be showing up any day. In fact, Kerouac was at that exact moment on his way to Ginsberg's house, high on Benzedrine.

While a student at Reed College in 1949, Snyder dove into a four-volume haiku translation by R. H. Blyth and discovered writings of D. T. Suzuki. He said, "The two first powerful influences on me were D. T. Suzuki, and Sasaki (Sokei-an). Sokei-an's talks were published in a book called *Cat's Yawn*, which I was lucky enough to get a copy of around 1952. Suzuki was the intellectual, Sokei-an the wanderer, laborer, artist, and authentic Zen master."[36] In 1952 he and the future Zen master and poet Philip Whalen shared an apartment in Berkeley with the poet Lew Welch, deeply engaged in their own studies of Buddhism.

The reading on October 7, 1955, at the Six Gallery brought out

all of the "boho" and arty types. The crowd quickly swelled to standing room only. Rexroth, master of ceremonies, compared the feeling in the air to that which the Spanish anarchists must have felt. Philip Lamantia read work by a poet who had recently died. Michael McClure recited poems anticipating the world environmental movement, including "For the Death of 100 Whales," followed by Philip Whalen. Then there was a break.

The second half opened with Ginsberg reading *Howl* to about 150 people, ranting like an old-world Moses. Years later, during a cab ride, Ginsberg told one of his secretaries, Jacqueline Gens, that *Howl* was actually about Bodhicitta. First there was identification and compassion for suffering. Then there was identification with the causes (i.e., Moloch, conceptual mind and judgmental mind, this and that which categorizes and creates the will to power). Next is Holy, Holy, Holy, the brilliance and goodness in the world, the fruition. It was not, as he initially thought, an angry poem.[37]

Kerouac shouted "Go" to punctuate the end of each line of the poem. Ginsberg recounted, "It was Jack Kerouac, you know, who gave the poem its name. I mailed him a copy just after I wrote it—it was still untitled—and he wrote back, 'I got your howl.'"[38] Many were moved to tears, and there was a sense that literary history had been made. Snyder ended the evening with a gentle poem about the need for man to return to nature.

The event was a resounding success. The voices of the poets had been overwhelmingly heard and, better yet, understood. If any moment could be said to have launched the San Francisco poetry renaissance, this was it. And Ginsberg, who had been unsuccessful in finding a publisher, finally found one—Ferlinghetti's City Lights Books.

Rexroth wrote in the *Evergreen Review* that "*Howl* is the confession of faith of the generation that is going to be running the world

in 1965 and 1975—if it's still there to run." He did not know part of it had been written when Ginsberg was under the influence of peyote and looked at the Sir Francis Drake Hotel roof as a "robot Moloch face." He ingested peyote a second time, took a cable car to the heart of the city, and started rhyming verses using the word "Moloch," picked up from Fritz Lang's 1927 movie *Metropolis*. Rexroth correctly prophesied that Ginsberg would become the first authentically popular poet in a generation.[39]

There followed other poetry readings, wild parties, and drinking binges. Kerouac usually sat alone in a corner. This caught Snyder's eye, and he invited him to his house to talk. Kerouac, though deeply respectful of Snyder's knowledge, took issue with his austere, intellectual style of Zen. He felt it had a touch of cruelty with "all those Zen Masters throwing young kids in the mud because they can't answer their silly word questions."[40] But they both appreciated the Buddhist saint Avalokiteśvara in Sanskrit, Chenrezig in Tibetan, or Kannon in Japanese. Kerouac was impressed by Snyder's prodigious knowledge of "Tibetan, Chinese, Mahayana, Hinayana, Japanese, and even Burmese Buddhism,"[41] but kept coming back to the essential point: the first of the four noble truths, that all life is suffering. Kerouac didn't really believe that the cessation of suffering was possible, but he was open enough to consider that it could be and discussed his translations of Buddhist texts from the French, saying he had been studying all by himself in public libraries throughout America. Snyder was duly impressed.

Despite all the scholarly and intellectual interest in Zen, no one except Snyder and occasionally Whalen actually practiced formal meditation. Whalen felt Kerouac just didn't have it in him to endure any lengthy sessions, first because his knees were ruined by football and second, and more importantly, because he had a monkey mind

that could not remain still. But Ginsberg felt differently, that if only they had been exposed to a teacher or at least to someone who could have taught them proper posture and breathing techniques, "it would've been a great discovery."

Years later Snyder remarked. "Jack doesn't know anything about Zen. He admits it himself on page 13 of *The Dharma Bums*: 'I'm an old-fashioned dreamy Himalayan coward of later Mahayanism.' He's interested in Indian Buddhism, not Chan and Zen. He came onto it by reading the Sacred Books of the East series. I deeply respect Jack's insights in Buddhism, and I think they are very valid, but this is simply some of the American Buddhism as it's practiced. It's not the same as mine."[42]

Snyder told Kerouac the Zen story of Nansen the Zen master. Nansen said to his monks, "If you can tell me one word of Zen, I won't kill this cat; but if you can't talk, the cat is going to get killed." No one said anything, and the cat was killed. The next day Nansen's top disciple Joshu arrived, and Nansen relayed the story to him, asking him what he would have done to save the cat. Joshu put his shoes on his head and walked out the door. Nansen told the rest of the students that if that had happened the day before, the cat would still be alive. Kerouac was horrified. He believed anyone who would kill a cat to make a point about the dharma was wrong. He told Snyder, "This Zen business is bad." Even though it was a metaphorical example, it was too gruesome and full of suffering for Kerouac's "big old Mahayana heart."

Snyder invited Kerouac to go camping in the High Sierras, insisting they bring along all their food and no alcohol, an inconvenience Kerouac meekly protested but then accepted. Kerouac described their outing in great detail in *The Dharma Bums*, saying he made a "magic mandala" before they embarked to help aid them in their

climb. He did this to represent the void within all things, part of life's illusions. The climb became a parable between a Zen "just do it" type of ideology and a mystical vision quest. They wrote haiku full of vigor while ascending the mountain, but Kerouac quickly tired. Snyder emphasized the excursion was its own haiku and easily made it to the top of the mountain, but Kerouac did not. But the descent was easy, with both men happily bounding back down the mountain at breakneck speed.

This moment of happy abandonment and freedom did not last long. Neal Cassady showed up in San Francisco with Natalie Jackson, his speed-addicted girlfriend, who was in the middle of a bout of acute amphetamine psychosis. She climbed up to the roof of their building, broke the skylight, and used the shattered glass to cut her wrists. A neighbor who saw her bleeding on the roof called the police. In her flipped-out haze Natalie thought the police wanted to kill her, and in fleeing them she jumped six floors to her death. The newspapers reported "Unidentified Blond Leaps to Death."[43]

The suicide was traumatic for everyone. Kerouac thought if this was the result of their inquiry into dharma, what was the point? How had they changed the world? Whom had they helped? They couldn't even control themselves. He briefly moved in with Cassady, who in the aftermath of Natalie's gruesome death had returned home to his wife Carolyn. But Kerouac couldn't stand being around their domestic tension and left to grieve at his sister's house in Rocky Mount, North Carolina.

Buddha and Blake Are One

When he arrived at his sister's house, Kerouac was so overwrought from the death and chaos in Berkeley that he ran outside, convinced

he was about to die. Sitting underneath a tree, he mimicked the Heart Sutra chant, "form is emptiness, emptiness is no other than form" reciting,

Raindrops are ecstasy,
raindrops are not different from ecstasy,
neither is ecstasy different from raindrops,
yea, ecstasy is raindrops,
yea, ecstasy is raindrops,
rain on, O cloud.

Living with his sister and brother-in-law quickly became intolerable. His family laughed when he tried to explain that holding an orange in his hand was the essence of emptiness, and that "all things made have to be unmade . . . simply because they were made." His brother-in-law, trying to find some common ground, asked him how, if things were empty, was he able to taste and swallow an orange? Kerouac answered using the Heart Sutra as the basis for his argument: that one could see, hear, touch, smell, taste, and even think about the orange, but without mind it couldn't exist, since mind had created it in the first place. His brother-in-law, stymied by such a philosophical exegesis, gave up and said he didn't really care.

Though he focused on his Buddhist studies and tried to embody the religious life of a mountain hermit, Kerouac continued to drink heavily and pop bennies. In the tantric tradition, alcohol can intensify mind and sense perceptions if one is properly trained, but he wasn't and he couldn't. Though his legs swelled up with dangerous bouts of phlebitis, he maintained his discipline and wrote Ginsberg that he read the Diamond Sutra every day and practiced the ten *paramitas*. On Sunday he read *Dana* (generosity), Monday *Sila*

(discipline), Tuesday *Ksanti* (patience), Wednesday *Virya* (exertion), Thursday *Dhyana* (meditation), and Friday *Prajana* (knowledge). On Saturday he read the conclusion of the sutras. He practiced meditation without any formal instruction and strove, despite his excesses, to see the sacred in everything. Drinking cups of green tea, he sat in a cross-legged lotus position, excruciating for a man with phlebitis, and wrote Ginsberg a poem about it.

When a thought
comes a-springing from afar with its held
forth figure of image, you spoof it out,
you spuff it off, you fake it, and
it fades, and thought never comes—and
with joy you realize for the first time
"Thinking's just like not thinking—
So I don't have to think
 any
 more."

Ginsberg wrote back with the revelation that "your Buddha experience and my Blake ones are on the same level."

Living as simply as possibly, he continued to write his biography of the Buddha as loose pages of typewritten sheets lay strewn about, full of scribbled thoughts and haiku. He drew lines around most of his poems and embellished everything as if it were some kind of eternal tomb while he waited and worried if his other books sold. Translating texts from French into English, he focused on the *Mahayana Samgraha of Asanga,* about a great scholar of the first century. Perhaps, he thought, he might even survive on the meager wages of a translator, but no such job materialized.

He wrote Ginsberg that *Some of the Dharma* had grown to over two hundred pages and that he would become a great writer and convert "thousands, maybe millions." He added in a letter a month later that even after reading D. T. Suzuki's book in the New York Public Library, his own writing would become as important and as influential, a heady statement that shows both his insight and arrogance. Different publishers did read his writing on Buddhism. Sadly, all rejected it. He wrote to Ginsberg that "Buddha Tells Us," one of his names for it, was given the cold shoulder by Cowley, Giroux, and even his agent, Sterling Lord. He strongly felt it would "convert" many people once it was published, but he had to wrestle the "money changers" so its "magical powers of enlightenment" could be heard. Half a century later, after he was dead and his prophetic words faded, he got his wish. Viking Penguin finally published it, since Kerouac was now a brand name that sold a hundred thousand copies annually, and they could make a handsome profit.

He had finally understood the nature of true "Mind Essence" and the purity of spontaneity and intuition. He felt he had "reached the point beyond Enlightenment" and could even abandon Buddhism because it was "an arbitrary conception." Insightful enough to know that the "seed-energy" of his mind could never stop, he thought he could do nothing the rest of his life, and it wouldn't matter. His sister, however, would have none of it and accused him of freeloading, thinking his interest in Buddhism was ridiculous. There were squabbles, and he finally left Rocky Mount.

After the Road

By the beginning of 1958 Kerouac was living in Orlando, Florida. In a letter to Philip Whalen he correctly prophesied that year would be

known as the year of Buddhism. Acutely aware of Alan Watts, the "big hero of Madison Avenue," he was surprisingly complimentary of Nancy Wilson Ross's breakthrough article about Buddhism in the women's magazine *Mademoiselle*. He also accurately predicted that everyone would soon be reading Suzuki. In an October letter to poet Gregory Corso he admitted he was unable to meditate any more and had begun writing Catholic poems, sending them to *Jubilee* magazine.

That year the Zen issue of the Chicago Review was published with Kerouac's "Meditation in the Woods," a description of a sesshin by Gary Snyder, translations by D. T. Suzuki and Ruth Fuller Sasaki, a poem by Philip Whalen, a painting by Franz Kline, and Alan Watts's wildly controversial article "Beat Zen, Square Zen, and Zen." Kerouac had also become famous enough to appear on Steve Allen's popular TV talk show.

By the beginning of 1959, Kerouac wrote Whalen he was no longer a Buddhist, wasn't anything and didn't care, a far cry from his predictions of the previous year. He wrote, "Fuck Suzuki, fuck Sasaki, fuck 'em all. They think Buddhism is something apart from Transcendentalism, well they're not Buddhists, they're Alan Watts Social philosophers and glad-to-meet-yas. They want 'group meetings' to 'discuss Zen.' That's what they want, not the sign."[44] However, he rallied in April and wrote to Ginsberg that a Chinese scholar from Staten Island (who might even have been the same Chen Chi Chang who filled in for Suzuki's classes at Columbia) had sent him never-before-translated selections from *The 100,000 Songs of Milarepa*, a tantric Tibetan text. Though he admitted not understanding much of it, he enthusiastically stated, "It's all about Milarepa dispelling hallucinations of demons and coming down from Lashi Snow Mountain to explain it to the people!"[45] But two months later

he wrote Whalen he had nothing left to say about the dharma, and anything he read seemed like a dream. All he could feel were angels.

In 1960 Kerouac went out to the West Coast to stay in Raton Canyon in a cabin offered to him by Lawrence Ferlinghetti. There he had a full-blown, paranoid, alcoholic breakdown. He believed his friends wanted to kill him, that his water was poisoned, and that the sound of flowing water was seeping into his brain. He stopped sleeping, had a panic attack, and saw a vision of the cross. Abandoning Buddhism for good, he headed back home to be with his mother on the East Coast.

In 1962 he wrote a letter to Carolyn Cassady from Orlando, Florida, describing himself as a drunk. To Stella Sampas, a childhood friend whom he married at the end of his life, he described himself as a literary monk who didn't get drunk. In an act of caustic self-mockery he wrote the publisher Robert Giroux that there could be a whole new series of work left in him yet: "The Dharma Bums Grow Up," "The Dharma Bums on Wall Street," and "The Dharma Bums in the White House." By 1963, he fell into a deep depression and by 1964 turned against Ginsberg and Corso, deeming them political fanatics. He wrote, "I am sick of life and that is why I drink."[46]

According to Ginsberg, "Kerouac's satori was clinging both to despair of suffering, fear of suffering, and permanent Hell, fear of a permanent Heaven,"[47] intensified by his advanced alcoholism. It left him susceptible to "the phantasm of the monotheistic imposition" of Western culture. His original understanding of the concept of mind, space, and awareness of Buddhism gave way to his boyhood fixations and faith of the Catholic cross, and the suffering caused by the crucifixion. He started painting Christ crucified, the cross, Mary, cardinals, popes, and finally himself on the cross, a

metaphor he aptly accomplished by drinking himself to death on October 21, 1969.

Ginsberg also felt washed up. On a July 18, 1963, train ride from Kyoto to Tokyo, en route to the airport to fly to the Vancouver Poetry Festival, he renounced his Blake vision, and renounced Blake as well. He realized he had to rid himself of everything, or he would just be hanging onto a memory of his experience. He wrote the poem "The Change" to confront his fears and serve as an exorcism. He was no longer Blake's disciple; nor had he become a full-blown student of Tibetan Buddhism. He was in transition. But a new counterculture was brewing in America, one that would anoint him as one of its most prominent spokespersons. Along with poems about political activism, pacifism, and gay rights, he was to become one of his generation's strongest adherents for Buddhist practice. Allen Ginsberg died on April 5, 1997.

The Tibetan Buddhists Finally Arrive: Tolstoy and the Kalmyks

In 1955, when the San Francisco poetry renaissance had just begun and Natalie Jackson leapt to her death, Geshe Wangyal, a Kalmyk Mongolian Buddhist from the Volga region of Russia, settled into a sizable community of displaced Kalmyks in Freewood Acres, New Jersey. They had been brought to the United States after World War II by the Tolstoy Foundation, which had been set up by Alexandra Tolstoy, the youngest daughter of the renowned writer Count Leo Tolstoy. The Kalmyks established four or five Buddhist temples more akin to local community centers.

Ilia, one of Tolstoy's grandsons and Alexandra's nephew, felt a special affinity with the Tibetans. As OSS (the military precursor

to the CIA) foreign-intelligence agents for the United States during World War II, Lieutenant Colonel Ilia Tolstoy and Captain Brooke Dolan were sent on an expedition to find a shortcut to China in order to bring supplies to Chiang Kai-shek's Chinese Nationalist government, which was defending itself against the invasion of the Japanese army. A second objective of the mission was for Tolstoy to personally deliver a gold chronometer watch, one of only two such Swiss watches in existence, and a letter from President Roosevelt to the then-ten-year-old Dalai Lama.[48] Traditional silk greeting scarves (*katas*) were exchanged, and the young Dalai Lama inquired about Roosevelt's health. The Dalai Lama asked Tolstoy to stay on a few extra months while work was completed on an elaborate hand-embroidered silk-appliqué thangka to be presented to the White House. Tolstoy witnessed the Monlam New Year's festival and visited various monasteries.

Tolstoy and Dolan gave their report to both the OSS and the Pentagon, including 1,200 photographs and a short film "edited by John Ford, who was then in charge of the field photographic unit of OSS. It was in 16-mm color and narrated."[49] They also brought back presents from the Dalai Lama for President Roosevelt, including four thangkas and a collection of Tibetan stamps, later sold at auction after Roosevelt's death. Though Tolstoy and Dolan's mission to find a shortcut had succeeded, the U.S. government ultimately scrapped the plan to deliver supplies to China because it was too politically sensitive. Tolstoy was awarded the Legion of Merit for his service.

In the middle of the winter of 1943, Stalin deported all ethnic Kalmyks to Siberia, and most perished. In 1957 Nikita Khrushchev allowed them to reenter their homeland, which they did, only to find it occupied by Russians and Ukrainians. Geshe Wangyal (1901–1983), an ethnic Kalmyk Mongolian, was a Gelupa teacher, part of

the same Tibetan lineage as the Dalai Lama. Ordained at the age of six, he was somehow able to travel and studied at one of the three main Gelupa monasteries, Drepung in Lhasa, where he received his title of Geshe, the equivalent of a doctorate in logic, debate, and philosophy. While preparing to go back to Kalmykia after his studies in Lhasa, he heard about the Bolshevik repression of Buddhism and changed his plans. Instead, he journeyed to Beijing, where among other jobs he served as translator for the British political appointee to the Himalayan area (including Tibet), Sir Charles Bell, accompanying him throughout his extensive travels in China and Manchuria. Believing correctly that America would become fertile ground for the dharma, he prepared by learning English in Lhasa and continued his studies in Beijing. In 1951, when the Chinese first entered Kham or Eastern Tibet, he fled before most Tibetans were even aware of the danger and settled in Kalimpong, Sikkim.

Jack and Allen Never Knew

It took Geshe Wangyal over four years to secure a visa to the United States. In 1955 he moved into a simple house his Kalmyk friends found for him in Freewood Acres, New Jersey. There he obtained a charter from the Fourteenth Dalai Lama to establish the first Tibetan monastery in the United States, called the Lamaist Buddhist Monastery of America. Neither Kerouac nor Ginsberg were even aware the Geshe existed. Just a few years later Geshe Wangyal attracted many prominent Western students, including Columbia professor Robert Thurman, the first ordained Western Tibetan Buddhist monk, and the Harvard-educated translator and scholar Jeffrey Hopkins.

It is startling to realize that while Jack Kerouac delved into his own brand of Buddhist studies, an authentic Tibetan Buddhist lama

lived only an hour and a half away. Had either Kerouac or Ginsberg known of Geshe Wangyal, there is a good chance they would have at least visited him. As Geshe was fastidious about making his students learn Tibetan and study complex scriptures, it is hard to say if that type of scholarly path would have attracted Kerouac or Ginsberg for long. But fate decided that encounter would never happen, and Kerouac never found an authentic meditation teacher.

The Next Generation

However, the next generation of Beats was interested, including the young poet Anne Waldman. A child of bohemian New Yorkers who had met each other at a party given by the sculptor Isamu Noguchi at his studio on MacDougal Street in the late 1930s, Waldman was just seventeen years old and a college freshman when, in the summer of 1963, a friend brought her to Freewood Acres to the "pink suburban house" to meet Geshe Wangyal. She remembers the house as "very monastic," and met Geshe Wangyal in the early afternoon while monks were sitting around a table eating lunch. Walking into the shrine room, she was mesmerized by the wild colors and scrolls, the burning incense, and the butter lamps. She felt there was a "stopping the mind"[50] quality as she gazed at the moonlike face of Geshe, who was sitting in a comfortable chair. She visited him only twice and was the only woman present at both meetings. She had no thoughts of becoming his student, but in 1965, when she took her first acid trip, she saw the "mind track the grammar of mind," an experience akin to insight meditation. At age twenty she took a vow to poetry, and by 1966 she was working at the St. Marks Poetry Project. In 1968 she became its director. In 1970 Waldman visited Tail of the Tiger (later Karme Choling), set up by the Tibetan lama

Chögyam Trungpa, and by 1974 she and Allen Ginsberg founded the Jack Kerouac School of Disembodied Poetics at Trungpa's school, Naropa Institute (now University) in Boulder, Colorado.

CONCLUSIONS

The mid-twentieth century in the United States was a time when the overweening popular culture and conservatism of the Eisenhower years gave way to a full-blown counterculture. These transformations occurred simultaneously with the decline of modernism. *Nothing and Everything* has traced how Buddhism in New York and tangentially the art and creative worlds of Japan, Europe, and California were transmitted, received, and reconfigured into new, multifaceted, creative forms.

Zen emphasizes art as a focus of everyday life and makes clear there is no difference between the perceiver and perception. It sidesteps aesthetics through the act of immediacy and the inability to erase or second-guess one's moment of creation.

What artists received from D. T. Suzuki and other readings was a glimpse into the process of the nature of mind. This glimpse was heightened through the use of drugs and meditation; Allen Ginsberg had his visions, Ibram Lassaw took occasional psychedelics, and Jack Kerouac drank to explore the nature of their minds. Others, like John Cage, who did not indulge in substance-induced explorations intuited that mental perception and silence could highlight presence and lead to new avenues of creativity.

What started out as a smattering of individuals interested in Buddhism during the 1950s expanded exponentially. Buddhism helped explain a type of spontaneity that combined with abstract expressionism, assemblage, neo-Dada, rock and roll, jazz, and free-flowing poetics using the form of chance, accidents, process, immediacy of materials, and the sublime of the mundane. Artists became

innovative and adopted techniques leading to the creation of new works, with an emphasis on those that were ephemeral and time-based. This change enabled artists to incorporate modern media, mass technologies, and the crossing-over of artistic disciplines as demonstrated through the early work by Judson Dance Theater, Fluxus, and happenings.

After 1965 or so, Buddhism was no longer confined to such a small group. The cross-pollinating nature of the avant-garde, as well as the mass use and acceptance of psychedelic drugs, opened legions of young people to a host of "alternative" religions—Native American, Sufism, Hinduism, Wicca, and any number of variations on a theme. These coincided with Earthworks, minimalism, and new music as evinced in the work of Philip Glass, Terry Riley, and Steve Reich; the exploding spiritual scene of Naropa University in Boulder, Colorado; and the founding of authentic Zen centers and art movements in California. There is the rise of Theravadin Buddhist Centers throughout the United States and the mass diaspora of the Tibetan people and resettling of Tibetan lamas in the West. The influence of Tibetan Buddhism has briefly been mentioned. But that is for other scholars to explore. This book is a small beginning in what should turn out to be decades worth of future research.

APPENDIX I
Daisetsu Teitaro Suzuki—Teaching History
(United States, 1949-1957)

Source: *The Eastern Buddhist,* Vol. II, No. 5, August 1967, "In Memoriam Daisetsu Teitaro Suzuki 1870–1966"

1949—Age 79. Attended the Second East-West Philosophers' Conference in Honolulu (June). Stayed on to lecture on Zen Buddhism at University of Hawaii (September to February, 1950).

1950—Age 80. Lectured on Japanese culture and Buddhism at Claremont College, February to June. Moved to New York in September to lecture at Princeton, Columbia, Harvard, Chicago, Yale, Cornell, Northwestern, and Wesleyan on the subject of "Oriental Culture and Thought," sponsored by the Rockefeller Foundation.

1951—Age 81. Lectured at Columbia University on Kegon philosophy from February to June. Spent the summer in Japan. From September to February, 1952, lectured once more at Claremont.

1952—Age 82. At Columbia University as visiting professor; lectured on Zen Buddhist philosophy in the Department of Religion.

1953—Age 83. Continued lecturing at Columbia.

1954—Age 84. Continued lecturing at Columbia. In September, departed for Japan for a stay of four months.

1955—Age 85. Left Japan for New York again to lecture at Columbia University on "Philosophy and Religion of Zen

Buddhism" in the Department of Philosophy. Appointed Associate Professor.

1956—Age 86. Continued lecturing at Columbia.

1957—Age 87. Retired from Columbia in June. In September moved to Cambridge, Massachusetts, for the following seven months to join Shin'ichi Hisamatsu. Lectures given at Harvard, M.I.T., Wellesley, Brandeis, Radcliffe, and Amherst.

APPENDIX II
Employment Record of D. T. Suzuki from Columbia University

Source: Columbia University archives

Suzuki, Daiset [sic], Teitaro

LittlDl, Otani Univ., Kyoto

> 1952 (1/17) Appt.-Visit. Lecturer in Chinese,
> 2/4/52–6/5/52—HVVX for the period
>
> 1952 (6/3) Reappt. And change of title-Associate in Religion
> 1952–53—YXVX
>
> 1953 (6/2) Reappt. Associate in Religion 1953–54—YXVX
>
> 1954 (6/27) Reappt. Associate in Religion Feb. 1, 1955–June 30
> 1955, HXVX period
>
> 1955 (5/2) Reappt. Associate in Religion 1955–56—YXVX
>
> 1956 (5/7) Reappt. Associate in Religion 1956–57—YXVX
>
> 1957 (5/6) Prom. Adjunct Professor of Religion 1957–58—YXVX
>
> 1957 (7/1) Appointment Declined
>
> Deceased

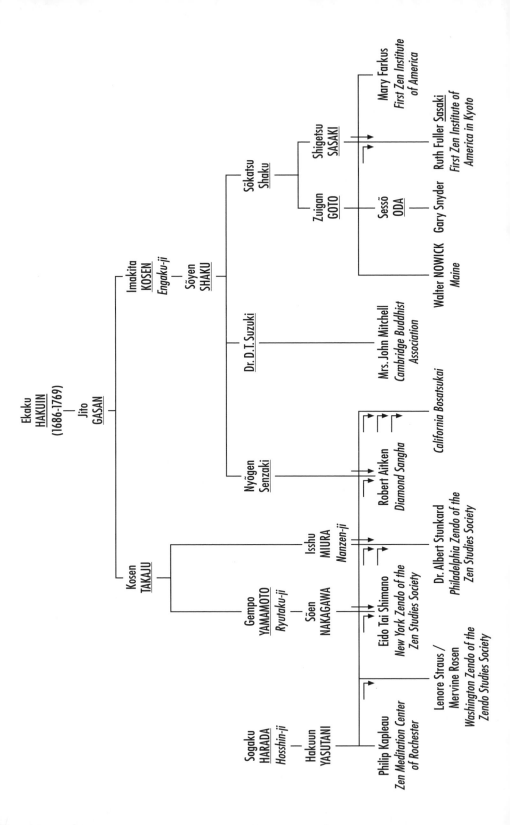

APPENDIX III
The Kosen and Harada Lineages in American Zen

Source: *Wind Bell* Vol. VIII, Nos. 1–2 (Fall 1969), published by the San Francisco Zen Center (reprinted here with permission).

- A surname in CAPS indicates a dharma heir. Lineages not significant to Zen in America are not given.
- A surname in lower case indicates a disciple—who may be a correspondent, founder, or leader, rather than teacher of the group he or she is associated with.
- An underlined surname indicates that the person is deceased.
- Arrows indicate multiple teacher-student relationships.

Note: Dr. D. T. Suzuki has no formal heirs or disciples in America, but he was the original teacher of Ruth Fuller Sasaki, Dr. Albert Stunkard, Philip Kapleau, and, through his books, of Gary Snyder and innumerable others. In some cases the chart is ambiguous. Mr. John Mitchell is not the disciple of Dr. Suzuki but a founding member of the Cambridge Buddhist Association; Dr. Stunkard is a disciple of Miura Roshi, but neither of them is the teacher of the Philadelphia Zendo.

According to Gary Snyder, "The line of Rinzai Zen that has come to the West has almost entirely been the work, the karmic work so to speak, of one man, Kosen Roshi. It was Kosen who opened it up by saying, 'There is no other line in Japanese Rinzai Zen which has even looked towards the West.'"

APPENDIX IV
List of Artists in Abstract Art around the World Today at the Museum of Modern Art, March 16, 1954

Japan Abstract Art Club

Kigai Kawaguchi
Masaki Suematsu
Macanari Murrai
Shinichi Nishida
Takeo Yamaguchi
Masaki Yamaguchi
Koshiro Onci
Saburo Hasegawa
Shigeru Ueki

American Abstract Artists

Joseph Albers
Calvin Albert
Lewin Alcopley
Will Barnet
Herbert Bayer
Maurice Berezov
Nell Blaine
Ilya Bolotowsky
Henry Botkin
Louise Bourgeois
Byron Browne
Fritz Bultman

George Cavallon
Robert Conover
Charlotte Cushman
Eleanor Delaittre
Kiser Eames
Clare Falkenstein
Perle Fine
Ida Fischer
A. R. Fleischmann
Suzy Frelinghuysen
Maurice Golubov
Luke Gwilliam
Fannie Hillsmith
Beate Hulbeck
Roer Jorgensen
Herbert Kallem
Paul Kelpe
Harold Krisel
Ibram Lassaw
Irving Lehman
Israel Levitan
Richard Lippold
Michael Loew
Alice T. Mason
George McNeil
Joseph Meierhans
Lily Michael
George L. K. Morris
Louise Nevelson
Easton Pribble

Stephen Pace

Hans Richter

John Sennhauser

Charles G. Shaw

Jean Sherman

Louis Silverstein

Hyde Solomon

Max Spivak

Esphyr Slobodkina

Florence Swift

Harry Tedlie

Charmion von Wiegand

John Von Wicht

Jean Xceron

APPENDIX V
Gutai Journals in Jackson Pollock's Library

Documentary on the Second Edition of "Gutai"
Published October 10, 1955

Jiro Yoshihara
Kazuo Shiraga
Shozo Shimamoto
Atsuko Tanaka
Michio Yoshihara
Itoko Ono
Akira Kanayama
Yasuo Sumi
Yoshio Sekine
Masatoshi Masanobu
Saburo Murakami
Toshiko Kinoshita
Shigeru Tsugimura
Yoshiko Mashigami
Chiyu Uemae
Hiroshi Okada
Michiko Inui

Gutai No 3.
Published October 20, 1956; special edition of Ashiya
 Outdoor Exhibition
Jiro Yoshihara, editorial supervisor
Shozo Shimamoto, editor and publisher

 Atsuko Tanaka
 Kazuo Shiraga
 Nichiei Horu
 Fujiko Shiraga
 Jiro Yoshiha
 Sadamasa Motonaga
 Yasuo Sumi
 Akira Kanayama
 Syozo Hiimamoto
 Yozo Ukita
 Tsuruko Yamasaki
 Michio Yoshihara
 Toshio Yoshida
 Itoko Ono
 Saburo Murakami
 Ken Shibata
 Tamiko Ueda
 Yoshiko Hashigami
 Masatoshi Masanobu

APPENDIX VI
Announcement by *It Is* Magazine, February 8, 1965

Sponsored by *It Is* magazine, a continuing series of panel discussions and conversations will be held in front of an artist's audience. These conversations shall be recorded and soon after printed in a new publication titled *It Is Cahiers*—notebooks for painters and sculptors. A new format and new editors.

The name, Waldorf Panels, is chosen as homage to a method used by the old Eighth Street Club's pre-club. This pre-club met informally and regularly at the old Waldorf Cafeteria on Sixth Avenue in the early and mid forties. Its method—the conversation panel—was a fuse through which working ideas and soul-searchings were exchanged in practical ways. A desire for the artist's mandate and a deep respect for the artist's intuition were the foundations of this method. When the Eighth Street Club was founded by the very same Waldorf nucleus in the late forties these conversation panels continued. In its early stage, the Eighth Street Club held these conversation panels on Wednesday nights and were closed to the public.

The Eighth Street Club of the late forties should not be confused with "Studio 35," which was started by another group. "Studio 35" was an advertised art school for art students with a surrealist curriculum called "Subjects of the Artist." Totally opposite, the Eighth Street Club's membership was composed only of mature artists and its conversation panels were recruited from this artist membership. What could be confusing is that it was located at 39 East Eighth Street in between "Studio 35" at 35 East Eighth Street and Hayters Atelier 17 also a few doors away. But it was only the Eighth Street

Club that survived into the fifties, that cut through the surrealist jungle and discovered a new clarity for Abstract Art.

To continue this method is part of our manifesto.

APPENDIX VII
Mission of Bokubi

Presently, a great future has opened for the art of modern calligraphy. Avant-garde artists of the West and progressive critics and artists in Japan frequently knock upon calligraphy's gate. I felt this strongly when, just recently, I had a pleasant, daylong chat with Isamu Noguchi, whom I had met through a close friend of the Bokujinkai, Saburo Hasegawa. The calligraphy world, having sat idly within a feudalistic shell for so very long, has finally begun to break free with help from the outside. The art of calligraphy has done its part in continuing to defend Asia's ancient tradition. But when looked at from a larger, international perspective, [it becomes clear that] calligraphy must be reborn as a modern art or risk suicide by allowing itself to be cannibalized by progressive artists [i.e., noncalligraphers]. That we have now fully arrived at this crossroads is clear to me.

When thinking of this time, of these circumstances, [I feel that] not another day can be spent in idleness. The five members of the Bokujinkai being, more or less, foolish people, each of us knew of the others' occasional reflection upon this point and decided to band together, abandon all encumbrances, and rise up. I would like to make it clear that our motives are not emotional or political, but are, rather, grounded upon a common understanding of the circumstances of our time.

First of all, I am certain that the first step in the reformation of calligraphy, in the establishment of the art of modern calligraphy, involves freedom from all conventions. To be free, each person must

stand as an individual, stripped-down human being and take hold of their tradition's roots . . .

It all starts now. To initiate this process, we have broken down existing conventions and begun from scratch. We have, therefore, declared autonomy from the Keiseikai. I do not want people to think, however, that we are rebelling only from the Keiseikai. Naturally, we must dismiss "Niten" [Japan Art Exhibition, the government-sponsored art exhibit] as well. If we are truly to become avant-garde, we must, naturally, rebel against all existing establishments. If we compromise whatsoever, we will never break through to avant-gardism. Rebellion and opposition—the path is thorny. A difficult path, however, is the only path that leads to the reformation of calligraphy. This has been proven many times in the history of both East and West. Criticism, outright attacks, and ridicule come before resolution. I sincerely believe, however, that there are many others with ambitions similar to our own. As a matter of fact, we have received much encouragement from every direction.

Our hope is always to defend purity. This does not mean that we intend on isolating ourselves in self-conceit, nor do we wish to become like so many political movements. We wish to move forth always as genuine artists. We five are equals; we shall never interfere with each other's art: the freedom of individuality. Naturally, a Bokujinkai "style" of calligraphy is unthinkable. Each individual proceeds on whatever path is pleasing. We are bound together only by our faith. In our effort to advance calligraphy, we hope to deepen our exchange with various groups. And if there are kindred souls who wish to join our ranks, who are truly sincere, we will happily welcome them into our fold on equal grounds.

Courtesy of Ryan Holmberg, "Bokujinkai kessei aisatsu"

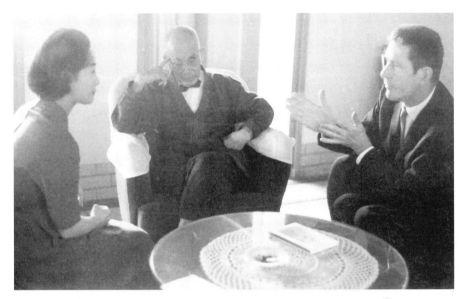

ABOVE: D. T. Suzuki with John Cage and Mihoko Okamura (circa 1962–1964).

Courtesy of the John Cage Trust.

BELOW: D. T. Suzuki (center) at the Chicago Buddhist Church with Reverend Gyomay Kubose and others, 1951.

Courtesy of Rev. Yukei Ashikaga, The Buddhist Temple of Chicago.

RIGHT: Portrait of Merce Cunningham by Marianne Preger-Simon, drawn at Black Mountain College.
Courtesy of the Asheville Art Museum, Black Mountain College Collection.

ABOVE AND RIGHT: Reenactment of Yoko Ono's "Cut Piece" at the Emily Harvey Gallery, New York City, 2003. (In this version, both men and women get cut up.)
© *Ellen Pearlman.*

LEFT: Portrait of John Cage by Marianne Preger-Simon, drawn at Black Mountain College.
Courtesy of the Asheville Art Museum, Black Mountain College Collection.

ABOVE: Alison Knowles of Fluxus in front of a painting by Atsuko Tanaka, a Gutai artist; part of the "Electrifying Art" show at New York University Grey Art Gallery, 2004.
© Ellen Pearlman.

LEFT: Atsuko Tanaka's electric dress; also from the "Electrifying Art" show, 2004.
© Ellen Pearlman.

ABOVE: Reenactment of Allen Kaprow's "18 Happenings in 6 Parts" as part of Performa 07 (December 30, 2007).
© *Ellen Pearlman.*

BELOW: Reenactment of Nam June Paik's "Zen for Head." Emily Harvey Gallery, New York City, 2003.
© *Ellen Pearlman.*

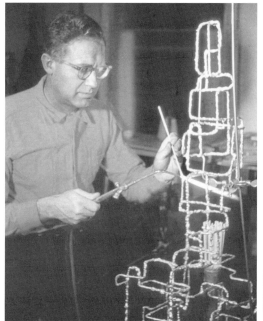

LEFT: Ibram Lassaw, 1954. Photograph taken by Lassaw's Stereo Realist camera in his studio at 487 6th Avenue in New York City.

Photographer unknown. Courtesy of Denise Lassaw.

BELOW: Jackson MacLow, ca. 2002. St. Mark's Poetry Project, New York City.

© Ellen Pearlman.

BELOW: From left to right: Ibram Lassaw, Philip Pavia, Marsha Pavia, and Bob Richenberg. Photograph taken at Ibram Lassaw's studio in Provincetown, Massachusetts, ca.1952.

Photographer unknown.
From the collection of Robert Richenburg; courtesy of Denise Lassaw.

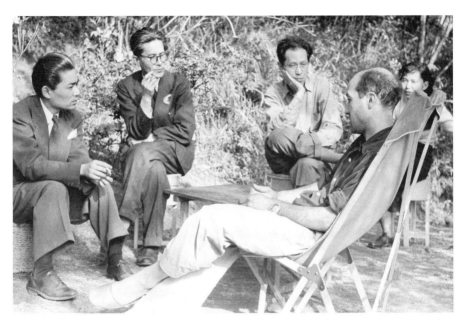

ABOVE: Isamu Noguchi meeting with Saburo Hasegawa and other friends and relatives on his trip to Japan, 1950.
Courtesy of The Noguchi Museum, New York.

ABOVE: Allen Ginsberg and Peter Orlovsky with young Tibetan monk, New Delhi, Spring 1962. A note on the back of the photograph reads "who is the lama? Joanne Kyger says looks like Chogyam Trungpa."
© Gary Snyder; photo provided by the Allen Ginsberg Estate. Reprinted with permission.

LEFT: Saburo Hasegawa, Isamu Noguchi and Yoshiko (Shirley) Yamaguchi in Japan, 1950.
Courtesy of The Noguchi Museum, New York.

RIGHT: Geshe Wangyal, the first Tibetan lama to teach in the United States. Photo taken in 1966 at Labsum Shredrub Ling, Freewood Acres, New Jersey.

© Richard Munn; photo provided by Diana Cutler at the Tibetan Buddhist Learning Center. Reprinted with permission.

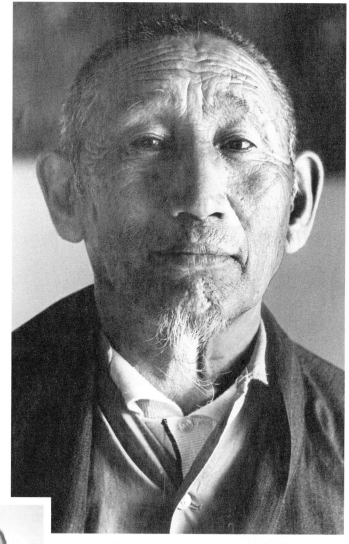

LEFT: Allen Ginsberg in his home in the East Village, 1990.

© Ellen Pearlman.

RIGHT: Allen Ginsberg circa. 1948.

© Allen Ginsberg Estate; reprinted with permission.

LEFT: Jack Kerouac, New York City, late 1944 or early 1945.
© Allen Ginsberg Estate; reprinted with permission.

BELOW: Anne Waldman with Allen Ginsberg circa 1976–1978.
Photographer unknown. Courtesy of the Anne Waldman Papers, Special Collections Library, University of Michigan. Used by permission of Anne Waldman.

RIGHT: Anne Waldman in high school, New York City, 1961.
Photo taken by Thomas Eldred. Courtesy of the Anne Waldman Papers, Special Collections Library, University of Michigan. Used by permission of Anne Waldman.

NOTES

Introduction

1. E. H. Johnson, ed., *American Artists on Art from 1940–1980* (New York: Harper and Row, 1982). From a 1950 interview with William Wright, www.script-o-rama.com /movie_scripts/p/pollock-script-transcript-ed -harris.html

2. Kathleen Pyne and D. Scott Atkinson, "Landscapes of the Mind, New Conceptions of Nature," in Alexandra Munroe, *The Third Mind: American Artists Contemplate Asia, 1860–1989* (New York: Guggenheim Museum, 2009), 90.

3. Ibid., 91.

4. Arthur C. Danto, "Upper West Side Buddhism," in *Buddha Mind in Contemporary Art,* eds. Jacquelynn Baas and Mary Jane Jacob (Berkeley: University of California Press, 2004), 55.

5. Ibid., 57.

6. Some art historians have suggested that the inspiration for the urinal, if not the piece itself, came from Duchamp's friend Elsa von Freytag-Loringhoven. In her book *Baroness Elsa: Gender, Dada, and Everyday Modernity,* Irene Grammel quotes Duchamp in a 1917 letter to his sister in which he writes, "One of my female friends, who had adopted the pseudonym Richard Mutt, sent me a porcelain urinal as a sculpture..." The debate is ongoing. (This point was suggested by Denise Lassaw, December 2011.)

7. Harold Rosenberg, *Artworks and Packages* (New York: Horizon Press, 1969), 14.

8. *Horizons: The Poetics and Theory of the Intermedia,* 1, retrieved from http://www.artnotart.com/fluxus/dhiggins-childshistory.htmls.

9. Chögyam Trungpa, *Journey without Goal* (Boulder, CO: Prajna Press, 1981).

Chapter 1

1. *A Zen Life: D. T. Suzuki,* a film by Michael Goldberg, executive producer and director, D. T. Suzuki Documentary Project Japan Inter-Culture Foundation, 2005–2008.

2. Descriptions of Suzuki's experiences are based on accounts in *A Zen Life: D. T. Suzuki Remembered,* by Masao Abe (New York: Weatherhill, 1986).

3. Bernard Phillips, "The Essentials of Zen Buddhism," selected from the writings of George Plimpton, *Paris Review, The Beat Writers at Work,* Modern Library, 1999.

4. *Wind Bell,* Zen Center of San Francisco, vol. 8, nos. 1–2.

5. Masao Abe, *A Zen Life: D. T. Suzuki Remembered* (New York: Weatherhill, 1986).

6. Ibid.

7. Ibid.

8. Michiko Yusa, *Zen and Philosophy: An Intellectual Biography of Nishida Kitaro* (Honolulu: University of Hawai'i Press, 2002), 21.

9. The priests represented the different schools of Buddhism in Japan. The first two represented the Mahayana school: Shaku for the Rinzai sect and Yatsubuchi Bunryū for the *Jōdo Shinshu* (Shin or Pure Land Buddhism) sect. Ashizu Jitsuzen represented the third school, *Tendai* (alternately referred to as "esoteric" or, more recently, tantric), and Toki Hōryū represented the *Shingon* lineage, another tantric school similar to the *Tendai.* The two others were the *koji* (laymen), Hirai Kinzō and Noguchi Zenshirō.

10. *Wind Bell,* Zen Center.

11. D. T. Suzuki, "A Glimpse of Paul Carus," in *Modern Trends in World Religions,* ed. Joseph Kitagawa (La Salle, IL: Open Court, 1957).

12. Mihoko Okamura, in discussion with the author, Kyoto, Japan, June 15, 2005.

13. From Suzuki's employment records, Columbia University archives.

14. Rick Fields, *How the Swans Came to the Lake* (Boston: Shambhala, 1981), 167.

15. Jackson Mac Low, in correspondence with the author.

16. Roger Lipsey, *An Art of Our Own* (Boston: Shambhala, 1977), 355.

17. William Barrett, ed., *Zen Buddhism: Selected Writings of D. T. Suzuki* (Garden City, NY: Doubleday, 1956), 279–80.

18. A. W. Sadler, "In Remembrance of D. T. Suzuki" (Reminiscences), *Eastern Buddhist* (New Series) 2 (August 1967): *198–199*.

19. Listing for the 1941 American Abstract Artists show at the Riverside Museum: Albers, Bolotowsky, Browne, Corazzo, Cavallon, Christie, Drewes, Frelinghuysen, Greene, Harari, Holty, Joralemon, Kaiser, Knaths, de Laittre, Lassaw, Mason, Moholy-Nagy, Mondrian, Morris, Pereira, Reinhardt, Shaw, Slobodkina, Swift, Swinden, Wolff, McNeil. List courtesy of Denise Lassaw.

20. Denise Lassaw wrote, "Ibram did not begin to keep Day Books (that is what he called them) until 1954. Before that he just scribbled notes on paper and the daily calendar that both he and my mother wrote on. So if he did attend earlier Suzuki lectures series, we don't have notes on that."

21. Ibid. "On Feb. 2, 1951, Ibram loaned Charmion von Wiegand *The Secret of the Golden Flower*, which was published in 1931. I don't know when Ibram got it. But he must have been reading it in 1951 or a little earlier. Charmion brought Kongla Rinpoche to America—it is possible she also attended Suzuki lectures."

22. According to the National Library of Peking in 1961, "The Diamond Sutra, printed in the year 868 . . . is the world's earliest printed book, made of seven strips of paper joined together with an illustration on the first sheet which is cut with great skill." The writer adds, "This famous scroll was stolen over fifty years ago by the Englishman Ssu-t'an-yin [Sir Aurel Stein] which causes people to gnash their teeth in bitter hatred." It is currently on display in the British Museum. The scroll, sixteen feet long and ten and a half inches wide, bears the following inscription: "reverently made for universal free distribution by Wang Jie on behalf of his parents on the fifteenth of the fourth moon of the ninth year of Xian Long [May 11, 868]," www.silk-road.com/artl/diamondsutra.shtml.

23. Ira Cohen in discussion with the author.

24. Chang had translated for Dr. Arthur Charles Musé (1919–2000) "Esoteric Teaching of the Tibetan Tantra," including the initiation rituals for the Six Yogas of Naropa, including Tsongkapa's commentary. Musé had written his 1951 doctoral thesis at Columbia on the philosophy of the German seer Jakob Bohem and served between 1950 and 1960 as editor-in-chief of the nonfiction publishing house Falcon's Wing Press. Musé also wrote on cybernetics, genetics, and biomedical computing.

25. His Holiness the Dalai Lama, http://www.circle-of-light.com/Mantras /om-mantra.html.

26. "She later married David Hare, and David is the one who first turned my parents on to peyote. She was also a good fiend of Noguchi, and my mother remembers eating peyote with him—he didn't like it much," Denise Lassaw in correspondence with the author.

27. Lenore Friedman in discussion with the author, July 2002.

28. Ibid.

29. Ibid.

30. Chögyam Trungpa, *Cutting Through Spiritual Materialism* (Boston: Shambhala Publications, 1987), 122.

31. D. T. Suzuki, *The Essentials of Zen Buddhism* (New York: Dutton, 1962), 371.

32. Ibid.

33. Mihoko Okamura in discussion with the author.

34. D. T. Suzuki interviewed by Huston Smith in a documentary by Michael Goldberg for NBC.

Chapter 2

1. Ellsworth Snyder, "John Cage Discusses Fluxus," in *Fluxus: A Conceptual Country, Visual Language* 26, no 11/12 (Winter/Spring 1992).

2. George Brecht, Notebooks I–V, 1958–1961, Cage Class, Summer 1958, ed. Dieter Daniels (Cologne: Verlag der Buchhandlung Walther Konig).

3. Ibid.

4. William Fetterman, *John Cage's Theater Pieces* (doctoral thesis), 158.

5. William Anastasi in discussion with the author, May 2006.

6. Nancy Wilson Ross papers, University of Texas.

7. Dada show, Museum of Modern Art, June 2006.

8. Ibid.
9. Bruce Altschuler, Merce Cunningham, Alison Knowles, Jackson Mac Low, "John Cage's Course in Experimental Music at the New School, 1956–60," lecture given in New York, September 24 to October 6, 1999.
10. David Revill, *The Roaring Silence: John Cage; A Life* (New York: Arcade, 1992), 57.
11. According to Jan Thompson, Nancy Wilson Ross "claims that she was the one that introduced Morris to Zen . . . I think probably it is true that she did introduce him, and probably John Cage, too." Ross also introduced him to his New York dealer, Marian Willard (http://www.aaa.si .edu/collections/interviews/oral-history-interview-jan-thompson-12209). However, Kenneth Callahan tells a different story: "Then in 1942, Marian Willard of the Willard Gallery was out at the museum [Whitney], and that's where she first saw Morris's things. I got a whole bunch of those things of Morris's to show her at that museum, and I spread them all over the floor of the studio room. Dorothy Miller was also there, the curator of the new Museum of Modern Art. And Marian Willard was with Dorothy Miller, and a little shrimp I never liked—Holger Cahill—Dorothy Miller's husband. So then she got this show for Morris. And the Museum of Modern Art bought [his paintings] through Dorothy Miller" (http:// www.aaa.si.edu/collections/interviews/oral-history-interview-kenneth -callahan-12975).
12. Ray Kass in correspondence with the author, August 2006.
13. Ray Kass, retrieved from http://www.zonecontemporary.com/aaa/?catediv =exhi&subnum=2past_sub&sqlnum=49_&detno=1&subinfo=50.
14. Cornish School of Applied Arts Archives, University of Washington Special Collections.
15. Kenneth Callahan interviewed by Sue Ann Kendall, http://www.aaa.si.edu /collections/interviews/oral-history-interview-kenneth-callahan-12975.
16. John Cage interviewed by Paul Cummings, May 2, 1974, http://www.aaa .si.edu/collections/interviews/oral-history-interview-john-cage-12442.
17. Ibid.
18. John Cage featured on KPFA's *Ode to Gravity* series (December 12, 1987), www.archive.org/details/JohnCageOTG.

19. Jonathan Katz, "John Cage's Queer Silence, or How to Avoid Making Matters Worse," http://www.queerculturalcenter.org/Pages/KatzPages/KatzWorse.html.

20. William Anastasi in discussion with the author, May 2006.

21. Cage interviewed by Cummings.

22. Cage interviewed by Cummings.

23. Anastasi.

24. Richard Kostelanetz, *Conversing with Cage* (New York: Routledge, 1988).

25. Morton Feldman had explored this idea as well in the essay "After Modernism." He argued that Renaissance choral music is about spiritual or religious ideals, Romantic music deals with literary and philosophical mores, and some of twentieth-century music wrestles with logic. Abstraction, he felt, left the viewer in a state of perpetual speculation.

26. Richard Kostelanetz, *John Cage: An Anthology* (New York: Da Capo, 1970), 77.

27. This is comprised of sixteen sonatas and four interludes and was premiered January 11, 1949, by Maro Ajemian.

28. Richard Lippold interviewed by Paul Cummings, *Archives of American Art*, 93.

29. Morton Feldman interviewed by Richard Wood Massi, www.cnvill.net/mfmassi.htm.

30. Kasmir Malevich, "Suprematist Compositions," www.ibiblio.org/wm/paint/auth/malevich/sup/.

31. "It was straight from the classes of Suzuki. The doctrine that he was expressing was that everything and every body, that is to say every non-sentient being and every sentient being, is the Buddha. These Buddhas are all, every single one of them, at the center of the universe. And they are in interpenetration, and they are not obstructing one another." From Richard Kostelanetz and John Cage, "The Aesthetics of John Cage: A Composite Interview," *Kenyon Review* (New Series) 9, no. 4 (autumn 1987): 106.

32. Cage interviewed by Cummings.

33. Richard Kostelanetz, *The Theatre of Mixed Means* (Dial Press, 1968), 57.

34. Martin Duberman, *Black Mountain: An Exploration in Community* (New York: Dutton, 1972).

35. Kostelanetz and Cage, "The Aesthetics of John Cage," 102.

36. John Cage interviewed by Richard Friedman, Pacifica Radio Archives Preservation and Access Project, December 1969.

37. Fields, *How the Swans Came to the Lake*, 196.

38. John Cage, *A Year From Monday* (Middletown, CT: Wesleyan University Press, 1967), 98.

39. John Cage, "Untitled statement, Stable Gallery, 1953," in *Silence* (Middletown, Connecticut: Wesleyan, 1961), 111.

40. The Heart Sutra reads,

> *In emptiness there is no form*
> *No feeling*
> *No perception*
> *No formation*
> *No consciousness*
> *No eye*
> *No ear*
> *No nose*
> *No tongue*
> *No body*
> *No mind*
> *No appearance*
> *No sound*
> *No smell*
> *No taste*
> *No touch*

41. Anastasi.

42. Kostelanetz, *John Cage: An Anthology*, 31.

43. April Kingsley, *Franz Kline: A Critical Study of the Mature Work, 1950–1962*, doctoral thesis, City University of New York, 2000.

44. Richard Kostelanetz, *John Cage, Writer* (New York: Routledge, 1993), xv.

45. Diamond Sangha Archives, "Conversation, D. T. Suzuki and John Cage," also possibly with David Tudor, transcription, published July 1975.

46. Larry Poons in discussion with the author, June 13, 2006.

47. John Cage at the Raymond Fogelman Library, New School University.

48. Fetterman, *John Cage's Theater Pieces,* 419.

49. Jackson Mac Low in correspondence with the author on 13 November 13, 1992, and September 6, 1999.

50. Richard Schechner and Michael Kirby, "John Cage Interview," *Tulane Drama Review* 10, no. 2 (Winter 1965): 67.

51. Altschuler et al., "John Cage's Course."

52. Ibid.

53. Ibid.

54. From Jackson Mac Low, "How Maciunas Met the New York Avant Garde," *Art and Design Magazine,* Profile No. 28, "Fluxus Today and Yesterday," 1993, Academy Group, London, edited by Johan Pijnappel.

55. Cage, *A Year from Monday,* 34.

56. This included Takehisa Kosugi, Yasunao Tone, Akimichi Takeda, Mieko Shiomi, and Nobutaka Mizuno.

57. Retrieved from http://www.mailartist.com/johnheldjr/InterviewWith AlanKaprow.html.

58. Ibid.

59. Allan Kaprow interviewed by Dorothy Seckler, Archives of American Art.

60. Allan Kaprow interviewed by John Held Jr., Dallas Public Library Cable Access, 1988.

61. Allan Kaprow, *Essays on the Blurring of Art and Life* (Berkeley: University of California Press, 1993), 7.

62. Schechner and Kirby, "John Cage Interview," 21.

63. George Brecht, *Journals,* vol. 2, 107.

64. George Brecht, *Journals,* vol. 6, 74.

65. The actual instructions say "Drip Music—For single or multiple performance. A source of dripping water and an empty vessel are arranged so that the water falls into the vessel." Ken Friedman's *Fluxus Performance Workbook* (2002) states, "Drip Music, Fluxversion 1—first performer on a tall ladder pours water from a pitcher very slowly down into the bell of a French horn or tuba held in the playing position by a second performer at floor level" (60).

66. Ken Friedman's *Fluxus Performance Workbook* (2002) notes, "Time-Table Event—To occur in a railway station. A time-table is obtained.

A tabulated time indication is interpreted in minutes and seconds (for example, 7:16 equals 7 minutes and 16 seconds). This determines the duration of the event."

67. Alison Knowles in discussion with the author, 2006.
68. New School Panel, a panel discussion on John Cage and his work, with Alison Knowles, Jackson Mac Low, Merce Cunningham, at the New School for Social Research, New York, October 1999.
69. Cage, *A Year from Monday*, 69.
70. History of Sogetsu Art Center retrieved from http://www.sogetsu.or.jp/e/know/about/timeline/.

Chapter 3

1. Ellsworth Snyder, "John Cage Discusses Fluxus," *Fluxus: A Conceptual Country, Visual Language* 26, no. 11/12 (Winter/Spring 1992).
2. According to Knowles, "So many of the pieces looked at an object as a beautifully shaped thing... [including] instruments for their beauty before they are played or an act destroys them." Alison Knowles in discussion with the author, February 2008.
3. This performance was known as *Zen for Head*.
4. Knowles, February 2008. Knowles also noted that *Zen for Head* doubles as La Monte Young's piece *Draw a Straight Line and Follow It*.
5. Knowles, February 2008.
6. Knowles, 2006
7. Knowles, July–October 2001.
8. Ibid.
9. Retrieved from theologytoday.ptsem.edu/oct1989/v46-3-article1.htm.
10. Video History Project, www.experimentaltvcenter.org/history/tools/ttext.php3?id=17&page=1.
11. Hannah Higgins, *Fluxus Experience* (Berkeley: University of California Press, 2002), 1. Higgins mentions that George Brecht, Al Hansen, Dick Higgins, Scott Hyde, Allan Kaprow, Florence Tarlow, Jackson Mac Low, Harvey Gross, George Segal, Jim Dine, Larry Poons, and La Monte Young also attended.

12. Emmett Williams, *My Life in Flux—and Vice Versa* (London: Thames and Hudson, 1992), 163.

13. John Cage, Philip Corner, Terry Riley, T. Jennings, Jed Curtis, Griffith Rose, Dick Higgins, La Monte Young, and George Brecht all performed in that first concert. Later in the evening a second concert featured an all Japanese line-up including Toshi Ichiyangi, Yoriaki Matsudaira, Shinichi Matsushita, Yoko Ono, Keijiro Sato, Yuji Takahashi, Toru Takemitsu, and Yasunao Tone.

14. Over the course of that month there were piano compositions by Karl Stockhausen, David Tudor, Alvin Lucier, Emmett Williams, Nam June Paik, and Richard Maxfield. Jackson Mac Low, another Suzuki and Cage alumnus, contributed *Ein Stück für Sari Dienes.* Nam June Paik performed his *Homage to John Cage,* and Ben Patterson showcased *Septet with Lemons.* George Brecht produced *Word Event.* Stan Vanderbeek showed a film, and on the final day there was French music and performances.

15. *Stars and Stripes,* October 21, 1962.

16. This piece is known as "Danger Music Number Two; Hat. Rags. Paper. Heave. Shave, 1961," according to Friedman, *Fluxus Performance Workbook,* 23. Knowles commented that Higgins picked up an egg from a bowl of a dozen eggs, broke it on his eye, and then smeared butter on his face and freshly shaved head (in discussion with the author, 2008).

17. *Stars and Stripes,* October 21, 1962.

18. Knowles, 2001, New York City.

19. "Proposition, Make a Salad," 1962, Friedman, *Fluxus Performance Workbook,* 33.

20. Knowles, 2001.

21. Knowles, 2001.

22. Other sources say it was 112 Canal Street.

23. These included Toshi Ichiyanagi, Terry Jennings, Henry Flynt, Joseph Byrd, Jackson Mac Low, Richard Marxfield, La Monte Young, and Simone Forte, with a sculptural environment by Robert Morris. There were performances by jazz musician Ornette Coleman, choreographer and dancer Yvonne Rainer, and avant-garde performer Charlotte Moorman.

24. La Monte Young, www.diapasongallery.org/archive/01_06_20.html.

25. Jackson Mac Low in discussion with the author, 2001.

26. Other accounts put this concert in August 1960 and mention Ray John-son, Reginald Daniels, and Jackson Mac Low as participating in addition to the others mentioned above.

27. "Tree Movie—Select a tree. Set up and focus a movie camera so that the tree fills most of the picture. Turn the camera and leave it on without moving it for any number of hours. If the camera is about to run out of film, substitute a camera with fresh film. The two cameras may be alter-nated in this way any number of times. Sound recording equipment may be turned on simultaneously with movie camera. Beginning at any point in the film, any length of it may be projected at a showing. For the word 'tree' one may substitute 'mountain,' 'sea,' 'flower,' 'lake,' etc." Jackson Mac Low, 965 Hoe Avenue, New York 59, NY, January 1961.

28. Higgins, *Fluxus Experience,* 198.

29. At those events were the poet Chester V. J. Anderson, the composer Joseph Byrd, the choreographer and writer Robert Dunn, the storyteller and writer Spencer Hoist, the poets Joan Kelly and Robert Kelly, the painter Iris Lezak, the dancer Simone Forti, the poet-critic John Perreault, the composer Shi-mon Tamari, the poet Diane Wakoski, and the composer La Monte Young. Preceding him was an evening of poetry organized by Diane Di Prima and Leroi Jones (Amiri Baraka) as part of their magazine *The Floating Bear.* Jackson Mac Low, "How Maciunas Met the New York Avant Garde," in *Fluxus Today and Yesterday (Art & Design Profile No. 28, Special Issue),* ed. Johan Pijnappel. (London: Academy Editions, 1993), 37–49.

30. The anthology included Concept Art, Meaningless Work, Natural Disas-ters, Indeterminacy, Improvisation, Plans of Action, Stories, Diagrams, Poetry, Essays, Dance Constructions, Compositions, Mathematics by George Brecht, Claes Bremer, Earle Brown, Joseph Byrd, John Cage, David Degener (none of whose works appeared in it), Walter De Maria, Henry Flynt, Yoko Ono, Dick Higgins, Toshi Ichiyanagi, Terry Jennings, Denis (Johnson), Ding Dong, Ray Johnson, Jackson Mac Low, Richard Maxfield, Robert Morris (who took out his work before the book was collated), Sim-one Morris (known for many years by her original name, Simone Forti), Nam June Paik, Terry Riley, Dieter Rot, James Waring, Emmett Williams,

Christian Wolff, and La Monte Young. La Monte Young was the editor and George Maciunas the designer, and it was published by both in New York in 1963. Heiner Friedrich published a second edition in 1970. Information from Jackson Mac Low in discussion with the author, May 2001.

31. The January 8 concert included George Brecht, Claes Bremer, Earle Brown, Joseph Beuys, John Cage, Walter De Maria, Henry Flynt, Yoko Ono, Dick Higgins, Toshi Ichiyanagi, and Terry Jennings. Jackson played the violin in Brown's piece. The February 1962 concert had works with Dennis Johnson, Ray Johnson, Richard Maxfield, Robert Morris, Simone Morris Forti, Nam June Paik, Terry Riley, Dieter Rot, James Waring, Emmett Williams, Christian Wolff, La Monte Young, and Jackson.

32. This performance actually had its roots in the work of Dada painter Jean Arp. In 1916 Arp created a collage using torn pieces of people coated with glue that were dropped by chance operations onto a larger piece of paper. Glued whereever they fell, the point was to revolt against technical virtuosity.

33. The Yam (May) festival coordinated by the Smolin Gallery, with happenings, performances, and dance events around the city on different days, including the Hardware Poet's Playhouse on West Fifty-Fourth Street with a number of Judson Dance Theater dancers. On May 19, at George Segal's farm in South Brunswick, Allen Kaprow presented an afternoon of happenings, dance, and music. Trisha Brown and Yvonne Rainer danced, Al Hansen threw rolls of toilet paper up into the branches of trees, and Wolf Vostell "prepared" a TV by covering it in barbed wire, smashing a hole through it, and, since this took place on private property, burning it. There was no one to interfere with the high jinks, and the artists could use anything and everything they wished: chicken coops, trees, even tractors.

34. Jackson Mac Low, "Buddhism, Art, Practice, Polity," in *Beneath a Single Moon,* eds. Kent Johnson and Craig Paulenich (Boston: Shambhala, 1991), 177.

35. However, this probably traces back to the Dadaist Raoul Hausman, who made the first sound poems ("bbb," "fmsbw," and "kpierioum")

in 1918, when printed letters were chosen out of a box (DADA Show, Museum of Modern Art, June 2006).

36. Snyder, "John Cage Discusses Fluxus," 63.

37. George Brecht, "Something about Fluxus," *Fluxus Newspaper No. 4,* June 1964.

38. Mac Low, "How Maciunas Met the New York Avant Garde."

39. The meal consisted of "a tuna fish sandwich on whole wheat toast with butter, no mayo, and a cup of buttermilk or the soup of the day." Higgins, *Fluxus Experience,* 47.

40. Knowles, 2001.

41. *Anthologist* 30, no. 4 (1959): 4–24. Unrevised score of "18 Happenings in 6 Parts."

42. Fales Library, NYU, the Downtown Collection. Available at http://library .nyu.edu/collections/policies/fales_dwntwn.html.

43. According to an interview Kaprow gave in 1988, the first use of the word "happening" occurred almost by accident in a paragraph toward the end of an article he wrote on Jackson Pollock concerning the painter's legacy ("The Legacy of Jackson Pollock," *Art News,* October 1958). Interview conducted by John Held, Dallas Public Library Cable Access Studio, 1988.

44. It ran on October 4, 6, 7, 8, 9, and 10.

45. The "Cast of Participants" was made up of Kaprow, Rosalyn Montague, Shirley Prendergast, Lucas Samaras, Janet Weinberger, Robert Whitman, Sam Francis, Red Grooms, Dick Higgins, Lester Johnson, Jay Milder, George Segal, Robert Thompson and Ben Priest. This list appeared in the original program in George Brecht, Notebooks, vol. 3, 52.

46. André Lepecki, "Redoing 18 Happenings in 6 Parts," in Allan Kaprow, *18 Happenings in 6 Parts* (Steidl Hauser & Wirth, Germany), 46.

47. John Cage interviewed by Ted Berrigan, umintermediai501.blogspot.com /search/label/interviews.

48. Allan Kaprow, "The Principles of Modern Art," *It Is* 4 (Autumn 1959): 51.

49. Fales Library.

50. *Time,* March 14, 1960, 80.

51. Diane di Prima, *Recollections of My Life as a Woman: The New York Years* (New York: Viking Penguin, 2001).

52. Di Prima and Baraka published *The Floating Bear* at 309 E. Houston Street. This was a small, semimonthly, mimeographed newsletter of 250 copies mailed to 117 people. *Floating Bear* No. 20 ran a story about how on April 25 and 26, 1962, Jones and di Prima had to go before a grand jury to determine if *Floating Bear* No. 9, which presented Jones's "System of Dante's Hell" and William Burroughs's "The Routine," was guilty of sending obscene works through the mail. Fortunately, they were not indicted. In 1963 Jones stepped down as coeditor, leaving di Prima as sole editor from 1963 to 1969. She published many writers including Philip Whalen, Charles Olsen, Allen Ginsberg, Frank O'Hara, John Weiners, Robert Duncan, Michael McClure, Robert Creely, Ed Dorn, and Joel Oppenheimer.

53. Higgins, *Fluxus Experience.*

54. Allen Hughes, "Dance: A Place and Time for Finding New Ways to Move," *New York Times,* June 3, 2001, 30.

55. Ibid.

56. The first official Judson Dance Theater concert took place on July 6, 1962, with dance works presented by Steve Paxton, Freddie Herko, David Gordon, Alex and Deborah Hay, Yvonne Rainer, Elaine Summers, William Davis, and Ruth Emerson.

57. Allen Hughes, "Judson Dance Theater Seeks New Paths," *New York Times,* June 26, 1963.

58. Sally Kempton, "Beatitudes at Judson Memorial Church," *Esquire,* 1966.

59. Robert Nichols (founder of Judson Poets' Theater), "An Evaluation of Judson Dance Theater," unpublished manuscript, Fales Library, New York University. Available at http://library.nyu.edu/collections/policies/fales_dwntwn.html.

60. Monk went on to perform *Break* at the Village Theater in 1967.

61. During 1962 to 1964 the center invited John Cage, David Tudor, George Brecht, Yoko Ono, the Merce Cunningham Dance Company, Jasper Johns, and Robert Rauschenberg. These events tremendously influenced young Japanese artists.

62. Retrieved from http://ubu.artmob.ca/sound/group_ongaku/Group-Ongaku_Automatism_1960.mp3.

63. Retrieved from http://www.scaithebathhouse.com/en/artists/genpei
_akasegawa/biography/.

64. Retrieved from www.new-york-art.com/e/Ushio-Shinohara.htm.

65. "Street Cleaning Event—Performers are dressed in white coats like labo-
ratory technicians. They go to a selected location in the city. An area of
a sidewalk is designated for the event. This area of sidewalk is cleaned
very thoroughly with various devices not usually used in street cleaning,
such as dental tools, toothbrushes, steel wool, cotton balls with alcohol,
cotton swabs, surgeon's sponges, toothpicks, linen napkins, etc." Fried-
man, *Fluxus Performance Workbook*.

66. *Gu* translates as tool and *tai* as body, so the translation can loosely be
"embodiment."

67. See Appendix V for a list of Gutai artists and journals.

68. Larry Miller in discussion with the author, October 27, 2004.

69. Al Hansen, *A Primer of Happenings and Time/Space Art* (New York:
Something Else Press, 1965), 68.

70. According to Kaprow, "Alfred Leslie told me about an article he had read
in the *New York Times* [Ray Falk, "Japanese Innovators," *New York
Times*, December 8, 1957, 24]. It was in the Sunday paper, but I hadn't
read the *Times* that particular Sunday. Leslie saw I was moving into a
kind of wild spatialized collage/assemblage mode, and he said, 'Hey, did
you read about this?'" Allan Kaprow interviewed by Susan Hapgood,
Encinitas, CA, August 12, 1992. Kaprow also mused, "It's possible to
say with some caution that the Happenings allowed a good bit of Fluxus
to take place, just as Gutai provided some justification for the early Hap-
penings. You can also say that earthworks, particularly earthworks that
were site-specific, were given their permission by the earlier example of
Happenings, although they had nothing to do with each other directly."

71. Yasunao Tone in discussion with the author.

72. Ibid.

73. Ibid.

74. Ibid.

75. Ibid.

Chapter 4

1. Other artists who frequented the Waldorf Cafeteria included Chaim Gross, Franz Kline, Isamu Noguchi, Mercedes Matter, Joop Sanders, Landes Lewitin, Ibram Lassaw, Aristodimos Kaldis, Arshile Gorky, John Graham, Hans Hofmann, Frederick Kiesler, and an occasional ambivalent Jackson Pollock.

2. According to Denise Lassaw (in correspondence with the author), "Some of these artists, esp. David Hare, who was basically a surrealist, they formed groups—at least two groups anyway, because they were all artists who were not selling, not showing their work. They were all interested in the philosophy behind what they were discovering, needed to talk to other artists who understood or at least were also on the same path. It was for mutual support—and cheered them up as they were all mostly broke. You have to remember that the New York scene was basically small. Everyone knew each other from the Village, the Washington Square art show, the WPA, Arts Students League, and other schools. Another place was the Clay Club, where several sculptors who later became well known began their studies. This included Noguchi, Lassaw, Harry Holtzman, etc. They showed together there since the late twenties, early thirties, and into the fifties . . . The Clay Club is now The Sculpture Center in Queens."

3. Mark Stevens and Annalyn Swan, *De Kooning: An American Master* (New York: Knopf, 2005), 286.

4. James T. Valliere in *Partisan Review,* Fall 1967. Quote provided courtesy of Denise Lassaw.

5. Denise Lassaw in correspondence with the author.

6. According to Philip Pavia's book, *Club without Walls: Selections from the Journals of Philip Pavia* (New York: Middlemarch Arts Press, 2007), "the space would not be available until September 1st. Lewitin and I rented it from Sailors Snug Harbor Real Estate Corporation for $80 per month" (53).

7. The twelve original charter members were Giorgio Cavallon, L. Al Copley, Bill de Kooning, Franz Kline, Ibram Lassaw, Landis Lewitin, Corrado

Marca-Relli, Philip Pavia, Milton Resnik, Jan Roelants, James Rosati, and Joop Sanders.

8. Pavia, *Club without Walls*, 55.

9. Denise Lassaw, July 2006.

10. Over the years some of the other members listed were Grace Borgenicht, Louise Borgeois, Rudy Burkhardt, Merce Cunningham, Edwin Denby, Joan Mitchell, Philip Pearlstein, Fairfield Porter, Richard Pousette-Dart, Larry Rivers, Barney Rossett, and David Tudor (Saburo Hasegawa and Isamu Noguchi were also listed). Past or suspended members were listed as William Barrett, Aldolph Gottlieb, Jackson Pollock, Mark Rothko, and Clifford Still.

11. Clement Greenberg, "The New Sculpture," *Partisan Review* 16, no. 6 (June 1949): 637–642.

12. American Abstract Artists had its first Exhibition in the Squibb Building in 1937, according to a handwritten note by Ibram Lassaw in the Archives of American Art.

13. Retrieved from http://www.aaa.si.edu/collections/interviews/oral-history -interview-herbert-ferber-12988.

14. Retrieved from www.artnet.com/Magazine/features/cfinch/cfinch5-15 -98.asp.

15. John Cage became a new member on December 11, 1953, according to Philip Pavia's papers at the Archives of American Art.

16. Cage's "Lecture on Something," given at The Club in January 1950, was not printed until 1959 in Pavia's *It Is*. John Cage, *Silence: Lectures and Writings* (London: Calder and Boyars, 1971), 128.

17. It also was backed by the International Arts Council, financed by the Rockefeller Brothers Fund and the USIA, who used the radical art movement to act as soft propaganda for America's interests during the cold war.

18. Kristine Stiles and Peter Selz, *Theories and Documents of Contemporary Art* (Berkeley: University of California Press, 1996), 42.

19. See Appendix VI for *It Is* announcement/manifesto.

20. Sarah Johnson, *Zen and Artists of the Eighth Street Club: Ibram Lassaw and Hasegawa Saburo*, doctoral thesis, CUNY, 2005, 19.

21. Ibid.

22. Ibid. At this point Cage had not yet attended D. T. Suzuki's weekly classes at Columbia University.

23. Retrieved from http://www.aaa.si.edu/collections/interviews/oral-history -interview-ludwig-sander-11909.

24. Based on an October 3 panel "On Music"; the speaker was Henry Cowell, introduced by Cage. Pavia's notes say "beginning of Cage influence: Zen," then an October 31, 1952, panel on Artaud, moderated by M. C. Richards and introduced by Cage with Pavia's notation "Zen."

25. Retrieved from http://www.aaa.si.edu/collections/interviews/oral-history -interview-james-brooks-12719.

26. Years later, in 1972, *Four Stones for Kanemitsu,* a short documentary about his work as a master lithographer at the Tamarind Lithography Workshop, was nominated for an Academy Award.

27. According to the daybooks of Ernestine Lassaw, on November 19, Holtzman, Hasegawa, John Ferren, and Ibram Lassaw gave a talk on Zen at The Club, Courtesy of Denise Lassaw.

28. Ibram Lassaw, MOMA Statement, 1956.

29. Lassaw, handwritten copy for statement, Archives of American Art.

30. Indra's Net consists of a jewel tied to each knot in a net, reflecting all images of all the other jewels on into infinity.

31. Ibram Lassaw, daybooks, Archives of American Art.

32. For an explanation of this see Chögyam Trungpa, *Dharma Art* (Boston: Shambhala, 1996).

33. Chögyam Trungpa, *The Art of Calligraphy: Joining Heaven and Earth,* ed. Judith L. Lief (Boston: Shambhala, 1994), 19.

34. Stanley Breul, "Kill the Buddha," *It Is,* no. 2 (Autumn 1958): 65.

35. Ibid.

36. Ibid.

37. Willem de Kooning, Stedelijk Museum catalogue no. 445, 1969, from *Willem de Kooning: Collected Writings* (Madras, India: Hanuman Books, 1988), 169. Quote courtesy research of Denise Lassaw.

Chapter 5

1. Proposal to the Bollingen Foundation: "A Proposed Study To the Environment of Leisure" (1949) The Isamu Noguchi Garden Museum, www .noguchi.org/proposals.html#bolligen Accessed March 8, 1998.

2. "Isamu Noguchi to no hibi" [My Days with Isamu Noguchi], in Saburo Hasegawa and Inui Yoshiaki, *Painting and Treatise,* vol. 2, *Ronbun* [Treatise] (Tokyo: Sansaisha, 1977), 100.

3. Alexandra Munroe, *Japanese Art after 1944: Scream against the Sky* (New York: Harry N. Abrams, 1944), 382.

4. Bert Winther, *Isamu Noguchi: Conflicts of Japanese Culture in the Early Postwar Years,* doctoral thesis, New York University, 1992, 136.

5. Larry Smith, Mei Hui Huang, Li Po Shan, and Wei Wang, *Chinese Zen Poems: What Hold Has This Mountain* (Huron, OH: Bottom Dog Press, 1999).

6. Ashton Dore, *Noguchi East and West* (New York: Knopf, 1992).

7. Isamu Noguchi, *Essays and Conversations* (New York: Harry N. Abrams, 1994), 33.

8. Ryan Holmberg, *Dragon Knows Dragon,* independent paper, Art History Department, Boston University, 1998. Used by permission of the author.

9. Ibid.

10. For a summary of the mission of *Bokubi,* see Appendix VII.

11. Letter translated from the Japanese in April Kingsley, *Franz Kline: A Critical Study of the Mature Work, 1950–1962,* doctoral thesis, City University of New York, 2000.

12. Ryan Holmberg, p. 61 from Kline, "Furansu Kurain-shi no tegami" [Franz Kline's Letter], written March 8, 1952, printed in *Bokujin* No. 2: 2. April Kingsley dates this letter as appearing in *Bokubi* No. 5 (May 1952).

13. Ibid. "Is there anyone not surprised at seeing the affinities between calligraphy and Kline's current paintings which were published in the May issue of *Bokubi*? In comparison with those that appeared in the first issue of *Bokubi,* the present works are more concise—a 'simplification,' just as Kline has said. Anyone can see this and I wonder if he was not influenced by the issues of *Bokubi* [that he has been receiving] over the past year. Some works resemble *mokkan* [ancient calligraphy on wood], and then

others (see fig. VI-4) look like the character for 'army' as in Empress Kmy's version of the 'Eulogy of Yue Yi.' I see an extremely pure, simple, bold, free, and open grasping of calligraphic form in Kline's work. Those calligraphers who are not impassioned upon seeing this are simply invalids beyond all help." Inoue Yuichi, "Kurain-shi no tegami wo yonde" [On Reading Kline's Letter], *Bokujin* No. 2, 39.

14. Holmberg, *Dragon Knows Dragon.*
15. See Appendix IV for a list of participants.
16. Archives of American Art, Abstract Art around the World Today, Panel at MOMA, March 16, 1954.
17. Ibid., 6.
18. Ibid., 10.
19. Ibid.
20. Ibid.
21. Museum of Modern Art Press Release No. 65, 1954.
22. Dore Ashton, "New Japanese Abstract Calligraphy," *Arts Digest,* August 1954.
23. Hasegawa was written about in *ARTNews, Art Digest, Atlantic Monthly, Boston Herald, Caellian, Chicago Tribune, Christian Science Monitor, New York Herald Tribune, New York Times, New Yorker, Oakland Tribune, San Francisco Chronicle,* and *Time.*
24. Isamu Noguchi interviewed by Paul Cummings, http://www.aaa.si.edu /collections/interviews/oral-history-interview-isamu-noguchi-11906.
25. Moira Roth, *Bernice Bing: A Narrative Chronology,* http://www .queerculturalcenter.org/Pages/Bingshow/BBChron.html.
26. Michael Wenger and Kaz Tanahashi, "Creation in the Instant: an Interview with Painter Gordon Onslow Ford," *Wind Bell,* Fall 1991, Zen Center of San Francisco.

Chapter 6

1. Gary Snyder in *A Zen Life: D.T. Suzuki,* a film by Michael Goldberg, executive producer and director, the D.T. Suzuki Documentary Project Japan Inter-Culture Foundation, 2005–2008. Used with permission of Gary Snyder.

2. Barry Miles, *Ginsberg: A Biography*, 2nd rev. ed. (New York: Virgin Books, 2001), 566–68.

3. The last living witness to this meeting, Edward H. Dougal, conveyed the following in private correspondence on June 27, 2011:

> In at least two talks I have had with M-san [Mihoko Okamura], she mentioned how she had wished you had referred to her story she told you (not in your chapter) about Kerouac coming to her mother's house in NYC with two guys to meet DTS [Suzuki] in about 1956. I was fuzzy in memory about her telling of the story, so for contrast/comparison, I read her the attached story I got from the Buddhist Society's short biography (50 pages or so) of DTS, which had been included as reference at the end of Carl Jackson's chapter in the SUNY book. (M-san said she did not have a copy of the bio, even though Louise Marchant is sure it had been sent to her long ago.)
>
> After I had read out this story, she said that part of it was true and part not true. We figured that Kerouac had lost some valuable details by the time he wrote it in 1960 at Berkeley, and M-san reminded me that she had told me parts of the story before. Now she gave me the whole thing, from start to end, and said she had given it to you this way also—not recorded perhaps. M-san:
>
> "I was sick with a cold that day when K [Kerouac] called around tea time in the afternoon. Dr. S [Suzuki] usually had ceremonial tea then and had been hoping to get in touch with K about his Zen views and their limitations. K had graduated from Columbia, before Dr. S's time there, and S. was biding his time until they crossed paths around Columbia or in NY anywhere, during one of K's visits. When he did call to ask to meet that day, S set up the chairs, without my help. Later he led the three men in. One of them was the poet fellow... (I asked, 'Snyder?' She said, 'No, the other poet.' I asked, 'Oh, Ginsberg?' She: 'Yes, I think so. He was not really interested in Zen, you know.')
>
> "I listened as Dr. S made thick ceremonial tea, turning the whisk, and serving them in traditional tea bowls/chawan. I heard K's loud

question about Bodhidharma through the sliding doors. Dr. S told them that freedom has to be accompanied by responsibility, otherwise it made no sense—that freedom has responsibility on the other side of the one coin, inseparable in essence. This was his main message to them, which he had been saving for them so long.

"When they went outside and the young men stepped down the stairway or stoop, K said these very words: 'I could live with you forever!' Dr. S immediately replied, 'Come along!'"

So, Ellen, it is the freedom-responsibility part that M-san wished you had included in your chapter. Everything rests on that one teaching to the three visitors. It was their only meeting—K's and S's, she says. (Although I know Gary Snyder tells of meetings with S and his enjoying M-san's beauty...)

4. D. T. Suzuki, "Zen in the Modern World," *Japan Quarterly* 5, no. 4 (October–December, 1958): 453.
5. Ibid.
6. Mihoko Okamura in discussion with the author, June 15, 2005, Kyoto, Japan.
7. Suzuki, "Zen in the Modern World," 373. Suzuki is quoting *La personne et le Sacre* (in *Ecrits de Londres,* Gallimard, 1957), as quoted in Richard Rees, *Brave Men: A Study of D. H. Lawrence and Simone Weil* (London: 1958), 45.
8. Michael Goldberg in correspondence with the author, Tokyo, Japan. Used with permission of Gary Snyder.
9. Ann Charters, *Selected Jack Kerouac Letters, 1957–1969* (New York: Penguin Books, 2000), 98.
10. Ellen Pearlman, "Biography, Mythology, and Interpretation: Interview with Allen Ginsberg," *Vajradhatu Sun* 12, no. 4 (April/May 1990).
11. George Plimpton, "Beat Writers at Work," *Paris Review* (1999): 53.
12. Ibid.
13. Ibid.
14. Ibid.
15. Ibid.

16. Ibid., 59.

17. Ibid.

18. Pearlman, "Biography, Mythology, and Interpretation."

19. Entry for Sunday, July 25, 1948, in Jack Kerouac, *Windblown World: The Journals of Jack Kerouac 1947–1954,* ed. Douglas Brinkley (New York: Viking Penguin, 2004).

20. Allen Ginsberg and Bill Morgan, *Deliberate Prose: Selected Essays 1952-1995.* (New York: Harper Collins, 2000), 364.

21. Rick Fields, *How the Swans Came to the Lake* (Boston: Shambhala, 1981), 213.

22. There are two points of view on the origin of "first thought, best thought." According to Peter Hale of the Allen Ginsberg Estate, "In Allen's mind writing slogans, he credits Trungpa. It's the very first slogan in fact. Whether that's Allen reattributing it, we'll never know. At the very top however, he quotes Blake's slightly alternate: 'First thought is best in Art, second in other matters.'" Peter Hale in discussion with the author, September 2008.

23. Ellen Pearlman, notes from weeklong seminars, lectures, and press conferences at the dedication of The Ginsberg Library at Naropa University, July 1994, Boulder, Colorado.

24. *Pull My Daisy* was a film by Robert Frank and Alfred Leslie. Cast members were Allen Ginsberg, Gregory Corso, Larry Rivers, Peter Orlovsky, David Amram, Richard Bellamy, Alice Neel, Sally Gross, Pablo Frank, Jack Kerouac, and Delphine Seyrig.

25. David Amram in discussion with the author.

26. Al Aronowitz website, www.blacklistedjournalist.com/1beat.html.

27. According to Joyce Johnston at a panel at the Brooklyn Literary Festival for the fiftieth anniversary of *On the Road* on September 16, 2007, Kerouac wrote *On the Road* "by drinking prodigious amounts of coffee, but typed it up high on Benzedrine."

28. Aronowitz.

29. Charters, *Selected Jack Kerouac Letters,* 356.

30. Ibid., 410. Following quote: ibid., 416.

31. Texts on Buddhism Kerouac told Ginsberg to read (ibid., 415–16):

Texts from the Buddhist Canon Known as Dharmapada (Samuel Beal, London and Boston 1878).

Life of Buddha, or *Buddha Charita* by Asvaghosh the Patriarch, translated by Samuel Beal (Sacred Books of the East, vol. 19)

The Gospel of Buddha by Paul Carus (Open Court, Chicago 1894).

Buddhism in Translations by Henry Clarke Warren (Harvard Oriental Series Vol. 3, Harvard U.P. 1896) Also in Harvard Classics.

The Buddhist Bible, Dwight Goddard (Goddard, Thetford, Vt.)

Buddhist Legends, E. W. Burlingame (Harvard Oriental Series Vol. 28, 30).

The Dialogs of the Buddha, Digha-nikaya (Rhys Davids, Oxford 3 vols.).

Visuddhi Magga by Buddhaghosha, trans. by P. M. Tin (The Path of Purity, Pali Text Society, Translation Series 11, 17, 21).

The Sacred Books and Early Literature of the East. Volume 18 India and Buddhism. (Parke, Austin and Lipscomb New York-London).

32. Aronowitz.

33. Charters, *Selected Jack Kerouac Letters,* 459.

34. Ann Charters, *Kerouac: A Biography* (New York: St. Martin's Griffin, 1994), 228.

35. Aronowitz.

36. Gary Snyder in discussion with the author, November 22, 2005.

37. Jacqueline Gens in discussion with the author.

38. Aronowitz.

39. *Evergreen Review* 1, no. 2.

40. Jack Kerouac, *Dharma Bums* (New York: Penguin, 1976).

41. Ibid.

42. Aronowitz.

43. Aronowitz.

44. Charters, *Selected Jack Kerouac Letters,* 199.

45. Ibid.

46. Ibid., 432.

47. Anne Waldman and Andrew Schelling, *Disembodied Poetics: Annals of the Jack Kerouac School* (Albuquerque: University of New Mexico Press, 1994), 372.

48. The letter from the president, dated July 3, 1942, reads, "Your Holiness: Two of my fellow countrymen, Ilia Tolstoy and Brooke Dolan, hope to visit your Pontificate in the historic and widely famed city of Lhasa. There are in the United States of America many persons, among them myself, who, long and greatly interested in your land and people, would highly value such an opportunity. As you know, the people of the United States, in association with those of twenty-seven other countries, are now engaged in a war which has been thrust upon the world by nations bent on conquest who are intent upon destroying freedom of thought, of religion, and of action everywhere. The United Nations are fighting today in defense of and for preservations of freedom, confident that we shall be victorious because our cause is just, our capacity is adequate, and our determination is unshakable. I am asking Ilia Tolstoy and Brooke Dolan to convey to you a little gift in token of my friendly sentiment towards you. With cordial greetings, I am very sincerely yours, Franklin D. Roosevelt." It is addressed to His Holiness The Dalai Lama, Supreme Pontiff of the Lama Church, Lhasa. From the Franklin D. Roosevelt Library, Hyde Park, NY.

49. Ilia Tolstyo, Letter to Jerome V. Deyo, September 21, 1970, Roosevelt Library.

50. Anne Waldman in discussion with the author, May 21, 2006.

BIBLIOGRAPHY

Books

Abe, Masao. *A Zen Life: D. T. Suzuki Remembered*. New York: Weatherhill, 1986.

Allione, Tsultim Ewing. *Fried Shoes, Cooked Diamonds, Interviews and Conversations,* unpublished manuscript, Carmina Cinematografica, 1978.

Art and Design Magazine, Profile No. 28, "Fluxus Today and Yesterday." London: Academy Group, 1993.

Ashton, Dore. *Noguchi East and West*. New York: Alfred A. Knopf, 1992.

Baas, Jacquelynn. *Smile of the Buddha*. Berkeley: University of California Press, 2005.

Baas, Jacquelynn, and Mary Jane Jacobs. *Buddha Mind in Contemporary Art*. Berkeley: University of California Press, 2004.

Banes, Sally. *Democracy's Body: Judson Dance Theater, 1962–1964*. Durham, NC: Duke University Press, 1993.

Banes, Sally. *Greenwich Village 1963*. Durham, NC: Duke University Press, 1993.

Batchelor, Stephen. *The Awakening of the West: The Encounter of Buddhism and Western Culture*. New York: Aquarian, HarperCollins, 1994.

Bowie, Henry. *On the Laws of Japanese Painting*. New York: Dover, 1951.

Brecht, George. *Chance Imagery*. New York: A Great Bear Pamphlet, 1966.

Brecht, George. *Notebooks I–V, 1958–1961*, ed. Dieter Daniels with collaboration of Hermann Braun. Cologne: Verlag der Buchhandlung Walther Konig, c. 1991.

Brinkley, Douglas. *Jack Kerouac: Windblown World; The Journals of Jack Kerouac, 1947–1954*. New York: Viking Penguin, 2004.

Burger, Peter. *Theory of the Avant-Garde*. Minneapolis: University of Minnesota Press, 1984.

Burroughs, William S. *The Retreat Diaries* (with the Dream of Tibet by Allen Ginsberg). New York: City Moon, 1976.

209

Cage, John. *A Year From Monday.* Middletown, CT: Wesleyan University Press, 1963.

Cage, John. *Silence.* Middletown, CT: Wesleyan University Press, 1961.

Charters, Ann. *Kerouac: A Biography.* New York: St. Martin's Press, 1973.

Charters, Ann. *Selected Jack Kerouac Letters, 1957–1969.* New York: Penguin Books, 2000.

di Prima, Diane. *Recollections of My Life as a Woman: The New York Years.* New York: Viking Press, 2001.

Duberman, Martin. Black *Mountain: An Exploration in Community.* New York: Dutton, 1972.

Duchamp, Marcel, Moira Roth, Jonathan Katz, and Saul Ostrow. *Difference / Indifference: Musings on Postmodernism, Marcel Duchamp, and John Cage.* In *Critical Voices in Art, Theory, and Culture.* Overseas Publishing Group, 1998.

Fields, Rick. *How the Swans Came to the Lake.* Boston: Shambhala, 1981.

Flemming, Richard, and William Duckworth. *John Cage at Seventy-Five.* Lewisburg, PA: Bucknell University Press, 1989.

Fluxus. *The Fluxus Performance Workbook.* Norway: El Djarida, 1990.

Freedgood, Lillian. *An Enduring Image.* New York: Thomas Crowell Company, 1970.

Friedlander, Benjamin, and Andrew Schelling, eds. *Jimmy and Lucy's House of "K,"* no. 9. *The Poetics of Emptiness.* January 1989.

Friedman, Ken, Smith Owen, and Lauren Sawdhyn. *Fluxus Performance Workbook,* Performance Research ePublication, 2002.

Gifford, Barry, and Lawrence Lee. *Jack's Book: An Oral Biography of Jack Kerouac.* New York: Penguin Books, 1979.

Glass, Philip. *Music of Philip Glass,* ed. Robert T. Jones. Cambridge, MA: Da Capo Press.

Goddard, Dwight. *A Buddhist Bible.* Boston: Beacon Press, 1994.

Goldberg, Rose Lee. *Laurie Anderson.* New York: Harry N. Abrams, 2000.

Goldberg, Rose Lee. *Performance, Live Art Since 1960.* New York: Harry N. Abrams, 1998.

Gudmunsen, Chris. *Wittgenstein and Buddhism.* New York: Barnes & Noble, 1977.

Hansen, Al. *A Primer of Happenings and Time/Space Art.* New York: Something Else Press, 1965.

Harris, Mary Emma. *The Arts at Black Mountain College.* Cambridge: MIT Press, 1987.

Heintze, James, R. *Perspectives on American Music Since 1950.* New York: Garland, 1999.

Heisig, James W., and John C. Maraldo. *Rude Awakenings: Zen, the Kyoto School, and the Question of Nationalism.* Honolulu: University of Hawai'i Press, 1994.

Herzogenrath, Wolf, and Andreas Kreul, eds. *Sounds of the Inner Eye: John Cage, Mark Tobey, Morris Graves.* Seattle: Museum of Glass: International Center for Contemporary Art in association with University of Washington Press, 2002.

Hisamatsu, Shin'ichi. *Zen and the Fine Arts.* New York: Kodansha International, 1982.

Hunter, Sam. *Isamu Noguchi.* New York: Abbeville Press, 2000.

Jackson, David P. *A Saint in Seattle: The Life of the Tibetan Mystic Dezhung Rinpoche,* Boston: Wisdom Publications, 2003.

Johnson, Kent. *Beneath A Single Moon.* Boston: Shambhala, 1991.

Kapleau, Philip. *The Three Pillars of Zen.* New York: Anchor Doubleday, 1980.

Kaprow, Allan. *18 Happenings in 6 Parts.* Germany: Steidl Hauser & Wirth.

Kaprow, Allan. *Assemblage, Environments, and Happenings.* New York: Harry N. Abrams, 1969.

Kaprow, Allan. *Essays on the Blurring of Art and Life.* Berkeley: University of California Press, 1993.

Kirby, Michael. *Happenings.* New York: Dutton, 1965.

Kostelanetz, Richard. *Conversing with Cage.* New York: Routledge, 1988.

Kostelanetz, Richard. *John Cage: An Anthology.* New York: Da Capo, 1970.

Kostelanetz, Richard. *John Cage (ex)plain(ed).* New York: Simon and Schuster, 1996.

Kostelanetz, Richard. *John Cage, Writer.* New York: Routledge, 1993.

Kostelanetz, Richard. *The Theatre of Mixed Means.* New York: Dial Press, 1968.

Kuenzli, Rudolph, ed. *Dada: Themes and Movements.* London: Phaidon, 2006.

Leonard, George. *Into the Light of Things: The Art of the Commonplace from Wordsworth to John Cage.* Chicago: University of Chicago Press, 1994.

Levy, Aaron, and Jean-Michel Rabaté. *William Anastasi's Pataphysical Society: Jarry, Joyce, Duchamp, and Cage.* Philadelphia, PA: Slought, 2005.

Lippart, Lucy R. *Six Years.* Berkeley: University of California Press, 1973.

Lipsey, Roger. *An Art of Our Own: The Spiritual in Twentieth Century Art.* Boston: Shambhala, 1997.

Lopez, Donald S., Jr.. *Curators of the Buddha: The Study of Buddhism under Colonialism.* Chicago: University of Chicago Press, 1995.

Lopez, Donald S., Jr. *Prisoners of Shangri-La.* Chicago: University of Chicago Press, 1998.

Maher, Paul. *Kerouac: The Definitive Biography.* Lanham, MD: Taylor Trade Publishing, 2004.

Midal, Fabrice. *Chögyam Trungpa: His Life and Vision.* Translated by Ian Monk. Boston: Shambhala, 2004.

Miles, Barry. *Ginsberg.* Rev. ed. New York: Simon and Schuster, 2000.

Mukpo, Diana. *Dragon Thunder.* Boston: Shambhala, 2006.

Munroe, Alexandra. *Scream against the Sky: Japanese Art after 1945.* New York: Harry N. Abrams, 1994.

Munroe, Alexandra. *The Third Mind: American Artists Contemplate Asia, 1860–1989.* New York: Guggenheim Museum, 2009.

Munroe, Alexandra. *Yes, Yoko Ono.* New York: Japan Society and Harry N. Abrams, 2000.

Nicholls, David. *John Cage.* Champaign: University of Illinois Press, 2007.

Nicholls, David. *The Cambridge Companion to John Cage.* New York: Cambridge University Press, 2002.

Noguchi, Isamu. *Essays and Conversations.* New York: Harry N. Abrams, 1994.

Noguchi, Isamu. *The Isamu Noguchi Garden Museum.* New York: Harry N. Abrams, 1987.

Packer, Randall, and Ken Jordan. *Multimedia: From Wagner to Virtual Reality.* New York: W. W. Norton, 2001.

Patterson, David W., ed. *John Cage: Music, Philosophy, and Intention, 1933–1950*. New York: Routledge, 2002.

Pavia, Philip. *Club without Walls: Selections from the Journals of Philip Pavia*. Edited by Natalie Edgar. New York: Middlemarch Arts Press, 2007.

Phillips, Bernard. "The Essentials of Zen Buddhism." Selected from the writings of George Plimpton, *Paris Review, The Beat Writers at Work*, Modern Library, 1999.

Porterfield, Amanda. *The Transformation of American Religion*. New York: Oxford University Press, 2001.

Portugés, Paul. *The Visionary Poetics of Allen Ginsberg*. Santa Barbara, CA: Ross-Erikson, 1978.

Retallack, Joan. *Musicage*. Middletown, CT: Wesleyan University Press, 1996.

Revill, David. *The Roaring Silence: John Cage; A Life*. New York: Arcade, 1992.

Rosenberg, Harold. *Artworks and Packages*. New York: Horizon Press, 1969.

Rychlak, Bonnie. *Zen No Zen: Aspects of Noguchi's Sculptural Vision*. New York: Isamu Noguchi Foundation, 2002.

Samuels, Robert. *The Boulez-Cage Correspondence*. New York: Cambridge University Press, 1993.

Schumacher, Michael. *Dharma Lion*. New York: St. Martin's Press, 1992.

Sharf, Robert. "The Zen of Japanese Nationalism." In *Curators of the Buddha: The Study of Buddhism under Colonialism*, edited by Donald S. Lopez Jr. Chicago: University of Chicago Press, 1995.

Shattuck, Roger, *The Banquet Years: The Origins of the Avant-Garde in France, 1885 to World War I*. New York: Vintage Random House, 1955.

Shultis, Christopher. *Silencing the Sounded Self*. Lebanon, NH: Northeastern University Press, 1998.

Starting at Zero: Black Mountain College, 1933–57. Mary Emma Harris, Arnolfini Gallery, Bristol and Kettle's Yard, Cambridge, England, 2005.

Stevens, Mark, and Annalyn Swan. *De Kooning: An American Master*. New York: Knopf, 2005.

Stiles, Kristine, and Peter Selz. *Theories and Documents of Contemporary Art.* Berkeley: University of California Press, 1996.

Suzuki, D. T. *Essays in Zen Buddhism.* 2nd series. New York: Samuel Weiser, 1971.

Suzuki, D. T. *The Essentials of Zen Buddhism.* New York: Dutton, 1962.

Suzuki, D. T. *Zen and Japanese Culture.* Princeton, NJ: Bollingen/Princeton University Press, 1959.

Tendzin, Ösel. *Buddha in the Palm of Your Hand.* Boston: Shambhala, 1982.

Tolstoy, Count Ilya. *Reminisces of Tolstoy, by His Son.* Translated by George Calderon. Available at Project Gutenberg, www.gutenberg.org.

Trungpa, Chögyam. *The Art of Calligraphy: Joining Heaven and Earth.* Edited by Judith L. Lief. Boston: Shambhala, 1994.

Trungpa, Chögyam. *The Collected Works of Chögyam Trungpa.* Vol. 7, *The Art of Calligraphy, Dharma Art, Visual Dharma.* Boston: Shambhala, 2004.

Trungpa, Chögyam. *Crazy Wisdom.* Boston: Shambhala, 1991.

Trungpa, Chögyam. *Cutting through Spiritual Materialism.* Boston: Shambhala, 1973.

Trungpa, Chögyam. *Dharma Art.* Edited by Judith L. Lief. Boston: Shambhala, 1996.

Trungpa, Chögyam. *Journey without Goal.* Boulder, CO: Prajna Press, 1981.

Trungpa, Chögyam. *The Teacup & The Skullcup,* Vajradhatu Publications, Halifax, 2007

Tsunoda, Ryusaku, William Theodore de Bary, and Donald Keen, eds. *Sources of Japanese Tradition.* Vol. 1. New York: Columbia University Press, 1958.

Tucci, Giuseppi. *The Theory and Practice of the Mandala.* New York: Samuel Weiser, 1973.

Tworkov, Helen. *Zen in America: Profiles of Five Teachers: Robert Aitken, Jakusho Kwong, Bernard Glassman, Maurine Stuart, Richard Baker.* New York: North Point Press, 1989.

Tytell, John. *The Living Theater: Art, Exile, and Outrage.* New York: Grove Press, 1995.

Vaughn, David. *Hazel Larsen Archer, Photographer.* Asheville, NC: Black Mountain College Museum Arts Center, 2006.

Victoria, Brian Daizen. *Zen War Stories.* London: Routledge Curzon, 2003.

Waldman, Anne, and Andrew Schelling. *Disembodied Poetics: Annals of the Jack Kerouac School.* Albuquerque: University of New Mexico Press, 1994.

Watts, Alan. *In My Own Way.* New York: Pantheon Books, 1972.

Watts, Alan. *This Is It.* New York: Vintage, 1960.

Westgeest, Helen. *Zen in the Fifties.* Amstelveen: Cobra Museum Voor Modern Kunst, 1996.

Wetzsteon, Ross. *Republic of Dreams: Greenwich Village; The American Bohemia, 1910–1960.* New York: Simon & Schuster, 2002.

Williams, Emmett. *My Life in Flux—and Vice Versa.* London: Thames and Hudson, 1992.

Winter-Tamaki, Bert. *Art in the Encounter of Nations: Japanese and American Artists in the Early Postwar Years.* Honolulu: University of Hawai'i Press, 2001.

Young, La Monte, and Marian Zazeela. *Sound and Light.* Lewisburg, PA: Bucknell University Press, 1996.

Yusa, Michiko. *Zen and Philosophy: An Intellectual Biography of Nishida Kitaro.* Honolulu: University of Hawai'i Press, 2002.

Zurbrugg, Nicholas. *Art, Performance, Media.* Minneapolis: University of Minnesota Press, 2004.

Articles

Abe, Masao. "Time In Buddhism." In *Zen and Comparative Studies, Part Two of A Two-Volume Sequel to Zen and Western Thought,* 163–169. Honolulu: University of Hawaii Press, 1997.

Anderson, Alan. "Writing on Water: By Chance, Two Interviews with John Cage." *Shambhala Sun* (November 1994): 11–13.

Aronowitz, Alfred. "The Beat Generation." *New York Post* (March 9, 1959).

Ashton, Dore. "New Japanese Abstract Calligraphy." *Arts Digest* (August 1954).

Barnes, Clive. Review of Dance Concert. *New York Times* (January 11, 1966).

Bernstein, David W. "John Cage and the Project of Modernity." *Corner Magazine* no. 3 (Fall 1999–Winter 2000).

Bois, Yve-Alain. "Missing in Action: The Art of the Japanese Group Gutai." *Artforum* (May 1999).

Brecht, George. "Something about Fluxus." *Fluxus Newspaper* No. 4 (June 1964).

Campbell, Bruce. "Jackson Mac Low." In *Dictionary of Literary Biography*, vol. 193: *American Poets since World War II, Sixth Series; A Bruccoli Clark Layman Book*, 193–202. Edited by Joseph Conte. Buffalo: State University of New York, the Gale Group, 1998.

Danto, Arthur. "Life in Fluxus." *The Nation* (November 30, 2000).

Dempsey, David. "In Pursuit of Kicks." Review of *On the Road*. *New York Times* (September 1957).

Deoree, Howard, D. "Abstract Japanese Calligraphy." *New York Times* (June 23, 1954).

Eastern Buddhist 11, no. 1 (August 1967).

"Flight of the Dalai Lama: Exclusive Photos of His Historic Trek over the Himalayas to Escape the Reds. Lama Reaches Safety." *Life* (April 23, 1951).

"Fluxus: A Conceptual Country." *Visual Language* 26, no. 11/12 (Winter/ Spring 1992).

Fóti, V. M. "Heidegger and 'The Way of Art': The Empty Origin and Contemporary Abstraction." *Continental Philosophy Review* 31, no. 4 (October 1998): 337–351.

Garfinkle, Perry. "In Buddha's Path: The Streets of San Francisco." *New York Times* (October 10, 2008).

Genocchio, Benjamin. "Painting with Hands and Feet." *New York Times* (August 23, 2009).

Glueck, Grace. "Forms to Free the Mind from Worldly Concerns: Zen No Zen; Aspects of Noguchi's Sculptural Vision." Art review. *New York Times* (April 19, 2002).

Glueck, Grace. "Judson Dance." *New York Times* (March 26, 1965).

Goldstein, Richard. "Be Here Then: Judson at 40." *Village Voice* (April 21–27, 1999).

Goodnough, Robert. "Artists' Sessions at Studio 35 (1950)." Archives of American Art, Smithsonian Institute.

Hanhardt, John. "Chance in a Lifetime: Nam June Paik." *Artforum* (April 2006).

Holmes, Clellon. "This Is the Beat Generation." *New York Times Magazine* (November 16, 1952).

Hughes, Allen. "A Place and Time for Finding New Ways to Move." *New York Times* (June 3, 2001): 30.

Hughes, Allen. "Judson Dance Theater Seeks New Paths." *New York Times* (June 26, 1963).

"Is It All Over at 25?" Twentieth Century series on CBS TV, part of *Generation without a Cause*. Narrated by Walter Cronkite, with a commentary by Sen. J. William Fulbright (D-Ark.), excerpted transcript, *New York Post* (March 9, 1959).

Jalon, Allan M. "Meditating on War and Guilt: Zen Says It's Sorry." *New York Times* (January 11, 2003): B9.

Johnston, Jill. "Dance Journal." *Village Voice* (May 5, 1966).

"Judson Dance." Review. *New York Times* (March 26, 1965).

Judson Review 1, no. 1 (1963). Edited by Al Carmines and Don Katzman.

Kaprow, Allan. (1959) Unrevised score of "18 Happenings in 6 Parts." *Anthologist* 30, no. 4.

Kempton, Sally. "Beatitudes at Judson Memorial Church." *Esquire* (1966).

Kerouac, Jack. "About the Beat Generation," published as "Aftermath: The Philosophy of the Beat Generation." *Esquire* (March 1958).

Kerouac, Jack. Article in *Berkley Bussei* (1960) about first meeting with D. T. Suzuki in New York.

Koplos, Janet. "Circuitries of Color." *Art in America* (November 2004): 144–147.

Kort, Pamela. "Georg Baselitz, '80s Then: Interview." *Artforum* (April 2003).

Kuivila, Ron. "Open Sources: Words, Circuits, and the Notation; Realization Relation in the Music of David Tudor." *Leonardo Music Journal* 14 (2004): 17–23.

Larsen, Douglas. "Secret Shangri-La Trek Finds Short China Route." *Washington Daily News* (September 25, 1945).

Larson, Kay. "The Art Was Abstract, the Memories Are Concrete." *New York Times* (December 15, 2002): 50.

Loy, David R. "Is Zen Buddhism? *Eastern Buddhist* 28, no. 2 (Autumn 1995): 273–276.

Lubelski, Abraham. "Nam June Paik." *New York Arts International Edition* 5, no. 2 (February 2000): 14–17.

Macel, Emily. "They Did What?! 12 Outrageous Sexual Moments in Dance History." *Dance Magazine* (November 2006).

Menand, Louis. "Unpopular Front: American Art and the Cold War." *New Yorker* (October 17, 2005).

Millstein, Gilbert. "Books of the Times: The 'Beat' Bear Stigmata; Those Who Burn, Burn, Burn." *New York Times* (September 5, 1957): 27.

"New York's Avant-Garde, and How It Got There." *New York: The Sunday Herald Tribune Magazine* (May 17, 1964): 6–10.

Patterson, David. "Cage and Beyond: An Annotated Interview with Christian Wolff." *Perspectives of New Music* 32, no. 2 (Summer 1994).

Patterson, David. "John Cage and the New Era: An Obituary-Review." *Repercussions* 2, no. 1 (spring 1993): 5–30.

Pearlman, Ellen. "All Cage, All the Time (with a Bit of Merce, Nam June, Shigeko, and Charlotte)." *Brooklyn Rail* (March 2004).

Pearlman, Ellen. "Biography, Mythology, and Interpretation: Interview with Allen Ginsberg." *Vajradhatu Sun* 12, no. 4 (April/May 1990).

Pijnappel, Johan, guest editor. "Fluxus Today and Yesterday." Profile no. 28. *Art and Design* (1993). London: Academy Group.

Rexroth, Kenneth. "Essay." *Evergreen Review* 1, no. 2 (1957).

Rolston, Dean. "Language and Communication: An Interview with Abbot Reb Anderson and Poet-Artist Laurie Anderson." *Wind Bell* 32, no. 1 (spring 1989).

Ross, Nancy Wilson. "What is Zen?" *Mademoiselle* (January 1959).

Ross, Nancy Wilson. "Why I Believe I Was Born a Buddhist." *Asia* (January/February 1981).

Sadler, A. N. "In Memoriam Daisetz Teitaro Suzuki (1870–1966)." *Eastern Buddhist Society* (New Series) 2, no. 1 (1967): 198.

San Francisco Zen Center. "The Kosen and Harada Lineages in American Zen."

Sargeant, Winthrop. "Great Simplicity: Profile of Dr. Daisetz Teitaro Suzuki." *New Yorker* (August 31, 1957).

Schechner, Richard, and Michael Kirby. "John Cage Interview." *Tulane Drama Review* 10, no. 2 (winter 1965): 50–72.

Schechner, Richard, and Michael Kirby, eds. Fluxus Issue. *Tulane Drama Review* 10, no. 2 (winter 1965).

Shute, Clarence. "The Comparative Phenomenology of Japanese Painting and Zen Buddhism." *Philosophy East and West* 18 (1968): 285–298.

Simon, Joan. "Scenes and Variations: An Interview with Joan Jonas, Performance Artist." *Art in America* (July 1995).

Smithsonian Archives of American Art. Interview with Allan Kaprow, conducted by Moira Roth. February 5 and 18, 1981.

Smithsonian Archives of American Art. Interview with Isamu Noguchi, conducted by Paul Cummings. November 7 and December 10, 18, and 26, 1973.

Smithsonian Archives of American Art. Interview with Robert Morris, conducted by Paul Cummings. March 10, 1968.

Specter, Michael. "Planet Kirsan." *New Yorker* (April 24, 2006): 112–122.

Suzuki, D. T. "Zen in the Modern World." *Japan Quarterly* 5, no. 4 (October–December, 1958): 452–461.

Time magazine. Review of Judson Gallery "Ray Gun." March 14, 1960: 80.

Tobey, Mark. "Japanese Traditions and American Art." By John Cage, Mark Tobey, Morris Graves, Kunsthalle Bremen (Corporate Author) Museum of Glass: International Center for Contemporary Art (Corporate Author), Wolf Herzogenrath (Editor), Andreas Kreul (Editor). University of Washington Press (August 2002): 156–157.

Tucker, Marcia. White Paper 2 (2001). No title. Retrieved from www.artandBuddhism.org.

Umehara. Takeshi. "Heidegger and Buddhism." *Philosophy East and West* 20, no. 3 (July 1970): 271–281.

Village Voice. Article on Judson Gallery Panel "The Real Bohemia." December 7, 1961.

Village Voice. Advertisement of Fluxus concert at composer Philip Corner's loft at 2 Pitt Street on the Lower East Side. November 5, 1964.

Watts, Alan. "Beat Zen, Square Zen, and Zen." *Chicago Review* (summer 1958).

Wenger, Michael, and Kaz Tanahashi. "Creation in the Instant: An Interview with Painter Gordon Onslow-Ford." *Wind Bell* (fall 1991).

Westkott, Marcia. "Horney, Zen, and the Real Self." *American Journal of Psychoanalysis* 28, no. 3 (September 1998): 287.

Doctoral Theses

Alker, Gwendoly. "Silent Subjectivities: Performance, Religiosity and the Phenomenon of Silence." New York University, 2003.

Dorish, Margaret Hammond. "Joshu's Bridge: D. T. Suzuki's Message and Mission, the Early Years 1897–1927." Claremont Graduate School and University, 1969.

Fetterman, William. "John Cage's Theatre Pieces: Notations and Performances." New York University, 1991.

Haskins, Rob. "An Anarchic Society of Sounds: The Number Pieces of John Cage." Eastman School of Music, University of Rochester, 2004.

Johnson, Sarah. "Zen and Artists of the Eighth Street Club: Ibram Lassaw and Hasegawa Saburo." City University of New York, 2005.

Kingsley, April. "Franz Kline: A Critical Study of the Mature Work, 1950–1962." City University of New York, 2000.

Kuhn, Laura Diane. "John Cage's Europeras 1 and 2: The Musical Means of Revolution." University of California–Los Angles, 1992.

Nelson, Mark Douglas. "Quieting the Mind, Manifesting Mind: The Zen Buddhist Roots of John Cage's Early Chance-Determined and Indeterminate Compositions." Princeton University, 1995.

Patterson, David Wayne. "John Cage, 1942–1954: A Language of Changes." Columbia University, 1996.

Smigel, Eric. "Alchemy and the Avant-Garde: David Tudor and the New Music of the 1950s." University of Southern California, 2003.

Winther, Bert. "Isamu Noguchi: Conflicts of Japanese Culture in the Early Postwar Years." New York University, 1992.

Master's Theses

Gonzales, Juan Carlos. "The Paradox of John Cage." Florida Atlantic University, 1992.

Lind, Carol Constance. "The First Zen Buddhist Painters Liang K'ai, Mu-ch'i, and Yü-chien and Their Relationship to Contemporary Painting." University of Minnesota, 1959.

McMullen, Tracy. "Presencing Absence." University of North Texas, 2003.

Smith, Christopher. "Eastern Philosophy and Jack Kerouac's Postmodern Poetry." University of Maine, 1997.

Statements, Letters, Manuscripts, Conversations, Lectures

Altschuler, Bruce, Merce Cunningham, Alison Knowles, and Jackson Mac Low. "John Cage's Course in Experimental Music at the New School, 1956–60." Lecture given in New York, September 24 to October 6, 1999.

Archives at the University of Washington, Seattle, Cornish School of Allied Arts, Manuscripts, Special Collections, Seattle.

Archives of American Art. Transcript of "Abstract Art around the World Today." New York: Smithsonian Institute, March 16, 1954.

Archives of Sarah Lawrence College. "Zen Buddhism in American Culture." April 18, 1959.

Archives of the Merce Cunningham Dance Company. New York.

Cage, John, archives at the New School University, Raymond Fogelman Library.

Cage, John, and David Tudor. Interviewed by Dick Witts. London: ICA, 1985. (In holdings of British Library National Sound Archive.) Transcription by Matt Rogalsky, 2002.

Cage, John. "Indeterminacy: New Aspects of Form in Instrumental and Electronic Music," liner notes for Smithsonian Folkways CD/FS 40804/5 [ninety stories written and read by John Cage with music by David Tudor and John Cage].

Cage, John. Interviewed by Richard Friedman. Pacifica Radio Archives Preservation and Access Project, December 1969.

Copley, Al. "'The Club': Its First Three Years." Unpublished manuscript.

Cronkite, Walter. "Generation without a Cause." Narration. March 1, 1963.

Dolan, Brooke. "Explanation of Stories in Thangkas Given to the President of the United States by His Holiness, The Dalai Lama." Unpublished manuscript.

Dunn, David. "A History of Electronic Music Pioneers." Catalogue for the exhibition Pioneers of Electronic Art, Ars Electronica. Linz, Austria: 1992.

Farwell, Denise. Collected papers. Seattle: University of Washington.

Higgins, Dick. "One Hundred Plays." Unpublished manuscript. 1961.

Holmberg, Ryan. "Dragon Knows Dragon." Boston University, 1998. Used by permission of the author.

Irwin, Ron. "On the Road and on the Path: Jack Kerouac's Exploration of Buddhism." Manuscript in preparation for Wisdom Publications, 2007.

Johnston, Jill. "20th century AD." *Art in America,* June 1994.

Judson Gallery Panel. "The Real Bohemia." December 3, 1961.

Kaprow, Allan. Interviewed by Susan Hapgood, Encinitas, California, August 12, 1992.

Kaprow, Allan. Interviewed by Moira Roth, Archives of American Art.

Kaprow, Allan. Interviewed by Dorothy Seckler, Archives of American Art, September 10, 1968.

Kaprow, Allan. Interviewed by John Held, Dallas Public Library Cable Access Studio, 1988.

Lassaw, Denise. Conversations and correspondence, 2005–2006.

Lassaw, Ernestine. Correspondence via Denise Lassaw, 2006.

Lassaw, Ibram. Daybooks, notes, clippings, articles, photos. Archives of American Art.

Lassaw, Ibram. Interviewed by Jim Owens. *Art Beat.*

Lippold, Richard. Interviewed by Paul Cummings, Archives of American Art.

Mac Low, Jackson. Manuscript on John Cage's Course in Experimental Music at the New School, 1956–60.

Motherwell, Robert. "The Arts and Protestant Culture." Transcription of talk, Judson Church Archives, Fales Collection, New York University, March 9, 1955.

Munroe, Alexandra. "Rethinking Art and Politics in Postwar Japan." Part of a panel with Harry Harootunian, Sabu Kohso, and Yuzo Sakuramoto. East Asian Studies Department, New York University, September 30, 2004.

Pearlman, Ellen. Notes from weeklong seminars, lectures, and press conferences at the dedication of the Ginsberg Library at Naropa University, Boulder, Colorado, July 1994.

Pearlman, Ellen. Correspondences with Jackson Mac Low, Gary Snyder, and Diane di Prima.

Roosevelt, Franklin D. Letter to the Dalai Lama from the White House, July 3, 1942. Hyde Park, NY: Franklin D. Roosevelt Library.

Ross, Nancy Wilson. Collected papers. Harry Ranson Humanities Research Center, University of Texas at Austin.

Suzuki, D. T. Chronological Sketch, 1949–1957.

Suzuki, D. T., and John Cage. Conversation, also possibly with David Tudor. Transcription. Diamond Sangha Archives, July 1975.

Suzuki, D. T., and Shin'Ichi Hisamatsu. "Zen in America and the Necessity of the Great Doubt," a recorded conversation in the Hotel Continental in Cambridge, Massachusetts, winter 1958. Courtesy of Yellow Springs Dharma Center, Yellow Springs, Ohio.

Tolstoy, Ilia. Letter to Jerome V. Deyo, GSA, National Archives and Records Service, Franklin D. Roosevelt Library, September 21, 1970.

Trungpa, Chögyam. "Tibetan and American." Lecture at Karma Boston, Massachusetts, October 9, 1973. Vajradhatu Archives.

Vivona, Alycia J. Registrar, Franklin D. Roosevelt Library, New York, August 30, 1990, including inventory of items given to Roosevelt in 1943 by the Dalai Lama via Colonel Ilia Tolstoy,

Yoshihara, Jiro. "Gutai Manifesto." *Geijusu Shincho* (December 1956).

Yoshimoto, Midori. Talk on the Gutai. Grey Art Gallery, October 2004.

Press Releases and Catalogs

"Beat Art: Visual Works by and about The Beat Generation." Catalog. New York University School of Education, 80 Washington Square East Galleries, 1994.

Dunn, David. "A History of Electronic Music Pioneers." Part of a catalog for Eigenwelt der Apparatewelt: Pioneers of Electronic Art, Ars Electronica, curated by Woody and Steina Vasulka. Linz, Austria: 1992.

Museum of Modern Art. "First Showing of Abstract Japanese Calligraphy." Museum of Modern Art, June 23, 1954, No. 65.

Museum of Modern Art. Press Release 127, undated.

Lectures

Art and Spirituality, at White Box, New York City, 2003. Panel with Bonnie Marenca, Alison Knowles, Elenor Heartney, Meredith Monk, and Linda Montano.

Art and Spirituality, at White Box, New York City, 2003. Second panel with Agnes Denes, Richard Foreman, Shirin Neshat, Eiko Otake of Eiko & Koma, and Meredith Monk.

Benren. "Sound Itself Is No Sound." Master Dogen's 300 Koan Shobogenzo. Dharma discourse by Roshi John Daido Loori, Zen Mountain Monastery, Woodstock, NY, June 30, 2002.

"Buddhism and Pop Culture." Panel with Helen Tworkov, Melissia Matheson, Pico Iyer, and Milton Glaser. New York: Asia Society, November 18, 1997.

Munroe, Alexandra. "Fluxus and the Tokyo Avant-Garde: A Prescient Exchange." Walker Art Center, February 12, 1993.

Munroe, Alexandra. "Rethinking Art and Politics in Postwar Japan." New York University, September 30, 2004.

New School. Transcription of New School University's ninetieth anniversary.

Van Itallie, Jean Claude. Talk with the Chronicle Project site.

Georgia, Olivia, Mary Beth Grayville, John Giorno, Kay Larson, and Ken Kraft. "Where Parallels Meet: The Place of Art in the Transmission of Buddhism." Japan Society, April 14, 2003.

White Box. Notes from a talk with Bonnie Marenca, Meredith Monk, Yvonne Rainer, Joan Jonas and others. April 30, 2003.

Yoshimoto, Midori. Grey Art Gallery, Gutai talk and discussions with Larry Miller of Fluxus. Grey Art Gallery, October 27, 2004.

Films

Variations: John Cage Film Video Music Festival, January 21–25, 2004. A showcase of thirty-three films of the legendary musician and composer presented jointly by Anthology Film Archives and the John Cage Trust. *A Zen Life: D. T. Suzuki.* A film by Michael Goldberg, executive producer and director. The D. T. Suzuki Documentary Project Japan Inter-Culture Foundation, 2005–2008.

Websites*

Aronowitz, Al. Beat Papers, http://www.blacklistedjournalist.com/1beat .html.

Atkin, Robert, Roshi, "Teisho, Some Words about Sesshin for Newcomers to Zen Practice," www.sacred-texts.com/bud/zen/aitken-0.txt.

"Authentic Voice: An Interview with Meredith Monk," www.mro.org/mr /archive/22-4/articles/monk.html.

"Awake: Art, Buddhism, and the Dimensions of Consciousness," www.artandbuddhism.org. (Last accessed 2001; website is not currently available.)

Bardwell, Laura. Anne Waldman's Buddhist "Both Both," www.jacketmagazine.com/27/w-bard.html.

Bate, David. "After Postmodernism," www.lensculture.com/bate1.html.

Bernstein, David W. "John Cage and the 'Project of Modernity': A Trans-formation of the Twentieth-Century Avant-Garde," www.cornermag .org/corner03/david_bernstein/bernstein01.htm.

Berkson, Bill. Interview regarding Morton Feldman, www.cnvill.net /mfbbint.htm.

Brooks, James. Interviewed by Dorothy Seckler, http://www.aaa.si.edu /collections/interviews/oral-history-interview-james-brooks-12719.

Burns, Kristine H. "History of Electronic and Computer Music Including Automatic Instruments and Composition Machines," http://www.djmaquiavelo.com/History.html.

* Unless otherwise indicated, all URLs were last accessed January 2011.

Cage, John. Featured on KPFA's *Ode to Gravity Series* (December 12, 1987), www.archive.org/details/JohnCageOTG.

Cage, John. "Music," http://www.newalbion.com/artists/cagej.

Cage, John. "An Autobiographical Statement." http://www.newalbion.com /artists/cagej/autobiog.html.

Cage, John. Biography, http://www.biographybase.com/biography /Cage_John.html.

Cage, John. Interviewed by Ted Berrigan, http://epc.buffalo.edu/authors /berrigan/cage.html.

Cage, John. Oral history interview with Paul Cummings, May 2, 1974, http: //www.aaa.si.edu/collections/interviews/oral-history-interview -john-cage-12442.

Cage, John. Silence Archives, http://ronsen.org/cagelinks.html.

Callahan, Kenneth. Interviewed by Sue Ann Kendall, http://www.aaa.si.edu /collections/interviews/oral-history-interview -kenneth-callahan-12975.

Castelli, Leo. Interviewed by Barbara Rose, http://www.aaa.si.edu /collections/interviews/oral-history-interview-leo-castelli-11784.

Castelli, Leo. Interviewed by Paul Cummings, http://www.aaa.si.edu /collections/interviews/oral-history-interview-leo-castelli-12370.

Ch'an and Zen Lineages, www.oller.net/zl.htm.

Cotter, Holland. Japan's Avant-Garde Makes Its Own Point, http://www.nytimes.com/1994/09/16/arts/art-review-japan-s-avant -garde-makes-its-own-points.html?pagewanted=all&src=pm.

de Kooning, Elaine. Interview, http://www.aaa.si.edu/collections/interviews /oral-history-interview-elaine-de-kooning-11999.

Diamond Sutra, www.silk-road.com/artl/diamondsutra.shtml.

Dienes, Sari. Interviewed by Robert Berlind, http://www.accessmylibrary .com/article-1G1-15383227/sari-dienes-aged-artist.html.

Experimental Television, http://www.experimentaltvcenter.org/.

Feldman, Morton. Interviewed by Richard Wood Massi, http://www.cnvill .net/mfmassi.htm.

Ferber, Herbert. Interview, http://www.aaa.si.edu/collections/interviews /oral-history-interview-herbert-ferber-12988.

Fluxlist, http://fluxlist.blogspot.com/.

Fluxus Debris Website, http://www.artnotart.com/fluxus/index2.html.

Flynt, Henry. The Crystallization of Concept Art, 1961, http://www.henryflynt.org/meta_tech/crystal.html.

Ford, James Ishmael. Boundless Way Zen: The Lineage of Boundless Way Zen, http://www.boundlesswayzen.org/teachers.htm.

Gann, Kyle. Breaking the Chain; An Essay on Downtown Music, http://www.kylegann.com/downtown.html.

Gann, Kyle. Minimal Music, Maximal Impact (November 1, 2001), http://www.newmusicbox.org/articles/Minimal-Music-Maximal-Impact/.

George, James. Interview. The Chronicle Project, http://www.chronicleproject.com/stories_287.html.

Getty Center. Timeline, Postwar Japanese Art Movements, http://www.getty.edu/art/exhibitions/postwar_japan/.

Ginsberg, Allen. "Negative Capability: Kerouac's Buddhist Ethic," excerpted from Disembodied Poetics: Annals of the Jack Kerouac School (2001), http://www.tricycle.com/ancestors/negative-capability-kerouacs-buddhist-ethic.

Goldsmith, Kenneth. Bring Da Noise: A Brief Survey of Sound Art, Fluxus: In Fractured Silence, http://www.newmusicbox.org/articles/Bring-Da-Noise-A-Brief-Survey-of-Sound-Art/.

Graves, Morris. Online encyclopedia of Washington State History, http://www.historylink.org/index.cfm?DisplayPage=output.cfm&file_id=5205.

Group Ongaku, http://www.japrocksampler.com/artists/.../group_ongaku/.

Hakuin School of Zen Buddhism, edited by Dr. T. Matthew Ciolek, http://www.ciolek.com/WWWVLPages/ZenPages/Hakuin.html.

Hakuin Zenji (Hakuin Ekaku) 1689–1796, http://www.kaihan.com/hakuin.htm.

Held, John Jr. Interviews with Fluxus Related Artists (John Cage, Allen Kaprow, Ray Johnson), http://www.fluxusheidelberg.org/jh_flux_int_v1.html.

Held, John Jr. Interview with John Cage, 1987 Dallas, http://www.fluxusheidelberg.org/jh_flux_int_v1.html.

Hi Red Center performance map, http://www.artnotart.com/fluxus /archives-alpha.html.

Higgens, Hannah. Interviewed by Jeff Abell, http://mouthtomouthmag .com/higgins.html.

Higgins, Dick. Various postings, http://findingaids.library.northwestern .edu /catalog/inu-ead-spec-archon-1413.

History of Electronic and Computer Music Including Automatic Instruments and Composition Machines, compiled and annotated by Dr. Kristine H. Burns, http://www.djmaquiavelo.com/History.html.

History of the Sogetsu Center, http://www.sogetsu.or.jp/e/.

Huang-po. The Dharma of Mind Transmission, www.dharmaweb.org /index.php/.

IchiyanagI Toshi. Essay, www.arttowermito.or.jp/1960/music-e.html.

Japanese Art, 1960s Events Planned and Produced by Concert Hall ATM, www.arttowermito.or.jp/1960/music-e.html.

Kaprow, Allen. Interview by John Held Jr., http://www.mailartist.com /john-heldjr/InterviewWithAlanKaprow.html.

Kass, Ray. John Cage: Watercolors, Selected Drawings and Prints, http:// www.zonecontemporary.com/aaa/?catediv=exhi&subnum=2past_sub &sqlnum=49_&detno=1&subinfo=50.

Katz, Jonathan. "John Cage's Queer Silence or How to Avoid Making Matters Worse," http://www.queerculturalcenter.org/Pages/KatzPages /KatzWorse.html.

Katz, Jonathan. The Art of Code, 1993, www.queer-arts.org/archive /show4 /forum/katz/katz_text.html from Significant Others: Creativity and Intimate Partnership, edited by Whitney Chadwick and Isabelle de Courtivron (London: Thames and Hudson, 1993). http://www.queer-arts.org/archive/show4/forum/katz/katz_text.html.

Kazumitsu Kato. Interview, www.cuke.com/Cucumber%20Project /interviews/kato.html.

Kootz, Samuel. Interviewed by Dorothy Seckler, http://www.aaa.si.edu /collections/interviews/oral-history-interview-samuel-m-kootz-12837.

Kyger, JoAnn. Interview, Crooked Cucumber, the Life and Zen Teaching

of Shunryu Suzuki, by David Chadwick, http://www.cuke.com/sangha
_news/sangha.html.

Lane, Belden C. Merton as Zen Clown, http://theologytoday.ptsem.edu
/oct1989/v46-3-article1.htm.

Larsen, Kay. John Cage Was Not Only All Ears, He Was All Eyes Too,
http://www.nytimes.com/2001/02/04/arts/art-architecture-cage-was
-not-only-all-ears-he-was-all-eyes-too.html.

Larson, Kay. Shaping the Unbounded: One Life, One Art,
http://bendingmybrainin4d.blogspot.com/2010/01/buddha-mind-in
-contemporary-art.html.

Lehmann, Thelma. Masters of Northwest Art: Morris Graves; Serious Art,
Insouciant Antics, http://www.historylink.org/_content/printer_friendly
/pf_output.cfm?file_id=3603.

Lichtenstein, Roy. Chronology, www.image-duplicator.com/main.php
?decade=50.

Lieberman, Frederic. Zen Buddhism and Its Relationship to Elements of
Eastern and Western Arts, www.terebess.hu/english/basiczen.html.

Mac Low, Jackson. Tree Movie, http://www.artnotart.com/fluxus
/jmaclow-treemovie.html.

Magden, Ronald E. Buddhism Comes to Seattle and King County,
www.seattlebetsuin.com/betsuin_history_centennial.htm.

Malevich, Kasmir. Suprematist Compositions, ttp://www.ibiblio.org/wm
/paint /auth/malevich/sup/.

Mongol Diaspora, intermongol.net/diaspora/stories/geshe_wangyal.html.

Mostel, Rafael. The Tale of a Chance Meeting That Set the Music World
on Its Ear, http://www.forward.com/articles/136180/.

Motherwell, Robert. Interview conducted by Paul Cummings, Smithsonian
Institute http://www.aaa.si.edu/collections/interviews/oral-history
-interview-robert-motherwell-13286.

MUSA, Sample Edition Essay, www.umich.edu/~musausa/009%20sp
%20sf%20period.htm.

Noguchi, Isamu. Interviewed by Paul Cummings, http://www.aaa.si.edu
/collections/interviews/oral-history-interview-isamu-noguchi-11906.

Noguchi, Isamu, www.noguchi.org.

Okada, Frank. Interviewed by Barbara Johns, http://www.aaa.si.edu
/collections/interviews/oral-history-interview-frank-s-okada-11693.

Om Mani Pade Hum, The Government of Tibet in Exile, Buddhism
/om-mantra.html, www.tibet.com/.

Other Minds, www.otherminds.org.

Paik, Nam June, www.paikstudios.com/bio.html.

Perloff, Marjorie. Dada without Duchamp, Duchamp without Dada,
http: //marjorieperloff.com/articles/dada-without-duchamp/.

Persson, Matt. To Be in Silence, Morton Feldman and Painting,
http://www.cnvill.net/mfperssn.htm.

Rauschenberg, Robert. Interview conducted by Dorothy Seckler,
http://www.aaa.si.edu/collections/interviews/oral-history-interview
-robert-rauschenberg-12870.

Regarding Mu, http://the-wanderling.com/.

Restoring a Sense of Place in Seattle's Nihonmachi, http://www.seattle.gov
/dpd/cms/groups/pan/@pan/@plan/@citydesign/documents/web
_informational/dpds_007023.pdf.

Rexroth, Kenneth. The Visionary Painting of Morris Graves,
http://www.bopsecrets.org/rexroth/essays/art/morris-graves.htm.

Ronsen, Josh. John Cage Online, http://ronsen.org/cagelinks.html.

Roshi and His Teacher, Dharma Transmission, and the Rockester Zen
Center Lineage, Sensei Bodhin Kjolhede, rzc.org/drupal/sites/default
/.../Roshi %20and%20His%20Teachers.pd.

Roth, Moira. "Bernice Bing, A Narrative Chronology,"
http://www.queerculturalcenter.org/Pages/Bingshow/BBChron.html.

Russolo, Luigi. The Art of Noise, www.unknown.nu/futurism/noises.html.

Sander, Ludwig. Interviewed by Paul Cummings, http://www.aaa.si.edu
/collections/interviews/oral-history-interview-ludwig-sander-11909.

Sato, Reverend Professor K. T. Public Talks and Lectures, by Spiritual
Directorof Three Wheels Japanese Shin Buddhist Temple, London,
Document VIII of XII, http://www.threewheels.co.uk/index.php?option
=com _remository&Itemid=11.

Satori in Zen Buddhism, sped2work.tripod.com/satori.html.

Schwabsky, Barry. Larry Poons, First Break, First Show. Artforum

(February 2003), http://findarticles.com/p/articles/mi_m0268/is_6_41
/ai_98123120/.

Shannon, Joshua. Claes Oldenburg's The Street and Urban Renewal in
Greenwich Village, 1960. Art Bulletin (March 2004),
www.mariabuszek.com/ucd/Thesis/ShannonOldnburg.pdf.

Silliman, Daniel. The Failure of the New York Intellectuals,
http://www.cardus.ca/comment/article/199.

Tanaka, Atsuki, https://en.wikipedia.org/wiki/Atsuko_Tanaka_%28artist
%29.

Thompson, Jan. Interviewed by Sue Ann Kendall, http://www.aaa.si.edu
/col-lections/interviews/oral-history-interview-jan-thompson-12209.

Tolstoy/Dolan Expedition, http://tibetan-studies-resources.blogspot.com
/2007_03_01_archive.html.

Touchionini, Ceciliano. "Avant-garde?" International Post-Dogmatist
Quarterly 1, no. 3 (Fall 1994), http://postdogmatist.com/quarterly
/Avntgard.htm.

Ushio Shinohara, http://www.new-york-art.com/e/Ushio-Shinohara.htm.

Video History Project, www.experimentaltvcenter.org/history/tools/ttext
.php3?id=17&page=1.

Watts, Alan. *In My Own Way* (New York: Pantheon Books, 1972), web
excerpt, www.lcdf.org/indeterminacy/about.html.

Welch, Matthew. The Art of Twentieth-Century Zen: Paintings and Callig-
raphy by Japanese Masters by Audrey Yoshiko Seo with Stephen Adiss
(1988), kc-shotokan.com/Essays/nantenbo.htm.

Wolff, Christian. Meeting Cage and the Genesis of Indeterminacy, March
1, 2002, http://www.newmusicbox.org/articles/a-chance-encounter
-with-christian-wolff/.

Young, La Monte. Diasasong Gallery, www.diapasongallery.org/archive
/01 _06_20.html.

Young, La Monte, and Marian Zazeela at the Dream House (October 1,
2003), http://www.newmusicbox.org/articles/la-monte-young-and
-marian-zazeela-at-the-dream-house/.

Zen Buddhism, Rinzai Style, https://en.wikipedia.org/wiki/Rinzai_school.

Zen Studies Society, www.daibosatsu.org/.

Interviews

Amram, David, Peekskill, New York, October 1994
Anastasi, William, New York, May 2006
Arthur, Richard, Boulder, Colorado, 1994
Brownstein, Michael, July 2001, October 2001
Burroughs, William, by Tony Cape, Naropa Institute
Cohen, Ira, New York, 2001
Dilley, Barbara, Shambhala Center, New York, October 9, 2000
Dunn, Douglas, New York, 2002
Ellgar, Jean, Karme Choling, Vermont, August 16, 2000
Fagin, Larry, New York, 2001
Fenley, Molissa, New York, 1992
Foreman, Richard, New York, 2002
Friedman, Lenore, phone interview from California, July 2002,
Ginsberg, Allen, *Vajradhatu Sun,* April/May 2001
Goldberg, Rose Lee, New York, May 2005
Granelli, Jerry, Naropa Institute, July 1994
Gray, Spaulding, *Brooklyn Rail,* New York, October/November 2001
Green, Ellen, New York, August 2002
Harrison, Catherine, Vermont Studio Center, Johnson, Vermont, April 2003
Hollo, Anselm, Boulder, Colorado, July 1994
Kass, Ray, private email correspondence, August 2006
Knowles, Alison, New York, July 2001, October 2001, May 2006
Kyger, JoAnn, Boulder, Colorado, July 1994
Landes Levi, Louise, New York, 1995
Mac Low, Jackson, email correspondence, 2001
Malina, Judith, New York
Mayfield, Barbara, New York, 2001
McClellend, Maurice, New Jersey, 1994
Monk, Meredith, New York, January 2003
Mostel, Rafael, New York, 1994
Okamura, Mihoko, Kyoto, 2005
Paul, Jim, Breadloaf Writers Conference, Vermont, 1994

Poons, Larry, New York, June 2006
Schelling, Andrew, Boulder, Colorado, 1994
Tone, Yasunao, New York, 2002
Waldman, Anne, New York, May, 2006
Whorley, Lee, Boulder, Colorado, 1994
Young, La Monte, and Marian Zazeela, email correspondence, 2006
Ziska, account of the death of Maurice McClelland, 1993/1994

INDEX

ABOUT THE AUTHOR

Photograph by Gae Savannah

ELLEN PEARLMAN is one of the founders of *Tricycle Magazine* and *The Brooklyn Rail* and is affiliated with nine Utne Independent Press Awards. She has been an arts contributor to *Time Out Beijing, Yishu Magazine of Contemporary Asian Art, Art Asia Pacific,* and other publications. She is a member of the International Association of Art Critics and is listed in *Who's Who in America.*

Pearlman has taught at Columbia University, Parsons School of Design, and the New School University. She has been a four-time Vermont Studio Center Special President's Fellow and has been a resident at the Great River Arts Colony in Patzcuaro, Mexico; the Repino Arts Colony in St. Petersburg, Russia; the ACO Artist Residency in Hong Kong and the Red Gate Artist Colony in Beijing, China. She was part of the government-sponsored Chinese Photographers Association trip to Guangxi Zhang Autonomous Region and has worked on collaborate projects with Hong Kong Polytechnic University. Pearlman is the Artistic Adviser of Yuanfen Gallery—the first gallery of new media in Beijing—and was on the Art Panel Review Board for SIGGRAPH ASIA in Yokohama, Japan.

EVOLVER EDITIONS promotes a new counterculture that recognizes humanity's visionary potential and takes tangible, pragmatic steps to realize it. EVOLVER EDITIONS books explore the dynamics of personal, collective, and global change from a wide range of perspectives.

EVOLVER EDITIONS is an imprint of the nonprofit publishing house North Atlantic Books and is produced in collaboration with Evolver LLC, a company founded in 2007 that publishes the web magazine Reality Sandwich (www.realitysandwich .com), runs the social network Evolver.net (www.evolver.net), and recently launched a new series of live video seminars, Evolver Intensives (www.evolver intensives.com). Evolver also supports the Evolver Social Movement, which is building a global network of communities who collaborate, share knowledge, and engage in transformative practices.

For more information, please visit www.evolvereditions.com.